IRANIAN CONTEMPORARY ART

IRANIAN CONTEMPORARY ART

by Rose Issa, Ruyin Pakbaz
and Daryush Shayegan

Barbican Art
Booth-Clibborn Editions

Cover Illustration

Fereydoun Ave
Rostam in Late Summer 1998
collage and house paint on cardboard, 112 × 75cm
Collection of the artist

Iranian Contemporary Art
12 April – 3 June 2001
Curve Gallery
Barbican Centre
London EC2Y 8DS

Exhibition organised by Barbican Art in association with the Iran
Heritage Foundation and Tehran Museum of Contemporary Art
Supported by Balli Klockner plc with additional support provided
by Asia House, Delfina Studios, the Foreign & Commonwealth
Office, the Iran Society and Visiting Arts

Exhibition selected and organised by Rose Issa, Guest Curator,
and Carol Brown, Head of Exhibitions, Barbican Art Galleries,
with the assistance of Sophie Persson, Curatorial Assistant

Barbican Art Galleries are owned, funded and managed by the
Corporation of London
Copyright © 2001 Corporation of London, Tehran Museum of
Contemporary Art, Trustees of The British Museum, the authors
and the artists

Catalogue edited by
Rose Issa
Carol Brown, Barbican Art Galleries
Mark Sutcliffe, Booth-Clibborn Editions

Design
Carolin Kurz

Translation
Babak Fozooni and Ros Schwartz

First published in 2001 by Booth-Clibborn Editions
12 Percy Street, London W1T 1DW
info@booth-clibborn.com
www.booth-clibborn.com

ISBN 1-86154-206-2

Printed in China

IRAN HERITAGE
FOUNDATION

BALLI KLOCKNER

ASIA
HOUSE

Visiting Arts

CONTENTS

FOREWORD

This exhibition and accompanying publication celebrates the vitality and diversity of contemporary Iranian art as it has emerged over the past forty years. In bringing this project together, we were keenly aware that Iranian culture has been presented in Britain almost exclusively in terms of its past history, and that little or no attention has been given to recent work, with the notable exception of Iranian film – an area that has flourished and received due acclaim. The initial proposal for the exhibition came from Rose Issa, our Guest Curator (with whom we collaborated during the Africa 95 festival, and who curated the Iranian Film Season held at the National Film Theatre, London, in summer 1999), and we were eager to respond, given the Barbican's commitment to exploring an interplay between cultures in its artistic programmes. Tehran Museum of Contemporary Art's encouragement and willingness to lend gave further impetus to the idea, and it is clear that without the early and generous support of the Iran Heritage Foundation in London, we would not have been able to realise such a complex and highly significant enterprise.

The exhibition looks at the twenty years before and after the Islamic revolution of 1979. It does not pretend to be comprehensive, although in this book it has been possible to represent artistic trends and developments more fully. Of necessity, in order to concentrate on artists as yet unknown in Britain, we have had to omit talented artists who have had exposure elsewhere, as well as the more traditional calligraphers, miniature painters, and muralists of the war period. We have placed a focus on artists whose work – both from our own perspective and in individual ways – epitomises most clearly aspects that have been central to the evolution of contemporary art in Iran.

During the realisation of the exhibition we have been helped and advised by many people, both in Iran and elsewhere. Our selection has been informed by the views of artists, colleagues, collectors and critics, as well as gallery owners, historians and magazine editors. We are extremely grateful to each of them and acknowledge them individually on page 141. We also thank all the lenders to the exhibition, many of whom have been prepared for their works to travel from Iran, and we acknowledge them on page 140, but make special mention here of Dr Sami Azar, Director of Tehran Museum of Contemporary Art, and his staff for their enthusiasm and help in co-ordinating the exhibition. We also wish to acknowledge with our thanks all of the participating artists, without whose creative and innovative work the exhibition would not be taking place.

Alongside the Iran Heritage Foundation and Balli Klockner plc, we also thank Asia House, Delfina Studios, the Foreign and Commonwealth Office, the Iran Society, and Visiting Arts for their support in realising this important event. We hope that this, as a first, will lead to future explorations.

Carol Brown John Hoole
Head of Exhibitions Art Galleries Director Barbican Art Galleries

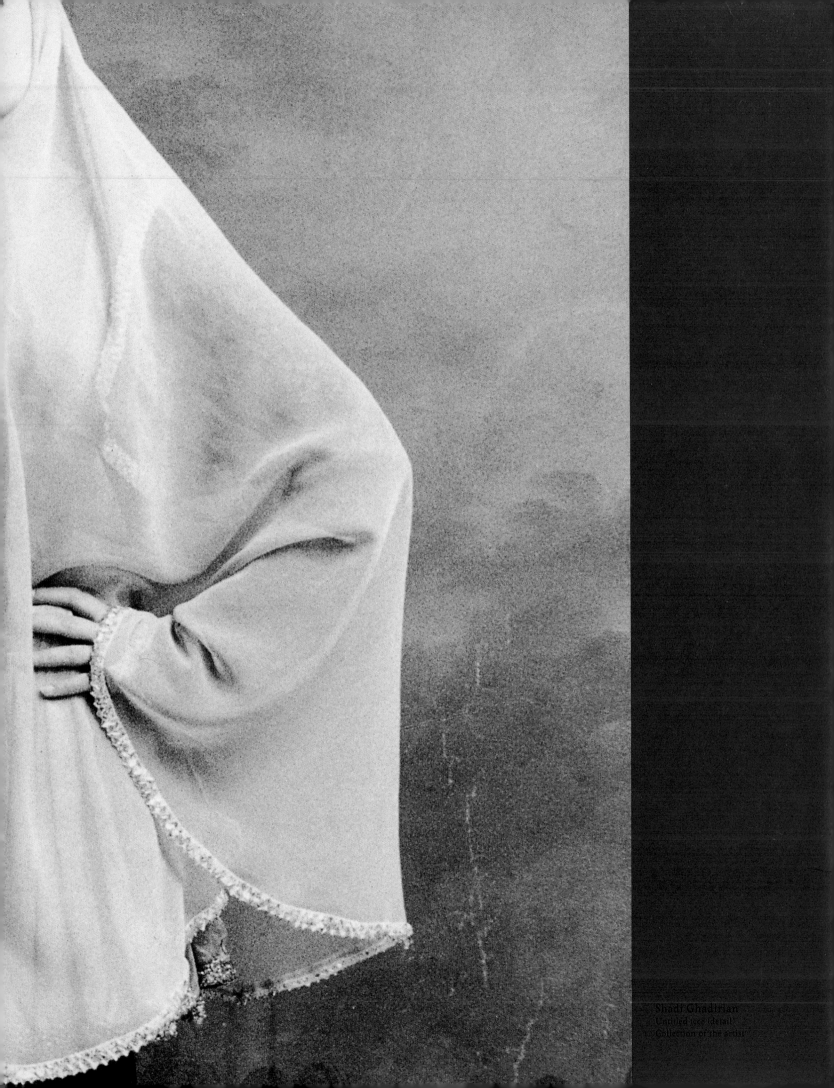

AT THE CUTTING EDGE OF INTERSECTING WORLDS

How does modern Iranian art fit into the current context of contemporary art? Fifty years ago, if people had wanted to define the art of Iran, Turkey or Egypt, for example, they would have had no trouble in categorising these different art traditions which they would readily have relegated to the margins, regarding them as cultural areas that were peripheral to the art of the West, the creative originality of which was universally considered to be beyond dispute.

Today, however, things have changed somewhat. We are witnessing a double shift of focus. First, the fundamental centre of western aesthetic values has been fragmented so that it is no longer possible to conform to one particular dominant school, as it was at the beginning of the twentieth century with the birth of Cubism and the avant-garde. Secondly, we are seeing new literary and artistic creations emerging from the sidelines towards the centre, bringing with them a whole range of new sensibilities. As the product of other milieus, nurtured by other visions and drawing on a memory rooted in other traditions, these creations, which are actualised in modern language – and this is highly important for they can only find expression by modernising themselves – reveal a whole spectrum of original visions with no equivalent in the western cultural arena. They go beyond the day-to-day preoccupations of so-called 'indigenous' cultures and reveal a new existential dimension which, because it flourishes at the cutting edge of intersecting worlds, bears witness to a specific human activity.

There is another, equally important, phenomenon: the mosaic-like configuration of this new civilisation to which we all belong, whatever our origins. This mosaic pattern reflects a simultaneity of all levels of consciousness. All the cultures of the planet seem to have a say in the matter. The very fact of these cultures' emergence, which is in a sense the post-modern condition of our situation in the world, poses the problem of their co-existence. The different cultures live side by side, overlap and cross with one another, so that it is impossible to reduce them to a linear representation. This has led to a whole area of hybridization, unprecedented in the history of humanity. World culture is becoming a sort of rag-bag in which all the vestiges of things, even the most apparently obsolete, are being revived. This has given rise to plural or 'border' identities, and also to 'border-crossers' who live in the interstices of this world of 'in-between spaces', as Homi Bhabha calls them.[1]

10

This area, which can also be described as a rainbow coalition, provides non-western artists with new sources of inspiration, enabling them to devise specific ways of being, conditions of displacement and internal contradictions – in short, breaches where myth and history, tradition and modernity confront each other. For most of these artists tradition, still rooted in the collective memory, is still very much alive; it reveals an experience where the analogical nature of symbols is still operational, where their vision is dominated by the magic of cultural archetypes and where the soul is still immersed in the empathy of social relations. Translated through the prism of modernity, they unearth whole chapters of repressed visions, consigned by the West to oblivion. This explains the success of Iranian cinema, which, like a breath of fresh air, is characterised by a naïve, almost elementary human simplicity, and is the antithesis of Hollywood's high-tech productions which anticipate the feats and angst of future centuries.

The kaleidoscopic perception of the world offers Middle Eastern artists tremendous expressive potential. In their broken vision of things, 'relational thought', as Edouard Glissant calls it,[2] takes the place of linear monolithic discourse, with interbreeding, 'creolization' and hybridity becoming 'rhizomatic', to use a term coined by Gilles Deleuze. All these transformations give rise to changing connections, to perpetual metamorphoses.[3] It is this prodigious wealth of this world that is nowadays highlighted by the writers and artists of the 'periphery'. The reason why Latin-American writers are so at home with their magical realism is because for them 'fiction blends with history'; similarly, Anglo-Indian writers can telescope so comfortably incommensurable worlds into themselves because they all embody to some extent the in-between world, which remains in a way the linchpin of all metamorphoses.

Let us take some powerful examples (without in any way negating the importance of other artists whose works are exhibited here). Bita Fayyazi's cockroaches do not, in my view, simply glorify fallen creatures, despised by humans; they also reveal a human condition (reminiscent of Kafka's *Metamorphosis*), metamorphosed in the exile of its own alienation. The almost obsessive replication of her cockroaches illustrates the extent of the damage that can be caused by a claustrophobic situation, where the sole refuge of humans excluded from their realm is in the solitary confinement of their own repression.

Shadi Ghadirian's photos are a subtle illustration of the grating humour which derives from incompatibilities. Women in ancient Qajar dress are seen with vacuum cleaners, bicycles, Pepsi Cola cans and other equally ordinary everyday items. The discrepancy between these activities and the women's outmoded look and haughty demeanour underscores the strangeness of this surrealistic situation. The bizarre, as such, becomes an event through which the juxtaposition of opposites emphasises the disturbing heterogeneity that is perniciously present in all our behaviour.

Ghazel's impulsive leaps of the imagination also draw widely on this indeterminate area, as we see a black-veiled woman in the most incongruous situations: participating

in summer games, mountaineering or cycling; or as an expectant mother, anxious about her pregnancy – metamorphoses which highlight the incongruities of situations that are disturbing, even grotesque. Humorous juxtaposition serves to emphasize their repetitive absurdity all the more.

To conclude, it should be said that, whatever register these artists belong to, they are ultimately migrants and nomads who live tirelessly in 'border zones', sliding effortlessly from one culture to another, amplifying *ad infinitum* the registers of their representation of the world. They manage to carve out a perilous path through the maze of fractured worlds – a maze which constitutes, whether we like it or not, the 'multicultural' consciousness of our time

By Daryush Shayegan

Translated by Ros Schwartz

Notes

1 Bhabha, Homi, *The Location of Culture*, Routledge, London 1994
2 Glissant, Edouard, *The Poetics of Relation* (trans. by Betty Wing), University of Michigan Press 1997
3 Guattari, Félix and Deleuze, Gilles, *A Thousand Plateaux*, The Athlone Press, London 1988

Parviz Tanavoli

Heech ('Nothingness') & Cage I 1972 (detail)
bronze, 14 × 21 × 16cm
Collection of the artist

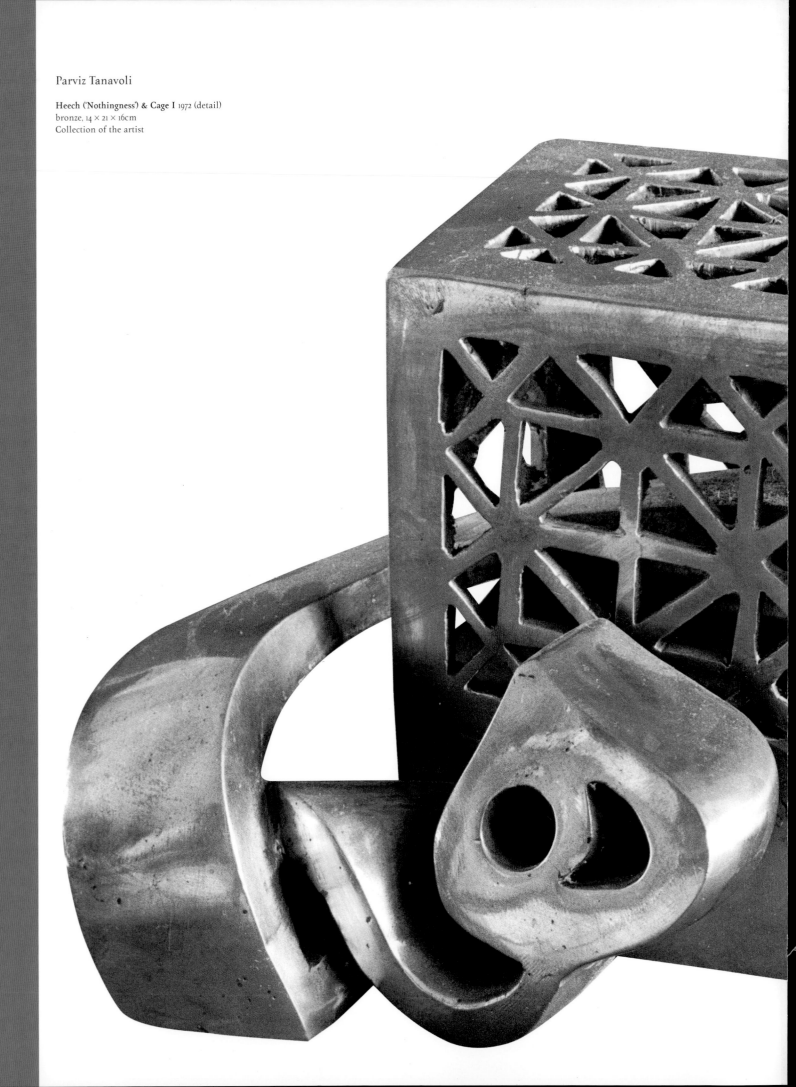

BORROWED WARE

When the last court painter of the Qajar shahs, Mohammad Ghaffari, better known as Kamal-ol-Molk, died in 1940 at the age of 88, Iran finally seemed ready to open its doors to the flood of modernism. It took almost twenty years for the academic realism that Kamal-ol-Molk introduced to be superceded by a new movement, led by a handful of artists whose quest for a new visual language found its most original expression in the 'neo-traditionalist', 'Spiritual Pop Art' school of *Saqqakhaneh*, which attracted the attention of local and international art circles.

The 1960s and 1970s witnessed a dramatic increase in cultural activity, with the creation of scholarships, awards, artist-led galleries, and participation in national and international art fairs, as well as an influx of foreign collectors. At the same time numerous festivals and cultural institutions were established, including the College of Decorative Arts, Tehran Museum of Contemporary Art (TMCA), and museums in Shiraz, Isfahan, and Kerman. The rise in oil prices led to an economic boom which seemed to offer promising new perspectives for Iran's cultural scene.

Then, just when the country's privileged circles began to think that Iran was developing with some panache, the social turmoil that ended with the victory of the Islamic Revolution in 1979 brought all artistic activity to a standstill. Most universities and galleries had to close, or reduce their activities to a minimum, for at least a decade.

For the first ten years following the revolution, daily life was completely overtaken by the new government's priorities – the war with Iraq (1980–1988), strict rules and tight censorship. Only posters and surrealist propaganda war murals, justifying martyrdom and encouraging heroism, appeared in public spaces. Following the end of the war, with more than a million dead, the frustrated youth of Iran, disillusioned by social, economic, and artistic strictures, managed to find a language – through photography, film, painting and, much later, sculpture – that skilfully dodged the heavy hand of censorship. The elections of 1997, won by the liberal wing of the Islamic Republic, provided an opportunity to experiment with a much needed freedom of expression, although not without staunch resistance from the conservatives.

This exhibition and catalogue present glimpses of key trends during the last forty years of work by contemporary Iranian artists who trace their cultural roots to Iran. It does not pretend in any way to be comprehensive or representative of each existing style, but it is my heartfelt wish that it may go some way to broadening our artistic learning and sensibility.

Historical Background

'J'aime trop mon pays pour être nationaliste',
Albert Camus, *Lettres à un ami allemand*

The first western-style art school was estalished in
Tehran by Kamal-ol-Molk (1852–1940), court painter
to five shahs, upon his return from Europe in 1911.
The school brought the first radical change to the
traditional style of painting two-dimensional, stereo-
typed portraits or landscapes by introducing per-
spective and naturalistic rendering of people and
nature. Kamal-ol-Molk freed Persian painting from
the confines of the Qajar court and enabled it to
adopt the tasteful precepts of European realism.
However, the highly academic style he taught,
which prevailed until the 1940s, ignored even the
Impressionists, and was a far cry from the new
trends and concepts that were developing in Europe
in the early twentieth century.

By 1910, the ban imposed by the Qajars forbidding
Iranians from travelling to Europe was lifted.
After the First World War 'modernism' – like many
imported concepts – was superficially and selective-
ly adopted in life as in art. But the infrastructure
that came with modernism in the West was missing
in the East: 'Democracy is not a superstructure, but
a popular creation. Moreover, it is the condition,
the basis, of modern civilisation', wrote Octavio Paz
(*One Earth, Four or Five Worlds, Reflections on Contem-
porary History* [Manchester, 1985], p. 168). Iran, like
other developing countries, still has difficulty in
accessing its own information sources. In many
ways, it also lacks the critical and modern intellec-
tual currents that help to build the infrastructure
necessary for new ideas. Today, the conundrum
that is Iran still faces the problem of synthesising
external models with internal conditions.

Before the 1940s, when Iran was subject to
Russian, Turkish, British and French cultural influ-
ences, it was the painter's skill and craftsmanship
in visualising narrative themes that was important.
This is evident in sixteenth- and seventeenth-
century illustrations of Ferdousi's *Shahnameh* ('Book
of Kings') in the form of manuscript paintings and
miniatures; in figurative and floral Safavid murals
(sixteenth to mid-eighteenth century); and in decora-
tive, life-size Qajar portraits and still lifes (late eigh-
teenth to early twentieth century). These were most-
ly made in the royal ateliers to fit a specific space.
A master artist's reputation in telling a story was
based largely on his draughtsmanship. The only
occasion when narrative seemed to take precedence
over execution was in popular art – in the rendering
of religious events mixed with old Persian legends
as seen in nineteenth- and early twentieth-century
coffee-house paintings.

Kohlan and Dame Gisia 1950
Coffee-House Painting
Collection of Saadabad Palace, Tehran

1940s & 1950s
the formative years, and the rise of
artist-led societies and galleries

Ruyin Pakbaz traces the origins of the Iranian modernist movement to 1942, the year Reza Khan's regime was overthrown and foreign forces occupied the land. By then the Academy of Fine Arts (*Daneshkadeh Honar-Haye Ziba*), established in 1940 under the supervision of a French orientalist, André Godard, already had several foreign teachers in addition to some of Kamal-ol-Molk's former students. Modernist trends, however, were not yet encouraged. Kamal-ol-Molk's rendering of Iranian subjects in a detailed and naturalistic style remained the template.

In 1946, during the first exhibition held at the Iran-Soviet Cultural Centre (*Anjoman Farhangi Iran va Shoravi*), a change in style was noticed, from academic portraiture and landscapes to Impressionism. But this, too, was soon considered outmoded, as most of the works produced were mainly derivative. Influenced by Post-Impressionism, artists such as Manouchehr Yektai, Ahmad Esfandiari and Hossein Kazemi began to teach at the Academy of Fine Arts. Postgraduate students, who were able to travel to Europe and the USA, also came back with new perceptions and a knowledge of new art forms, such as Cubism and abstract art. They were the forerunners of change.

On his return from Paris, Jalil Ziapour (b. 1928), who was introduced to Cubism in André Lhote's atelier, set up the Fighting Rooster Society (*Khourus-e-Jangi*) in 1949. This group of painters and poets wanted to propagate modernist teachings, and Ziapour was regarded as the staunchest defender of Cubism. In its short-lived existence, the group published several issues of a paper by the same name before being closed down in 1950.

Another modernist, Mahmoud Javadipour, wanted to showcase his own and his colleagues' impressionistic and abstract rendering of village life. He created the Apadana Art Gallery (1949–50), the first of its kind in Tehran. The gallery exhibited the paintings of Hossein Kazemi, an influential teacher, and work by such artists as Houshang Pezeshknia, but the gallery did not survive long:

the public was not greatly impressed by the perceived lack of craftsmanship involved in the works.

By 1953 – the year of oil nationalisation and Mossadegh's failed coup – the clash between the 'old' and the 'new' in the arts intensified. Nasser Assar left Iran for Paris, favouring the Parisian art scene. National identity became more than a political issue: it animated heated discussions in various art circles, such as the Mehregan Club, home of the National Teachers Association during the early 1950s.

Returning from Rome's Academy of Fine Arts, Marcos Grigorian (b. 1925), an Iranian of Armenian origin, brought with him the accomplishments of the Italian Expressionist movement. From 1954 to 1960 his Galerie Esthétique in Tehran held exhibitions and trained students. Later, influenced by the conceptual and minimalist art that he discovered during his visits to New York and Minnesota, he used soil, straw and polyester to produce embossed geometric abstractions. An enterprising activist, energetic artist and enthusiastic collector, Grigorian was instrumental in organising the first Tehran Biennial in 1958 and in introducing Iranian artists to international art scenes, and events such as the Venice Biennale.

Born into a family of painters and musicians, Jazeh Tabatabai (b. 1928), a versatile and unconventional poet, playwright, actor, dancer, painter and sculptor, launched his Iran Modern Art Gallery in 1957. Here, for more than a decade, Tabatabai exhibited the work of some of the best Iranian artists. His involvement with the gallery, and in teaching children, played a considerable role in popularising modernism. Today, on the three-floor studio-gallery, privileged visitors are welcomed to Tabatabai's world by hundreds of 'friendly metal men and animals' made of scrap iron (springs, coils, bicycle chains, padlocks, chassis parts), redeemed by his humour and highly developed sense of satire. These imaginative metal portraits oscillate delicately, while Tabatabai recounts anecdotes about each one. Two large *Lionesses with Sun Ladies* (*Khorshid Khanum*)

Jazeh Tabatabai

Sculpture *c.* 1958
in the artist's studio

– allegories of power, wisdom, and everlasting life – are reminiscent of the strong symbols perpetuated in so much Iranian folk and historical imagery.

Tabatabai's contemporary, Nasser Ovissi (b. 1934), a diplomat and painter, depicted reclining Saljuq and Qajar women in compositions with horses, calligraphy and decorative patterns made from wood blocks (*qalamkar*) mixed with gold and silver. These themes and motifs also influenced Sadeq Tabrizi (b. 1939), who drew upon miniatures and folk paintings, repeating the motifs on parchment.

By the late 1950s an energetic generation of artists, including Abol Qassem Saidi, Parviz Tanavoli and Hossein Zenderoudi, returned from Europe with a fresh outlook, and found their inspiration in hitherto unexplored sources in Iran. Tanavoli and Zenderoudi discovered the rich iconography of votive art, as found in shrines, *saqqakhaneh* (water fountains), *taaziyeh* (Shiite passion plays), and processions.

Following in the footsteps of Nasser Assar, Zenderoudi and Saidi settled in Paris (in 1961 and 1965 respectively), which at the time was still considered the capital of the art world, but they continued to go back and forth to Iran until the late 1970s, finding in their homeland a growing art market.

However, already by the end of the 1950s the Iranian art scene began to be visibly influenced by what was happening in New York, which was gaining prominence as the epicentre of the arts.

The activities and opportunities provided by the Iran American Society shifted the balance from an Iran-Europe dialogue towards Iran-America. Styles began to be influenced by Pop Art, Op Art, Kinetic Art and Minimalism, which were quick to replace the Abstract Expressionism of the 1950s.

The highly influential Abby Grey Foundation supported Iranian artists by acquiring their works for American collections, and also by providing funds to build kilns and furnaces (with Tanavoli's involvement) for the sculpture section of the Department of Fine Arts at Tehran University.

In the early 1960s there was a simultaneous exchange of artists emigrating from Iran and those returning to resettle. Hannibal Alkhas (b. 1930), for example, an Assyrian Iranian, returned to Iran in 1960 to teach, paint Mesopotamian subjects and set up the Gilgamesh Gallery, joining the club of artist-led galleries.

By 1960, Siah Armajani (b. 1939) left Iran for the USA to study philosophy, but kept in contact with key Iranian artists (Tanavoli, Grigorian and those invited to Minnesota to participate in exhibitions supported by the Abby Grey Foundation). Today Armajani, a conceptual artist known for his manifestos and constructed projects, is recognised by institutions in the USA and Europe as an outstanding creator of public art.

On his second return from Italy in 1960, Parviz Tanavoli (b. 1937) discovered the poor, southern quarters of Tehran ('it was like discovering Eldorado'), which gave him access to several pottery workshops, blacksmiths, foundries and scrapyards. He recognised that religious folk art was still alive and highly popular in the south. That year he created his first major studio with some financial help from the Department of Fine Arts of Iran. The Atelier Kaboud became a cultural workspace for poets and artists (frequented by Grigorian, Melkanian, Saffari, Sepehri and Shaybani). Zenderoudi held three exhibitions there, and undoubtedly it was here that the *Saqqakhaneh* school came into existence.

Nasser Ovissi

Untitled, *c.* 1960 (detail)
oil on canvas
Collection of Mr & Mrs Akbar
Seif Nasseri

1960s & 1970s
cultural institutions, the *Saqqakhaneh*,
personal styles, economic boom and
private galleries

'Let yourself be silently drawn by the stronger pull of what you really love' [RUMI]

Several major events were to shape the boom decades: the opening of the Tehran Biennial in 1958, the establishment of the College of Decorative Arts in 1961, the impact of the *Saqqakhaneh* school, the emergence of salons, active clubs and galleries, the influx of collectors, and the economic boom resulting from oil prices in the early 1970s. The opening of Tehran Museum of Contemporary Art (TMCA) in 1977, months before the uprising, was indicative of this new prosperity.

The opening of the first Tehran Biennial in 1958, held in the Abyaz Palace within the Golestan Palace compound, was supported by the Department of Fine Arts of Iran (which later became the Ministry of Art and Culture), and organised by Marcos Grigorian. This event was a seminal cultural moment that epitomised the introduction of modernism proper. The first four biennials, open only to Iranian artists, reflected a form of official sanctioning of the modernist movement. The fifth and last biennial, which took place at the Ethnographical Museum in 1966, also included artists from Turkey and Pakistan. The reason why the biennial did not continue after 1966 was never made public, and it was to be another 23 years before the next Tehran Biennial took place at TMCA.

Pahlbold, the Shah's brother-in-law, Director of the Department of Fine Arts and subsequently Minister of Culture and Art, had established a foundation attached to the court which funded the Tehran biennials. Gradually many government institutions and private companies became patrons of modern art: the Pahlavi Foundation; Iranian Radio Television (NIRT); Prime Minister Abbas Hoveida; Ehsan Yarshater; banks; corporations led by the Behshahr group; and the Lajevardi Foundation. These biennials provided an opportunity for foreign collectors and curators to select artists for their exhibitions, collections and museums. One such foreign collector was Mrs Abby Grey.

The Abby Grey Foundation, based in Minnesota, Minneapolis, played an important role in terms of introducing Iranian contemporary art to the USA. Mrs Grey's commitment to artists such as Tanavoli, Armajani and Grigorian – by not only acquiring works for her foundation but also providing funds for local projects – encouraged other institutions, such as the Museum of Modern Art in New York, to become involved and acquire works by Zenderoudi, Pilaram and others.

Cultural societies with external links and galleries, such as the highly active Iran American Society, the Goethe and the Italian institutes, began showcasing the modernist output. Prize-winning competitions, scholarships to study abroad, links with international associations, the hiring of foreign teachers, and the transformation of the educational curriculum along modernist lines were some of the factors determining the future outline of the Iranian art scene.

The College of Decorative Arts, whose president was Houshang Kazemi, played a major role: its teachers encouraged local sources of inspiration, symbols and idioms, unlike the large body of painters who took the West as their model. Many of the future *Saqqakhaneh* artists – Arabshahi, Pilaram, Qandriz, Tabrizi, and Zenderoudi – graduated from the college, and some later taught there.

The *Saqqakhaneh* artists

The term *Saqqakhaneh* was first used in 1962 by the art critic, translator and journalist Karim Emami to describe 'neo-traditionalist' artists – later labelled 'Spiritual Pop Artists' – who were trying to create a bridge between tradition and modernism. Zenderoudi, Pilaram, Tanavoli, Arabshahi, Qandriz, Tabrizi, Ovissi and Tabatabai were among the first to be so described. A common characteristic of this group was the use of votive art – religious folk art which found expression in inscriptions, talismans and depictions of famous love stories.

Talismanic plates
Iran 20th century
brass and silver
Private collection, London

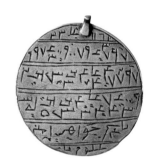

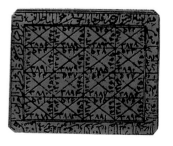

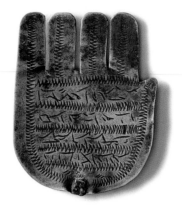

A *saqqakhaneh* is a votive fountain installed for public drinking, often in a modest niche in an old street corner of Iranian towns. It is usually erected by private individuals as a charitable gift given in memory of the Shiite martyrs who were massacred by their Omayyad opponents while unable to reach the Euphrates – and therefore quench their thirst – in the desert near Karbala in AD 680. Imam Hossein, grandson of the prophet Mohammed, is a symbol of political resistance, whose martyrdom increases in significance with changing political circumstances, and is still potent in post-revolutionary iconography. Thus the water fountain often has religious relics attached to it: decorative grills, lit candles, calligraphic tiles, green and black drapery, talismans, locks, and often a brass hand – a symbolic reminder of Abol Fazl Abbas, one of Imam Ali's sons, whose hand was cut off during the massacre.

The *Saqqakhaneh* school rapidly gained prominence within national and international art-houses, with the works of its leading practitioner, Hossein Zenderoudi (b. 1937), being particularly sought after. Zenderoudi was inspired by Shiite folk art as early as 1957, but later switched to calligraphy, although he was not a trained calligrapher. The freshness, intuitiveness and originality of his early work, inspired by a talismanic dress, was breathtaking and unique. His talent was quickly recognised and he was awarded first prize at Tehran's Biennial in 1960, the first of many awards. Immediately after this success, following his third exhibition organised by Tanavoli at the Atelier Kaboud, he left Iran for Paris, where he has lived since 1961.

For the next two decades Zenderoudi became a master at combining elements of calligraphy with *Abjad* figures (numeroligical formulae and letters), which replace the alphabet to convey secret messages. His rhythmical compositions of repeated interwoven words and numbers resemble *doa-nevisi* (written prayers), which are set formulas for every problem. Calligraphy remained the source material for much of Zenderoudi's later work. His large-format paintings, in which he explores the *shekasteh* (free-hand cursive script), resemble a page of calligraphy exercises. His kaleidoscope of colours, the proliferation of rhythms of different intensity, and his exploration of the semantics of calligraphy are spellbinding.

Above

Talismanic plate
Iran 20th century
silver
Private collection, London

Below

Talismanic shirt
Iran(?) 16th/17th century
The Khalili Collections, London

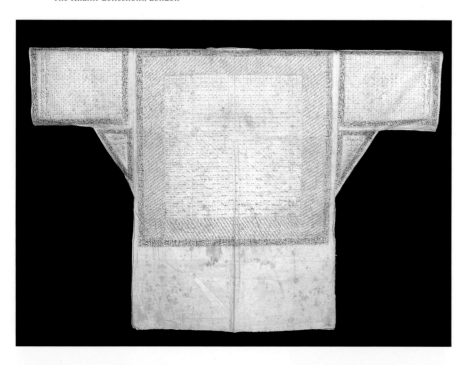

Calligraphy has always been a strong element in Persian culture and a constant source of inspiration: Zenderoudi's compositions soon found an echo in Faramarz Pilaram (1938–83), another graduate of the College of Decorative Arts in Tehran. Pilaram's early development paralleled that of Zenderoudi, and his work was often very similar, encompassing words, letters, and geometrical forms inspired from Shiite iconography. An accomplished calligrapher, Pilaram added seal impressions to his bold, large-scale calligraphic paintings. He also contributed to the creation of *Gouroub Azad* (the Free Group Association) in the mid-1970s.

Calligraphers outside the *Saqqakhaneh* school also produced free compositions: Nasrollah Afjai (b. 1933) worked with *Lettrisme* and *Naqashikhat* (calligraphism), experimenting with a style inspired from old cut-out calligraphy. Reza Mafi (1943–82) was born into a family of calligraphers in the religious town of Mashhad. He became a calligraphy teacher and explored the tensions and expressive lines of traditional *Nasta'liq* calligraphy (a variant of *taliq*, or hanging, script developed by Persians in the late fifteenth century), reducing a word, letter or a page to its purest aspect. His last work, which is in the collection of Akbar Seif Nasseri, was made on his deathbed and illustrates well the extent of his minimalist style.

Neo-traditionalism based on calligraphy manifested itself in other ways too: Mohammad Ehsai (b. 1939), another calligrapher from a religious background, first mastered formal calligraphy before exploring the flowing rhythms of the *Naskh* (late eighth-century cursive script), *Shekasteh* (broken form) and *Nasta'liq* script in his modern compositions. His calligraphical prowess, combined with his knowledge of modern art, gave new shape to old poetry. He uses Hafez's poems or Omar Khayyam's quatrains to create new compositions. His early work, *Gereh Haye Khayyam* ('the Entanglements of Khayyam'), made in 1967, refers to the many different interpretations intrinsic to Khayyam's poetry.

The trend of distilling calligraphy to its essence also influenced Koorosh Shishegaran (b. 1945) in the mid-1970s. This graphic artist uses calligraphical movement in a free, abstract and spontaneous way, producing dynamic compositions of curved lines in vivid colours.

While some artists concentrated exclusively on exploring calligraphy, others used mystical symbols to combine traditional and modern elements into abstract designs. Mansour Qandriz (1935–65) was a semi-abstract painter who used stylised Persian motifs, emphasising tribal forms and ancient metalwork in few colours. A graduate of the College of Decorative Arts, he participated in many artist-led initiatives and was popular with fellow artists. His sudden death in a car accident at the age of thirty prompted Pilaram to name the Talar Iran exhibition hall, opposite Tehran University, after Qandriz (*Talar Qandriz*, 1964–77). The proximity of the university made the Qandriz Club popular with students and intellectuals seeking debates outside official circles. The club published books and catalogues, and its gallery exhibited works by Qandriz, Momayyez, Pilaram, Tabrizi, Arabshahi and Pakbaz.

The abstract and geometrical forms of ancient metalwork and tombstones also inspired the interior designer Jaafar Rouhbakhsh (1940–95). The warm, golden colours of his compositions, allied to the sense of calm and mystery emanating from his work, give his compositions a spiritual quality. By the mid-1970s his work was exhibited at the Maeght Foundation, St-Paul de Vence, and at the Grand Palais in Paris.

Although the *Saqqakhaneh* school only lasted a few years, its impact on calligraphism persists to this day. Its brief existence paved the way for the resurgence of numerous decorative styles which, regrettably, became repetitive and far less impressive. Ironically, it was this desperate search for a genuine 'Iranian' style that led to a proliferation of superficial and amusing imitations, and the synthesis of this trend with modernism created mayhem in official art circles: a plethora of styles emerged. A wave of heterogeneous abstraction (for example in the work of Behjat Sadr and Mohsen Vaziri) influenced many sectors of Iranian art. The proto-Cubist and Expressionist artists furthered their deconstructivist simplifications by favouring form and bright colour. Others chose one of the many modernist styles on offer, borrowing from Op Art, Kinetic Art or Minimalist Art. Soon the pioneers of *Saqqakhaneh* transcended the school's original parameters, and the inquisitive mind of Tanavoli once again questioned the limitations of 'schools' *per se*.

In 1965 Parviz Tanavoli, disillusioned by the derivative works of those who had jumped on the bandwagon of western modern art or the *Saqqakhaneh*, produced his *Heech* ('Nothingness') series in protest. For almost nine years he made numerous versions of this theme, which was directed against the superficial hype and commercialism of the art world. This concept of nothingness was not new to Tanavoli: artists and poets in different lands and periods have reached the same universal concept, from Zen and Wabi Sabi to Sufi orders such as the *Hurrufiyya* (People of the Letter) and *Noqtaviyya* (People of the Point). Tanavoli openly declared that he preferred being called the 'Heech maker', and later the 'Wall maker', rather than an artist or sculptor, for he felt an affinity with the artisans whose locks, metalwork and rugs he started collecting.

The *Heech* series was followed by the *Wall* series, large sculptures resembling *minbars* (pulpits), with steps leading to the top, partly covered with indecipherable text. For Tanavoli, the pre-Islamic legendary sculptor Farhad the Mountain Carver was a principal source of inspiration for this series, Islam's ban on the making of idols having discouraged the development of sculpture for centuries.

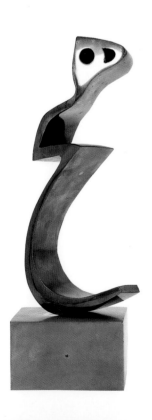

The pre-Islamic period also inspired Massoud Arabshahi (b. 1935), a graduate from the College of Decorative Arts, who from the outset had little aesthetic affinity with the *Saqqakhaneh* style with which he was linked. Arabshahi found his sources in the motifs of Achaemenian, Assyrian and Babylonian rock carvings and scripts. His drawings, inspired by Zoroastrian texts, resemble archaeological maps of ancient cities. His subtle abstract compositions gradually became more three-dimensional as he made embossed works with ceramics, copper and concrete.

Lost cities, ancient scripts and imaginary portraits are themes that emerge in the works of Maliheh Afnan (b. 1935). Born in Haifa to Persian parents, Afnan's life in exile is reflected in her work, which is rooted in memory. Like palimpsests, her very subtle works are relics of older civilisations, scripts and faces from a collective psyche.

With an opposite style and approach, Monir Farmanfarmaian (b. 1924) is, surprisingly, the only artist who explored the potential of mirror and glass as her main media. This traditional form of interior design has almost disappeared, except for a few remaining examples such as the Diamond Hall in Golestan Palace, as well as the mirror work and lattice stucco carvings that adorn the walls and ceilings of many residential houses and small traditional restaurants. Farmanfarmaian's commissions to make large panels for the Niyavaran Cultural Centre and the Hotel Intercontinental (now Laleh Hotel), Tehran, revived the technique, incorporating traditional Islamic designs, photographs and plastic cut-outs to create kaleidoscopic images reflected in diamond-shaped mirrored walls.

On the other side of the creative spectrum are the abstract mud works of Marcos Grigorian and those made later by Parviz Kalantari (b. 1931). Kalantari's early work was based on the form and content of the rural architecture of his hometown, Zanjan, using clay, straw and sometimes incorporating ceramics. Later Kalantari moved towards conceptual art. His recent *Mudvision* series is a blatant criticism of what is shown on television. One work in the series, *Peer dar Khesht Kham Mibinad* ('The Wise Sees within the Raw Clay'), is taken from a well-known saying:

Anche Javan dar Ayneh Binad
Peer dar Khesht Kham Mibinad
('What youth can only see in the mirror
The old can already see in raw clay')

At the margins of these styles and approaches, one man stands out as the artist's poet and painter *par excellence*: Sohrab Sepehri (1928–80), who instills poetry into painting. By following the aesthetics of Zen masters, Sepehri's representational or semi-abstract paintings achieved impressive brevity in their representation of nature. As in his poems, his interest lies with the simple and the serene. Using earthy colours (ochre, sienna, brown) and black brushstrokes, Sepehri was one of the very few artists who looked to the East for inspiration, travelling to India and Japan. The serenity of his minimalist landscapes, where the panorama is simply suggested, is also reflected in his delightful poetry. In his depictions of close-ups of branches, tree trunks or pebbles, his intimate understanding of nature and love for harmony and peace are conveyed.

Mahmoud Kavir, a scholar and writer who has often given lectures on Sepehri, writes: 'Sepehri paints his poetry and puts poetry in his paintings…

He lauds Nature, as an artist who has his roots at the heart of Iranian *irfan* [mystical, agnostic illumination]. His nature is a place of worship... and in reality it is not the painting of a tree that is represented, but the tree itself... Sepehri is from Kashan, but is not a Kashani. Nor do you see it in his paintings. His Kashan is bordered by India on one side and the reverse side of Night – meaning Day and Tomorrow – on the other... Sepehri's pictures are windows opening to "Heechestan", the ethereal realm of Nothingness.'

There is little in Sepehri's work, or that of another painter inspired by nature's details – Abol Qassem Saidi (b. 1926) – that can be described as local or parochial. From his studio in Paris, Saidi paints bright and colourful semi-abstract leafy trees, foliage, flowers and still lifes, representing a suspended moment in nature. His intention is to freeze time in order to trace its path to the past.

While Sepehri and Saidi explored the enchanted world of nature, painters such as Bahman Mohassess (b. 1931) created works of bitter protest and eloquent satirical metaphors. After living in Italy for many years, Mohassess found a strong Expressionist style in his representation of still lifes and human creatures, preferring to express his vehement comments through his depictions of metamorphosed, solitary, deformed beings roaming through a mysterious plane.

Ali-Reza Espahbod's (b. 1951) figurative paintings also sought to capture the anxieties of this period. His *Crows and Trees* series are black omens of difficult times to come, years of hope and fear. In his later work, Espahbod embodied the tradition of narrative art in different ways, and became more explicitly political in his disquieting images. Espahbod's nightmare visions find an echo in the dreamlike paintings of Nicky Nodjoumi, who on the other side of the Atlantic used figurative narratives to explore socio-political situations.

Through the deliberate subversion of Renaissance masters, Aydeen Aghdashlou (b. 1940) visualised the vulnerability of absolute values by mixing Persian themes and paraphernalia in his highly skilled, detailed paintings. *Ice and Fire III* (*Khatereat Atash va Barf, III*), from the *Memories of Devastation* series, was made in the early months of the revolution, when many confiscated artworks

Golestan Palace
Tehran 19th century

were destroyed and cinemas burned. His later series, *Falling Angels* (made between 1993–2000), with naked torsos, burned miniatures and broken ancient ceramics, convey his anger at cultural destruction. They refer not only to the Iranian calendar years (Anno 1372–1379) but also to the Dark Ages of uncertainty and change. A teacher and a scholar as well as artist, Aghdashlou had many followers amongst his students.

By the early 1970s most artistic innovations in the West found an echo in Iran, and the first examples of post-modern art were beginning to make their presence felt. Many galleries flourished, such as the Borghese, Saman, Negar, Saba, Mess and Zand galleries, and the Seyhoun, which is still open today under the energetic direction of Massumeh Seyhoun, a painter and a woman of great taste, courage and determination.

Rasht 29, a private arts club founded by Tanavoli and Kamran Diba, was frequented by artists and patrons alike. Many informal salons were held by intellectuals: Ebrahim Golestan, for example, a collector, film-maker, producer and director of the Golestan Studios, organised artists' gatherings every Friday in competition with the salon of Goli Moqtader, owner of the Borghese gallery.

However, despite the impressions of liberalism, in the mid-1970s the Shah's regime continued to ban films, books and artworks critical of the regime, and some members of the artistic community began to leave the country: film directors such as Shahid Saless left Iran for Germany, followed by the painters Akbar Behkalam and Ardeshir Mohassess.

When Ardeshir Mohassess (b. 1938), Iran's greatest visual satirist and a voice of dissent in the 1960s and 1970s, was banned by the Shah in 1976 from publishing his cartoons, he left Iran where he had many followers among writers, poets and painters, going first to Paris, and then in 1977 to the USA, where he still lives. Akbar Behkalam (b. 1944), who expressed his horror of political abuse in his paintings, also left Iran for political reasons in 1976. Both continued outside their country to depict further abuses in Iran and elsewhere.

This 'brain drain', however, did not alert the Shah's regime to the discontent arising from the visible gap between the elite and the rest of the popula-tion, between the progressive capital and the rest of the country unable to follow the speed of change.

The opening of Tehran Museum of Contemporary Art (TMCA) in Laleh Park (formerly Park Farah) in 1977, just months before the uprisings which culminated in the 1979 revolution, epitomised Iran's artistic activities. The museum director, Kamran Diba, who also designed the museum complex, started the collection with help from the many advisors who surrounded its patron, Queen Farah Diba-Pahlavi. A coherent collection was assembled, supported by a group of international advisors such as Toni Shaffrazi, who has a gallery in New York, and David Galloway, its first curator. Petro dollars helped to acquire some of the best works of the late 1960s and early 1970s by contemporary Iranian and western artists (such as Rothko, Bacon, Warhol, Dine, Johns, Oldenberg, Lichtenstein, Rauschenberg, Hockney, Nicholson, Twombly and Tapies, to name but a few). These were bought from galleries in Iran, New York, Paris, Germany and Italy, the bulk of the budget being spent in New York. Most of the works on loan from Tehran Museum of Contemporary Art are from this pre-1979 collection.

After the revolution, with eighteen different directors in twenty years, the collection became more eclectic. But apart from the well-publicised exchange of Willem de Kooning's *Woman III* for the remains of the *Shahnameh Tahmasp's* illustrated manuscript, the collection remained miraculously intact – neither destroyed nor sold. The current director, Dr Sami Azar, a young architect educated in Britain, has displayed works acquired before the revolution alongside more recent acquisitions – an act of some courage, as many pre-revolutionary artists labelled *Taqouti* ('personification of evil'), and allegedly associated with the previous regime, were blacklisted after the revolution.

The Islamic Revolution of 1979 brought to an abrupt end the official artistic policies of Mohammad Reza Shah, but it also confronted modernist issues. Strict rules and censorship were applied not only to dress codes, imported western films, music and dance, but also to Iranian music and performing arts (women singers and dancers were forbidden from public appearances – a fact to which Shirin Neshat, in her work *Turbulence*, poignantly refers). Across every art form women's hair and male and female nudity were totally banned, and sculptures of human or animal forms discouraged.

During the uprising some students from the Department of Fine Arts joined the protesters and later became the official post-revolutionary painters: Habibollah Sadeghi, Kazem Chalipa and Hossein Khosrowjerdi. They gathered at the *Hosseiniyeh-e Ershad*, the centre of religious intellectual activity in the year preceding the revolution. Later, other Muslim intellectuals established the short-lived Cultural Society of the Islamic Movement, which was disbanded as a result of various conflicts of interest among its members. Another association was created, called the Centre of Islamic Thought and Art, whose co-founder, Mohsen Makhmalbaf, later became famous as a film director. The association aimed to 'democratise' the arts, and encouraged popular expressions of social and religious commitment.

After 1979 many private and public galleries were either confiscated or closed. Many artists, teachers, students and collectors fled the country and most universities were unable to function until the end of the Iran-Iraq war in 1988.

During the months immediately following the revolution, the personal collection of the Shah's family, as well as collections belonging to private institutions, companies and individuals allegedly linked with the previous regime, were confiscated. The *Bonyad Mostazafen va Jaanbazan Enqelab Eslami* ('Foundation for the Dispossessed and the Martyrs of the Islamic Revolution'), a 'semi-private, semi-public' institution created immediately after the revolution, took control of the confiscated goods,

destroying some works, selling others at public auctions in Tehran and Europe, and keeping the rest in storage. The conservation department of the Foundation has confirmed that a small gallery within their headquarters served as an auction venue to dispose of artworks, both in the immediate aftermath of the revolution and between 1990 and 1992, when money was needed for its various 'causes'.

Today, the Foundation is under the control of Iran's spiritual conservative leader, Ayatollah Khamenei. It has several museums, including the Museum of Money, Museum of Time and Museum of History. It also possesses several storage rooms of confiscated archaeological goods, ceramics, metalwork, carpets, textiles and various European and Iranian artifacts and paintings, both old and new. The painting storage rooms contain some magnificent Qajar and nineteenth-century coffee-house paintings. There are also many copies of European masters, several damaged portraits of the Shah and Queen, and some lesser contemporary Iranian and western art. Rumour has it that most of the more prestigious Iranian contemporary artworks were sold early on.

Kaveh Golestan

Photograph of Friday sermons. Mural on walls surrounding football field, painted by Islamic Students Association, University of Tehran

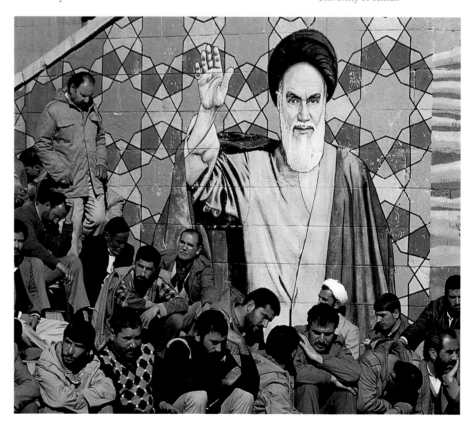

Photography and film

Kaveh Golestan

Photograph of mural painted by
Basiji artists near University of
Tehran, on Enghelab Street, c. 1985

'The same wind that uproots trees makes the grasses
shine' [RUMI]

The increasingly claustrophobic atmosphere of the
post-revolutionary years produced its losers (painters
and sculptors) and winners (photographers and
film-makers). The need to document the changes
and thereby register the moods and significant
moments of Iranian collective history became a
powerful tool in the hands of young photographers.
With priorities shifting, photography and film-mak-
ing came to the fore and prospered. Film-makers
found a simple language that was accessible to all,
and which gradually won international recognition.

A handful of photographers quickly became
household names. In Paris these included Abbas
Attar, Alfred Yaqoubzadeh, and Reza and Manouchehr
Deqatti; and in Iran: Seifollah Samadian, a talented
photographer and editor-in-chief of *Tasswir*
magazine; Bahman and Rana Jalali, who created
the House of Photography (*Akaskhaneh Shahr*) and
published books on photography; the energetic
Kaveh Golestan, who teaches photography in
Tehran and Azad universities and works with the
BBC; Jamshid Bayrami, a teacher and well known
on-set photographer; Mahmoud Kalari, a director
of photography who contributed generously to
the high quality of many Iranian films; Mariam
Zandi, known for her portraits of artists; and Abbas
Kiarostami, a celebrated film director whose photo-
graphs resemble paintings. Great talent is also
to be found among the younger generation, many
of whom are gradually achieving international
recognition.

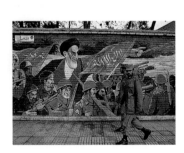

Painting

The first decade after the revolution mostly resulted
in the production of posters and murals glorifying
religious devotion, the heroism of war victims,
portraits of spiritual leaders, and anti-imperialist
slogans. The commissioned artists often used a
crude and elementary visual vocabulary that com-
bined social realism, symbolism and surrealism.
A new genre emerged, which consisted of a realistic
rendering of faces and images from photography
combined with a surrealist background representing
heaven or sacred places, such as the Dome of

the Rock in Jerusalem. This sentimental militant
iconography brought success and prosperity to
artists such as Chalipa, Palangi and Sadeqi.

With the end of the Iran-Iraq war, another
theme emerged to capture the imagination of
militant painters: the Palestinian struggle against
its Zionist enemy, almost always shown alongside
anti-American slogans.

A renewed interest in calligraphy – a safer sub-
ject matter – resulted in the creation of the Iranian
Institute of Calligraphers, and the Association of
Calligraphers (*Anjoman Khoshnevissan*), with branches
in 75 different cities. Today, the association has some
32,000 members including, surprisingly (as they
were previously discouraged from this field), 7000
women. The number of students continues to rise.

Decorative artworks, such as miniatures,
watercolours of landscapes and still lifes, gradually
became popular with commercial galleries.
But only a handful of artists, such as Farah Ossouli
and Rezvan Sadeghzadeh, created an innovative
style in miniatures.

Artists independent of any school (Hassanzadeh,
Fayyazi, Tirafkan, Bahari) created their own 'oases'
in which they could exchange ideas and concerns,
while others gathered around their teachers (such as
Aghdashlou, Etemadi, Khosrowjerdi, Jalali, Golestan,
Bayrami, Pakbaz).

When Khatami, previously Minister of Culture,
became President in 1997, the artistic community
benefited from an unprecedented relaxation of
the rules. Suddenly, instead of working in fear of
closure, galleries could publically announce their
programmes. The then Minister of Culture,
Mohajerani, relaxed the laws by no longer requiring
a special permit for each exhibition and painting
intended for public exposure.

Today, there are more than a dozen recognised
commercial galleries. The Niyavaran Cultural
Centre, built by Kamran Diba just before the revo-
lution, along with public galleries such as the Barg
gallery, are exceptionally active. However, most gal-
leries have no special policy or guidelines, and exhi-
bitions tend to last only a week, to satisfy the artists'

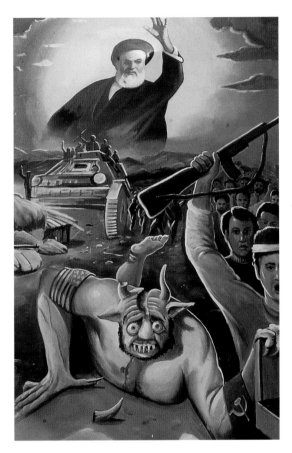

Artists of the Iranian diaspora

'Your real "country" is where you're heading,
not where you are' [RUMI]

Many young art students who were, for one reason
or another, outside Iran when the revolution took
place remained by accident or by choice in their
country of study: Shirazeh Houshiary (b. 1955) has
established herself in London as one of the leading
sculptors of her generation, finding inspiration in
Islamic sacred geometry and Rumi's poetry; Shirin
Neshat (b. 1957) stayed in New York and has chal-
lenged perceptions of Iran's social, cultural and
religious code in photography and video installa-
tions; Seyed Edalatpour (b. 1962) came to England
in 1983, when most universities were closed in Iran,
to study sculpture; Massoud Golsorkhi, a photogra-
pher well-known in international fashion and
design circles, founded TANK magazine in London;
and Golsorkhi's student, the photographer Mitra
Tabrizian, is becoming increasingly known. Paris
was the chosen home for the photographer and
ceramicist Malekeh Nayini, and the painters Leyla
Matin-Daftari, Maliheh Afnan, Bijan Saffari, and
also Christine Khondji and Ali Mahdavi. Siah
Armajani, Nicky Nodjoumi and Ardeshir Mohassess
continued their successful careers in the USA.

demand for exposure. Such a rapid change of pro-
gramme often results in a lowering of standards.

One of the most popular venues is TMCA, where
many young students come to watch films and meet
directors at the Cinemathèque, and also to comment
on the many biennials: of painting (which restarted
in 1989), photography, graphic art (launched in 1984),
pottery, miniatures, calligraphy, cartoons (launched
in 1993), and Islamic art (launched in summer 2000).
Most of the year a few rooms display a selection
of modern western artworks acquired before the rev-
olution. The number of activities sometimes makes
it difficult for visitors to see the museum's unique
collection, but there is talk of building an adjacent
venue which would allow the museum to display its
permanent collection within its compound.

Many of the artists who remained in Iran either
took a break from painting or stopped altogether.
A few, such as Aghdashlou and Pakbaz, devoted
most of their time to writing and documenting the
former and current art scene in Iran; others adapt-
ed their aesthetics to the changing mores and
circumstances.

After his last exhibition in Iran in 1993, Qassem
Hadjizadeh (b. 1947) cut himself off completely from
his homeland and went to live in Paris. The son of
a photographer, Hadjizadeh has consistently used
his father's studio photographs as the basis for
paintings of famous people in incongruous situa-
tions. He is best known for his many depictions
of Taj-ol-Saltaneh, the famous Qajar princess whose
recently published diaries reveal a liberal, even
feminist, character – she was one of the first female
aristocrats to drop her veil and ride a bicycle.

Some artists travelled back and forth, mostly
for financial gain. The well crafted paintings of
Hojatollah Shakiba (b. 1949), popular with Iranians

Left

Kaveh Golestan

Photograph of mural showing
Iman Khomeini urging Iranian
Basiji volunteers against Eastern
and Western Imperialism c. 1983

Below

Ali Mahdavi

Untitled 2000
costume: Mr Pearl and Studio
h. 70cm
Courtesy of Galerie 213, Paris

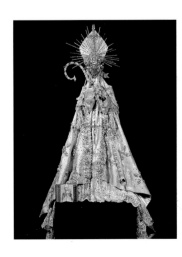

in exile, also makes use of old images. Shakiba incorporates nineteenth-century photographs of Qajar kings and princesses with flowers, nightingales, decorative motifs and lacquer paintings, and ages them by painting in cracks, burns and tears. Shakiba is also the son of a photographer, but while Hadjizadeh is attracted to celebrities, Shakiba is interested in family portraits. Both use nostalgic figures, such as Mirza, the Kurdish freedom fighter who resisted the Russians and the British, or Qajar princesses, but while Hadjizadeh is attracted by satire and characters at the margins of society, Shakiba prefers skilfully painted decorative canvases that emphasise the transience of life.

While photography gained prominence and became increasingly employed in paintings, by the mid-1990s unknown artists with a darker vision of daily life began to emerge. Khosrow Hassanzadeh (b. 1963) was only seventeen when the Iran-Iraq war began. He first volunteered and was then obliged to remain a conscript, his height and bravery making him an exemplary soldier. When he returned from war, having miraculously escaped death ('my constant companion'), he chose disciplines that he had always dreamed about: painting and poetry. The urge to describe and depict his experiences resulted in his series *War* (1995–98), which reveals his personal vision of war's absurdity, when friends become anonymous body-bags of white linen.

From the same generation as Hassanzadeh, Bita Fayyazi (b. 1962) is one of the few artists who returned to Iran after the revolution – in 1982. She uses clay to explore her obsession with the animal world: in her *Road Kill* series she created 150 dead earthenware dogs, which she later buried in her garden (only a video of this work remains). *The Crows* series, part of a group installation work in an abandoned house, was also destroyed. Her most recent series – more than 1000 ceramic cockroaches (1997–2001) – is still increasing in number. Fayyazi has a 'profound fascination' with a creature generally considered repugnant and sinister, which has chosen to impose its presence upon us and make our home its home. She quotes Don Marquis, creator of 'Archy and Mehitabel': 'Step into a world that, until now, you've only stepped on!'

The youngest artist in this exhibition, Shadi Ghadirian (b. 1974), recreates formal studio portraits in her home, dressing friends and family in borrowed or remade Qajar costumes. The women in her photographs, mostly of her own age, are posed in Qajar stances, then juxtaposed with objects from modern daily life – a CD player, a television, a Pepsi Cola can, a bicycle, or a newspaper – the implication being that elements of forbidden Iranian and western culture are insinuating their way into society. When no forbidden elements are shown, her women are completely veiled and covered, resembling beautiful inanimate objects, while others look out with a serene but forceful gaze, their veil lifted – a sign which in Qajar times signified protest.

Ghadirian's dry humour illustrates the paradoxes faced by Iranian women of her generation, and the contradictions of a society torn between tradition and modernity. The defiance of the women in the photographs seems real and forceful, even though it takes place within a studio or behind closed doors.

In the *Me* video installation series, Ghazel (b. 1966) continuously jumps from an outdoor to an indoor activity. Though she refers to Iran and the West as home, she emphasises that she is an outsider in both. The paradoxes she reveals are a constant reminder of her nomadic life. In short, witty, 'haiku-like' self portraits, lasting from one second to two minutes, she reflects on her parallel identities, and her 'endless drifting from one to another'. When she left Iran in 1985, she was all too familiar

Bita Fayyazi

The Crows 1997
in *The Art of Demolition* exhibition,
Tehran

with the restrictions of the chador. Coming from a privileged background, she portrays herself water-skiing, motorcycling, swimming, riding and dancing ballet, with the dress restrictions imposed upon her in her teens, all of which make her look out of place. Back in Iran after years spent wandering through Europe and the United States, Ghazel's work with street children in southern Tehran led her to discover another world, and another self. Her familiarity with foreign languages is shown in the texts running across the bottom of these visual diaries. She insists on keeping errors in the texts so that they reflect her multiple imperfect identities and her foreignness at home and abroad.

Dividing his life between Paris, New York and Tehran, where he owns a gallery, Fereydoun Ave (b. 1945) started his career in 1970 as artistic director to several institutions (Iran American Society, Tehran National Theatre, NIRT, and Zand Gallery). In the mid-1970s he met his mentor and major source of inspiration, Cy Twombly: 'I don't want to be original, I want to be like Cy Twombly'. Yet original he is, his training as a set designer providing him with a wide array of techniques with which to express his eclectic interests. For example, his beautifully executed minimalist watercolours were made to demonstrate his draughtsmanship to those 'who are still too impressed by craftsmanship'.

While he admires Zenderoudi, who explored his Islamic background extensively, Ave considers that as a Zoroastrian his inspiration comes from pre-Islamic themes, while the invention of the camera and the study of the subconscious are his liberating guidelines.

In Ave's work the onlooker can find a resonance with the concerns of modern Iran. His Rostam series comes from his search for 'what makes one Iranian', for what makes the 'Iranian collective consciousness'. Rostam is a hero of the pre-Islamic Persian legend, the Shahnameh ('Book of Kings') by Ferdousi (died c. 1025), a poet who described the limitations of individual monarchs. This book of epics, so intrinsic to Iranian culture, was almost banned after the revolution, as the new regime wished to stress the Islamic identity of Iran rather than its national identity. Even statues of Ferdousi were threatened with destruction. The Shahnameh represents mostly Persian archetypes, with the herculean figure of Rostam epitomising the tradition of chivalry: a sort of Hercules and King Arthur combined in one. In Rostam in Late Summer (Rostam dar Akhar Tabestan), 1998, Ave uses his depiction of the wrestler Abbas Jadidi, 1998 Olympic gold medalist, to explore the concept of the Pahlavan, the ultimate Iranian athlete. This Rostam (Jadidi in his competition attire) is introduced in the full bloom of late summer, back from his victorious battles.

But Iran's legendary hero Rostam differs from his Graeco-Roman counterparts in one crucial respect: in the Shahnameh it is the father, Rostam, who kills his son, Sohrab, out of loyalty to the sanctity of an unworthy king. In Rostam and Sohrab, Ave uses his own photographs of the champion wrestler during his training to illustrate the tragic story of the struggle between father and son. In this battle, Sohrab will be killed because he has sworn to overthrow the unworthy Shah Kavus. The faithful Rostam, Iran's foremost hero, must therefore kill his son. In this tragedy, both familial bonds and personal dignity are sacrificed to unwavering obedience to a ruler. This allegory of the forces of tradition and the past silencing the voice of modernism and the future is still strongly felt and experienced in Iran today.

In his prologue Ferdousi writes, 'For nothing that exists will long endure'. This brings us back to the title of this essay: 'Borrowed Ware', which also relates to a common Sufi saying – *In Niz Migozarad* ('This too will pass') – which hangs on the walls of many artists' studios and traditional coffee houses. It is a concept strongly rooted in the Iranian psyche, one which finds an echo from Omar Khayyam's poems to Tanavoli's *Heech*.

Borrowed Ware is also the title of an inspiring book of medieval Persian epigrams translated by Dick Davies (see Bibliography). Just as Davies's selection of poems illustrates the atmosphere and variety of Persian poetry, our aim in this publication is to convey the essence, in differing styles, of Iranian contemporary art.

A seminal work that inspired this exhibition is Daryush Shayegan's *Le Regard Mutilé* (1989), translated in English as *Cultural Schizophrenia* (see Bibliography). The book is essential reading for anyone interested in the process of critical debate surrounding one's own culture, and its relationship to western modernity. In his essay on the mental distortions afflicting those civilisations that 'have remained on the sidelines of history and played no part in the festival of changes', Shayegan underlines how enriching the situation can be if one accepts the ambivalent challenge consciously, lucidly and without resentment. For despite the underlying disparities between Iran and the West, they should be considered the 'two faces of humanity's single, common experience'.

The Golden Lion award was given to Shirin Neshat at the Venice Biennale in 1999, and the Tate's Turner Prize (which had previously shortlisted Shirazeh Houshiary, Mona Hatoum and Anish Kapoor) included three other foreign contenders in 2000. Both acknowledge once again that art is international, and that its vitality depends on continual dialogues with 'elsewhere', even if the immediate subject-matter is determinedly local.

I owe to Edward Said the courage to have undertaken this essay. Despite the fact that there are many more knowledgeable experts in this field in Iran, what may seem important to a historian and critic of Iranian contemporary art in the country itself may be less relevant to a non-Iranian public. As there was no existing text that could convey – in terms of scope, angle and choice of artists – the field of interest related to this exhibition, I undertook to write one.

Finally, I would not have been able to write this essay were it not for the continuous support of Carol Brown, my co-curator, without whom this project could not have been realised. I would like also to acknowledge the generous support of Dr Sami Azar, whose energy and enthusiasm enabled us to stage this event; the guidance of Ruyin Pakbaz, artist and art historian; Karim Emami, eminent Iranian art critic; Kamran Diba, for his valuable information; Manijeh Mir Emad Nasseri, painter and editor of the English Persian art quarterly *Tavoos*; Aydeen Aghdashlou, painter and scholar; Katia Hadidian, for her comments; and Parviz Tanavoli, whose advice is an inspiration. I would like to extend my gratitude to all for their generous and kind collaboration.

Rose Issa
London, January 2001

Seyed Edalatpour

12th and the 13th 1997–98 (detail)
Portland stone
Courtesy of Pratt Contemporary
Art, Sevenoaks, Kent

ILLUSTRATIONS

* indicates works that are not in the exhibition
Sizes are given in centimetres, height preceding width, preceding depth

Hossein Zenderoudi

Untitled *c.* 1959–62
vegetable paint, pigments and
Chinese ink on papier collé
mounted on wood, 154 × 100cm
Tehran Museum of
Contemporary Art
TMCA 2307

Pages 32–33

**Quand prendrons-nous
le thé ensemble?** 1977
acrylic on canvas, 130 × 203cm
Tehran Museum
of Contemporary Art
TMCA 521

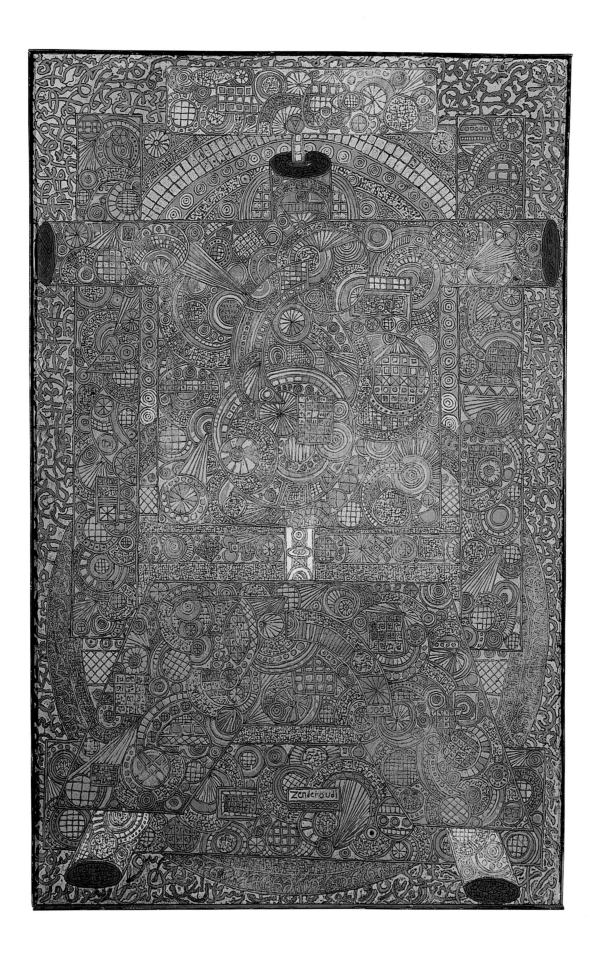

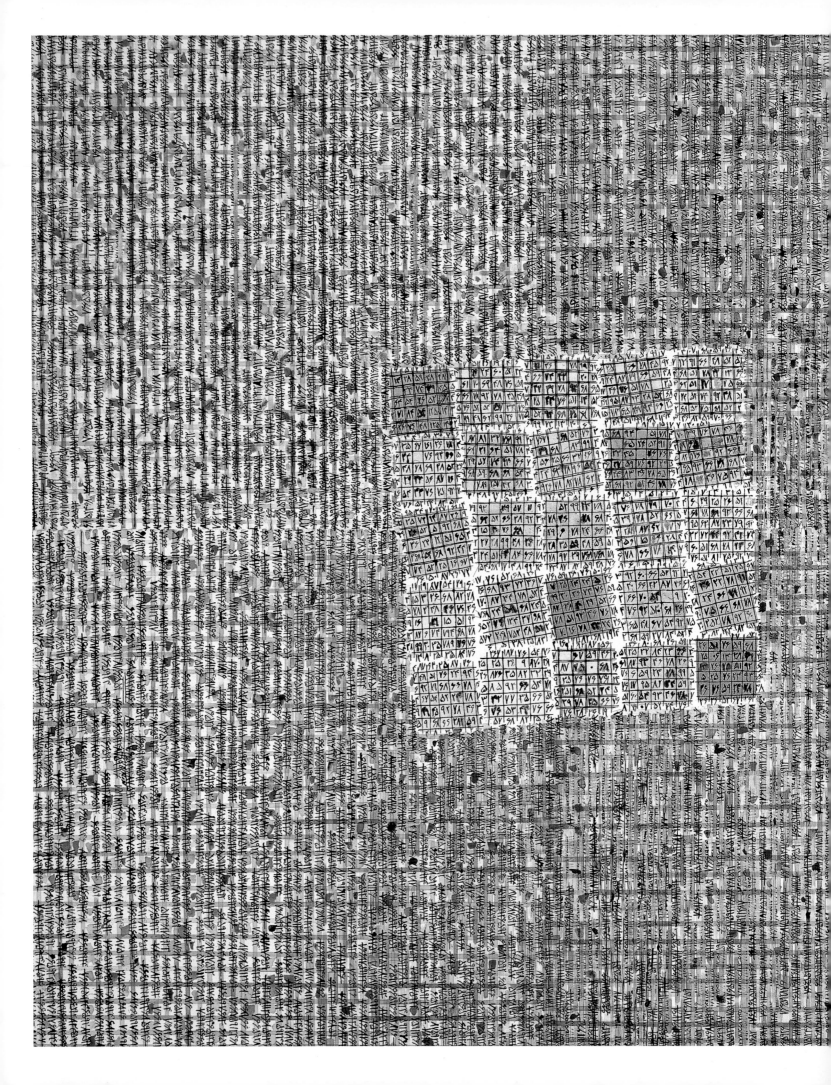

Hossein Zenderoudi

Hale 1984 *
oil on canvas, 163 × 106cm
Collection Stichting Vrienden van
het Wereldmuseum, Rotterdam

Eyn + Eyn 1970
acrylic on canvas, 195 × 130cm
Collection of Fereydoun Ave

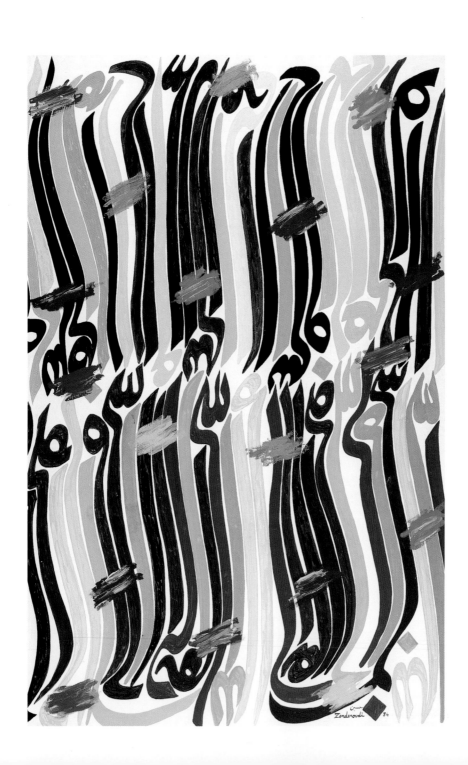

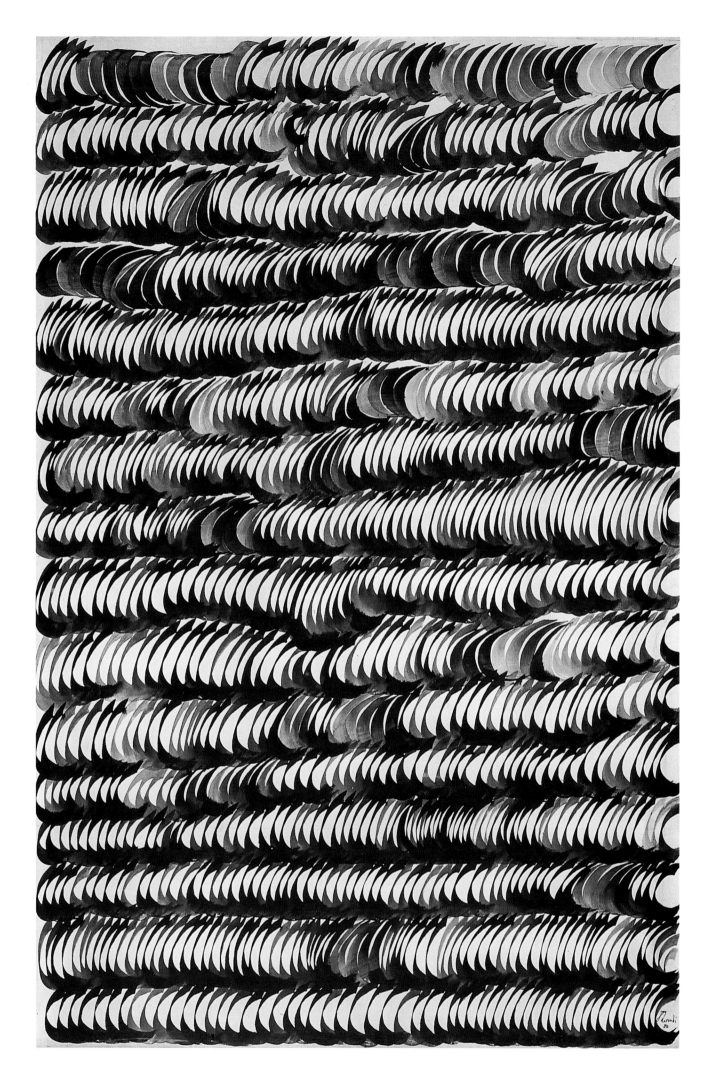

36

Mohammad Ehsai

**The Entanglements
of Khayyam** 1967
oil on canvas, 100 × 137cm
Collection of the artist

Pages 38–39

The Echo of the Word 1990
oil on canvas, 160 × 310cm
Tehran Museum
of Contemporary Art
TMCA 3292

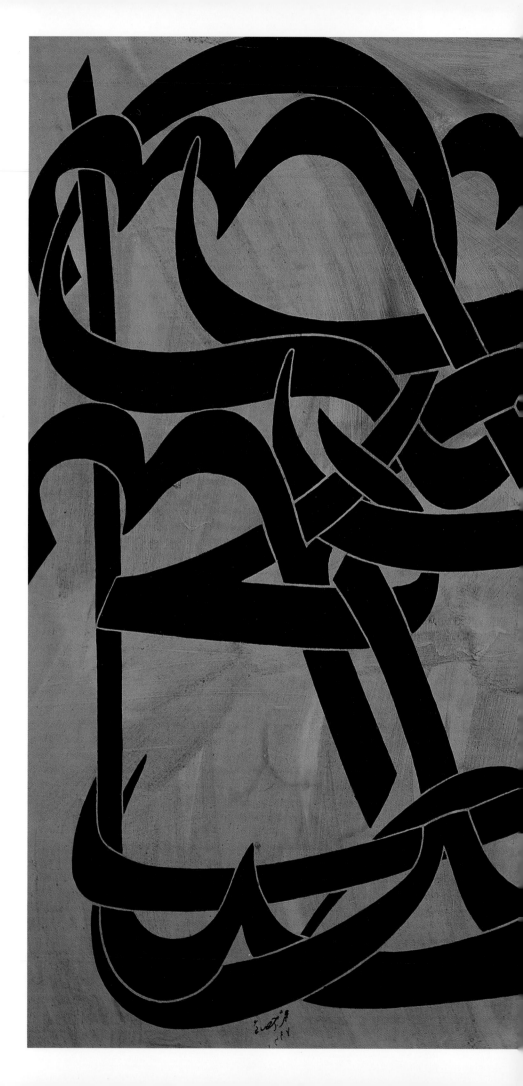

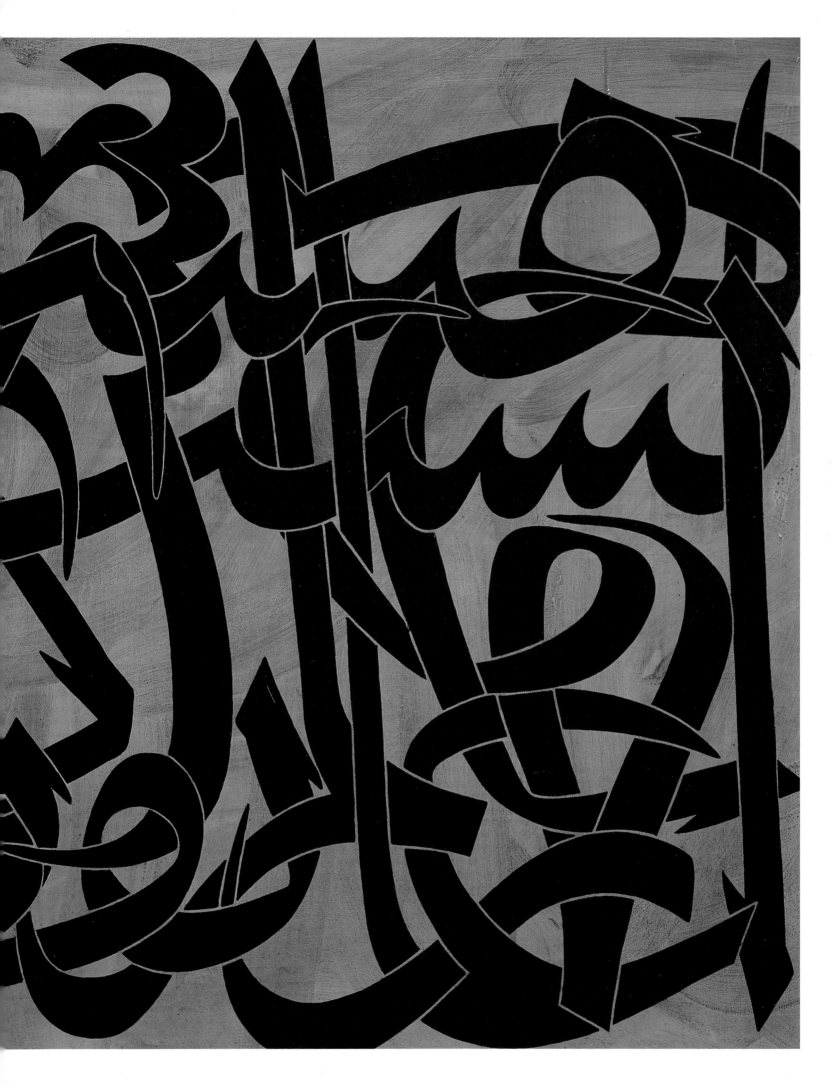

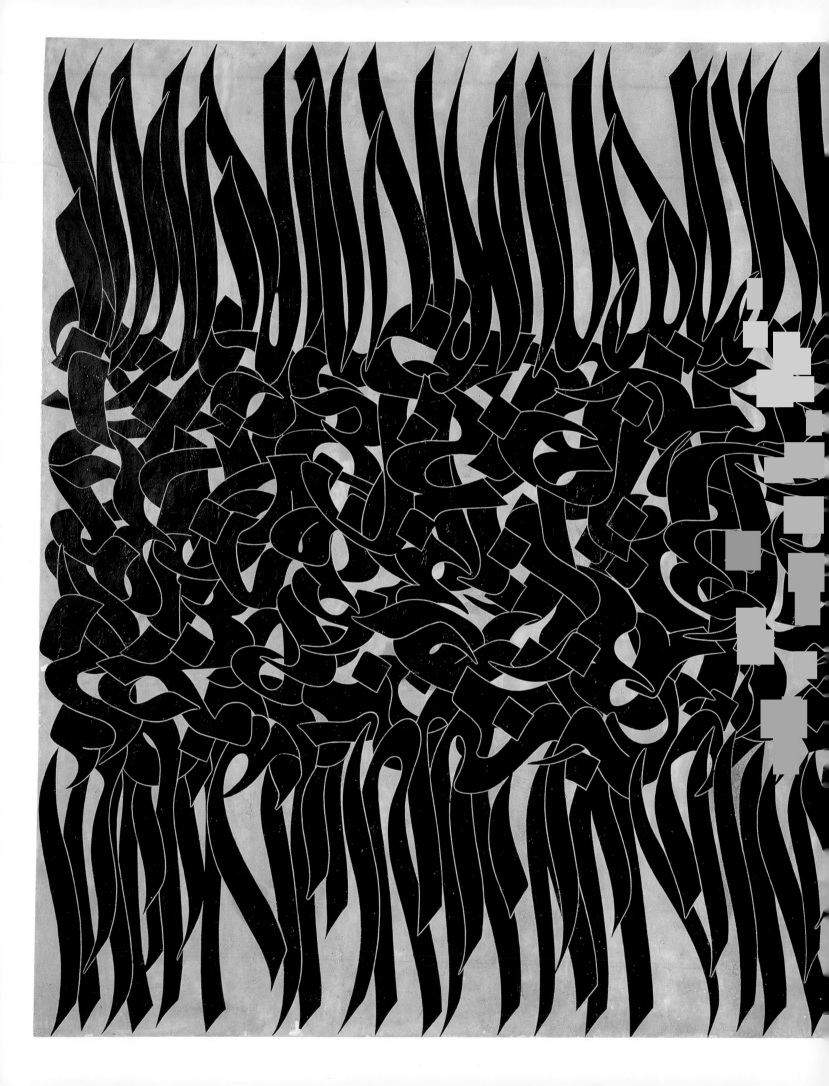

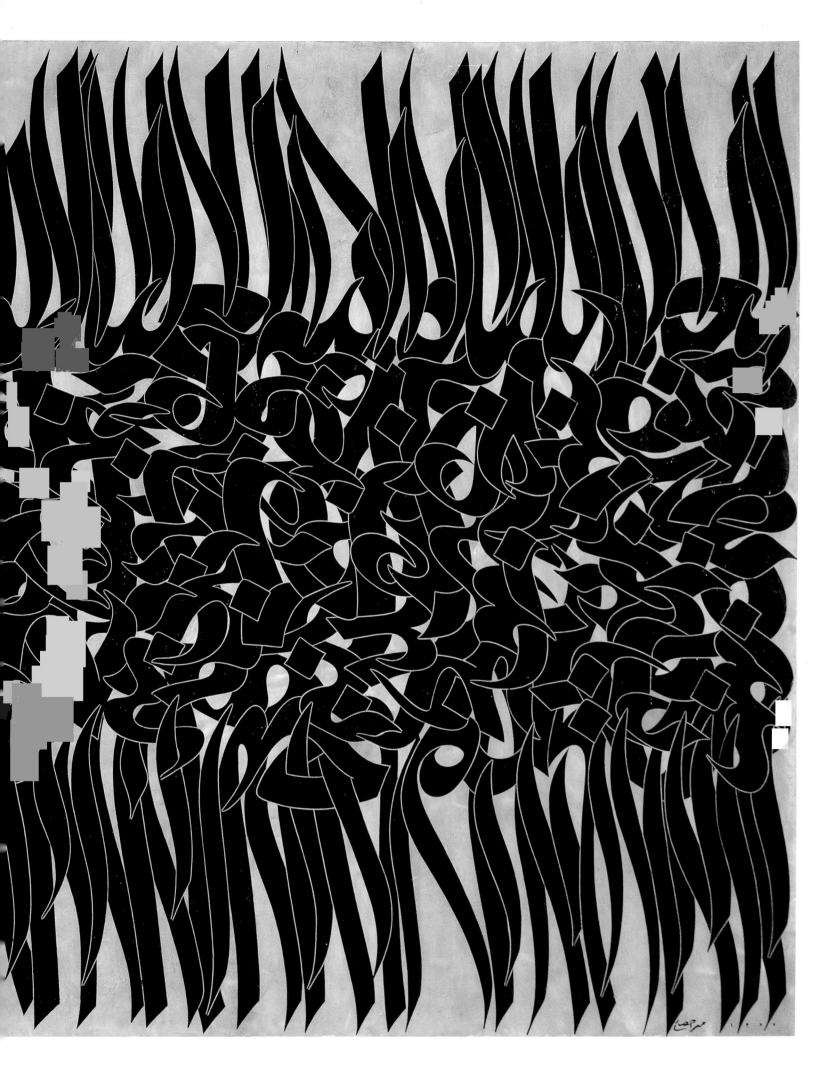

Faramarz Pilaram

Untitled 1975
oil on canvas, 200 × 200cm
Tehran Museum
of Contemporary Art
TMCA 140

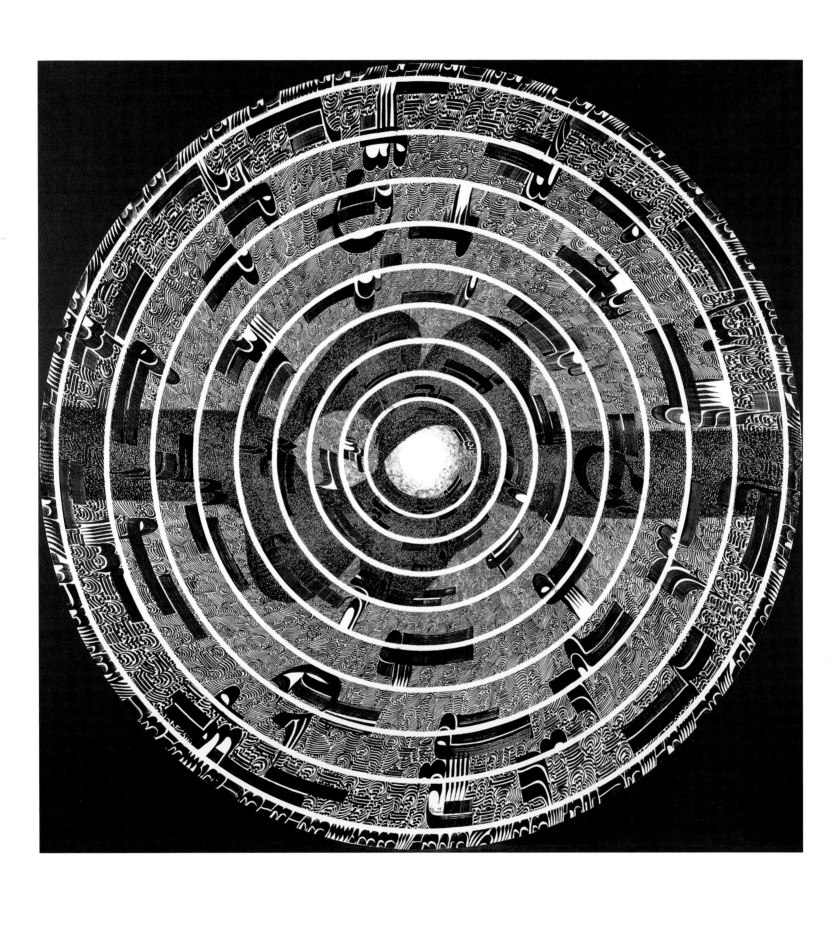

42

Nasrollah Afjai

Calligraphy 1972 *
oil on canvas, 65 × 65cm
Tehran Museum
of Contemporary Art
TMCA 494

Calligraphy 1975 *
oil on canvas, 64 × 64cm
Tehran Museum
of Contemporary Art
TMCA 500

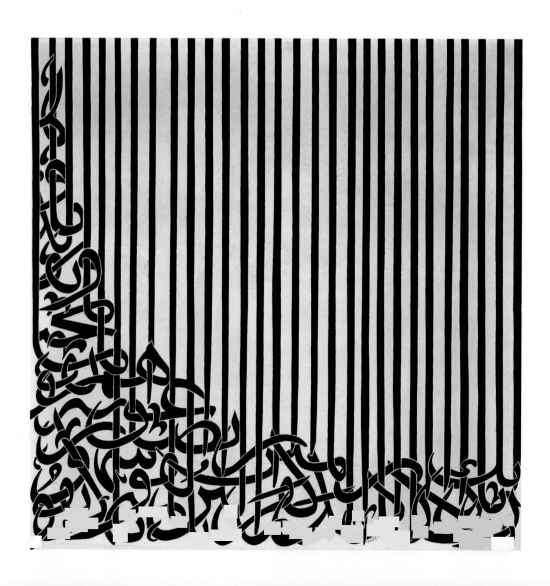

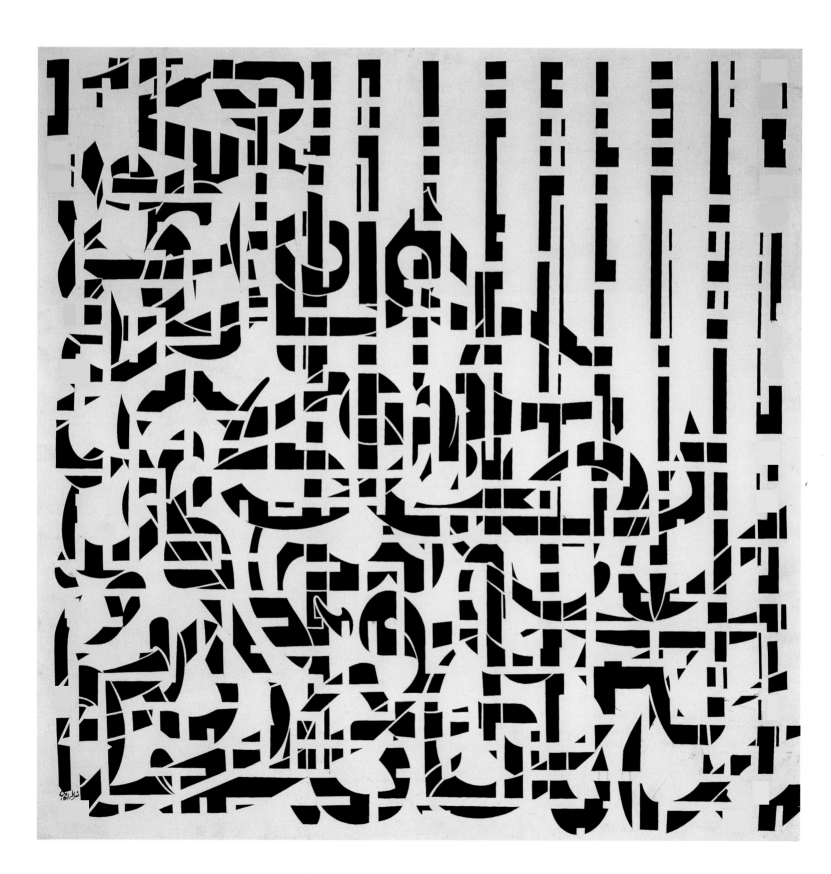

Reza Mafi

Poetry 1977 *
oil on canvas, 76 × 100cm
Tehran Museum
of Contemporary Art
TMCA 188

Untitled 1982 *
oil on canvas, 108 × 150cm
Collection of
Mr & Mrs Akbar Seif Nasseri

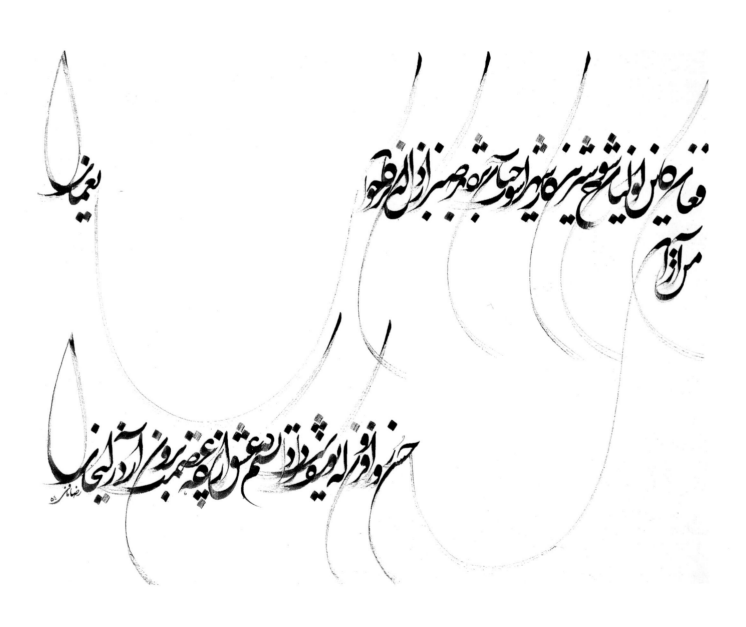

Mohammad Ali Taraghijah

Tranquil Soul 1992 *
watercolour on paper, 31 × 24cm
Tehran Museum
of Contemporary Art
TMCA 2982

Research No. 5 1991 *
watercolour on paper, 32 × 26cm
Tehran Museum
of Contemporary Art
TMCA 2985

Koorosh Shishegaran

Untitled *c.* 1988 *
oil on canvas, 128 × 133cm
Collection of
Mr & Mrs Akbar Seif Nasseri

Untitled *c.* 1985 *
oil on canvas, 186 × 140cm
Collection of
Mr & Mrs Akbar Seif Nasseri

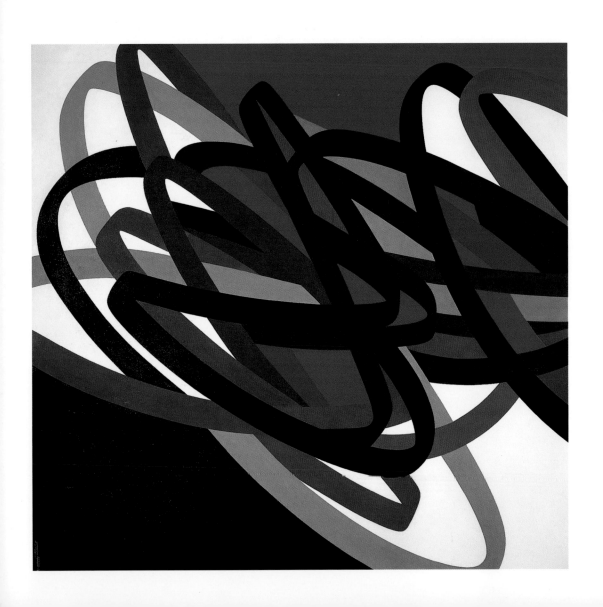

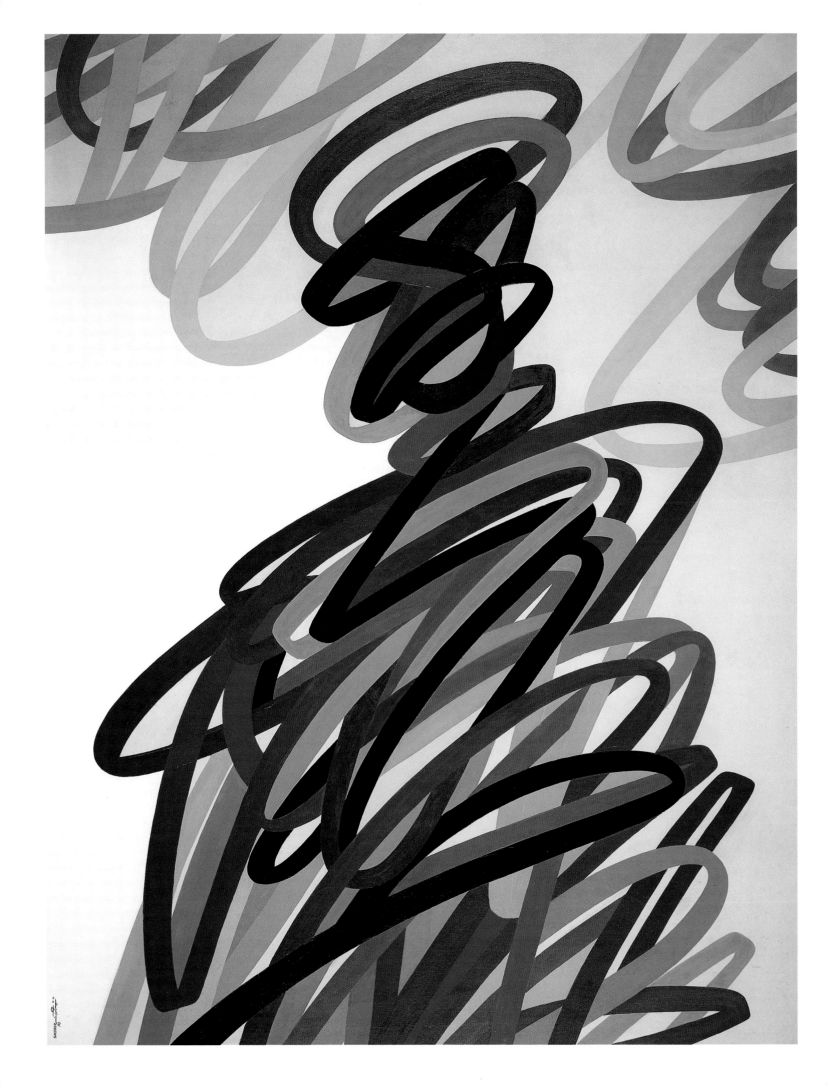

50

Maliheh Afnan

Letter of an Illiterate *c.*1980 *
mixed media on paper, 48 × 63cm
Courtesy of England & Co., London

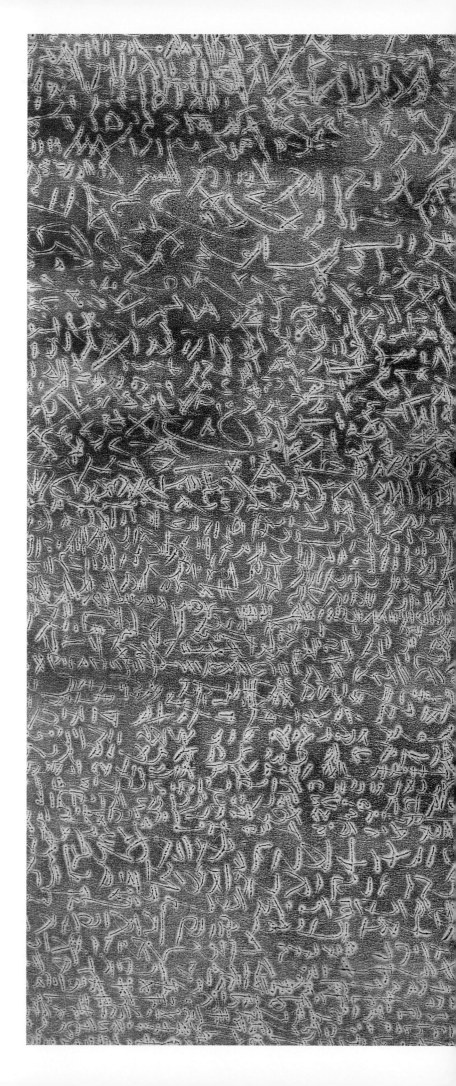

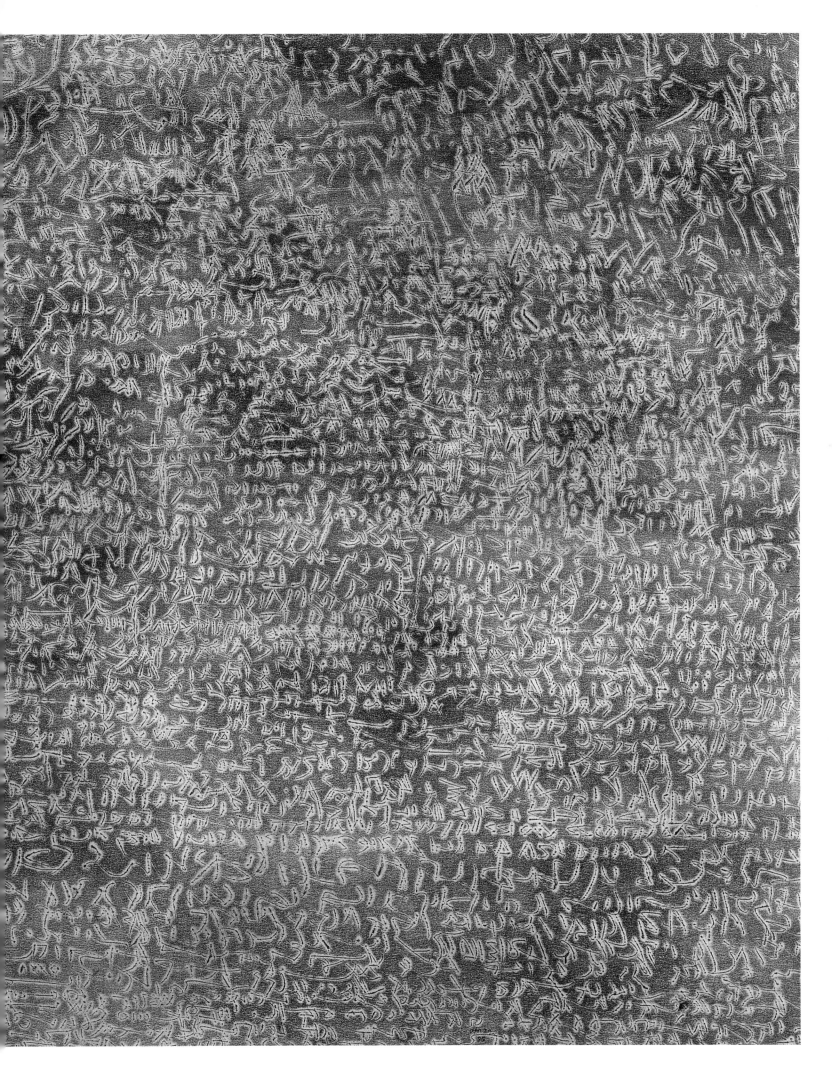

Parviz Tanavoli

**Heech ('Nothingness')
& Cage I** 1972 *
bronze, 14 × 21 × 16cm
Collection of the artist

The Walls of Iran II 1977 *
bronze, 209 × 108 × 63cm
Collection of the artist

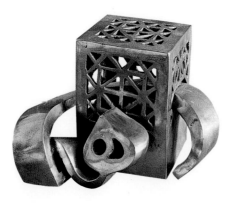

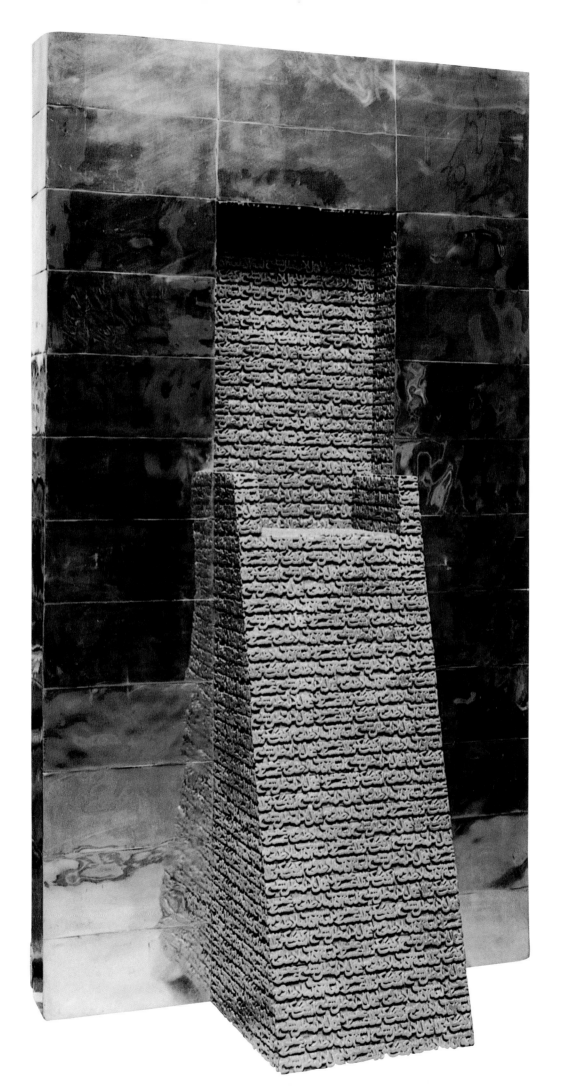

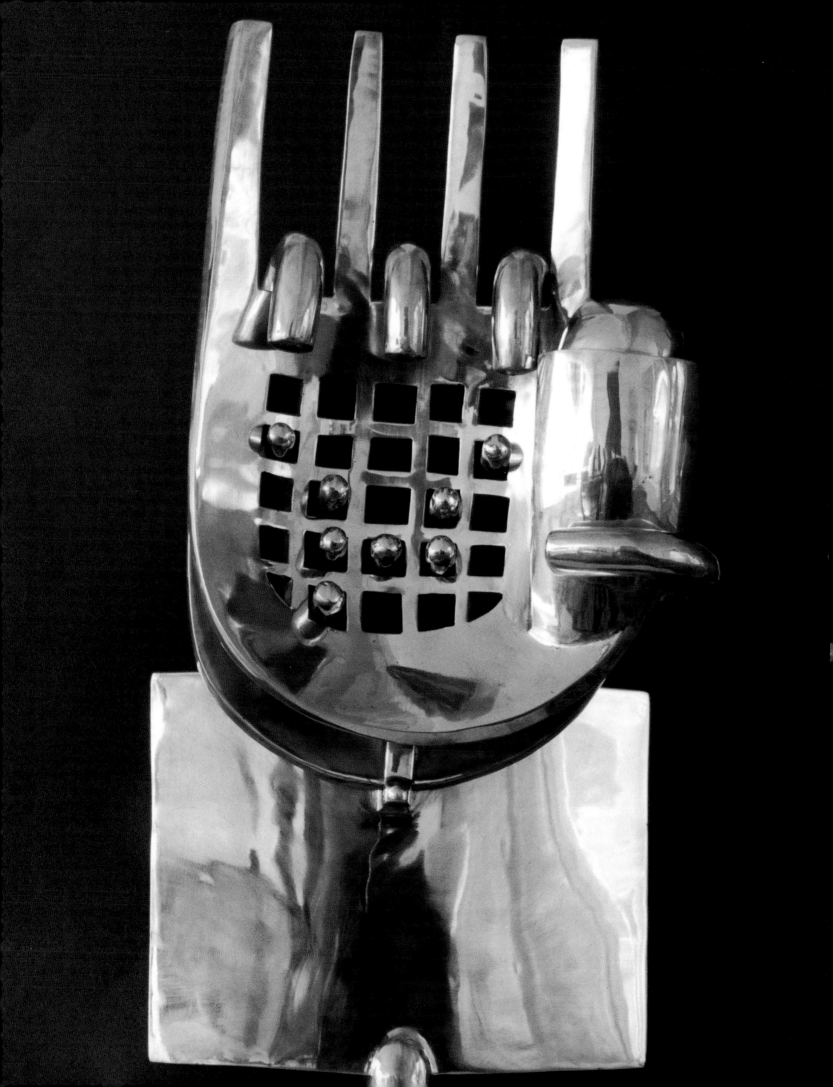

Parviz Tanavoli

Left

Hand on Hand 2000 *
bronze, 51 × 22.5 × 12.5cm
Collection of the artist

Right

Heech! ('Nothingness') c. 1962 *
ceramic, 77 × 50 × 30cm
Collection of
Mr & Mrs Akbar Seif Nasseri

Ooh! Limou Limou c. 1962 *
ceramic, 65 × 40 × 22cm
Collection of
Mr & Mrs Akbar Seif Nasseri

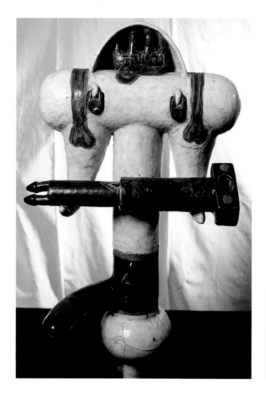
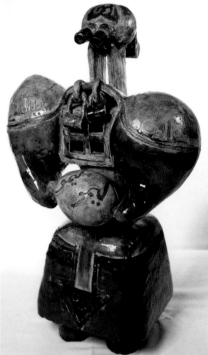

Massoud Arabshahi

Untitled 1964
mixed media on paper, 103 × 89cm
Collection of the artist

Untitled 1967
oil on canvas, 135 × 65cm
Tehran Museum
of Contemporary Art
TMCA 84

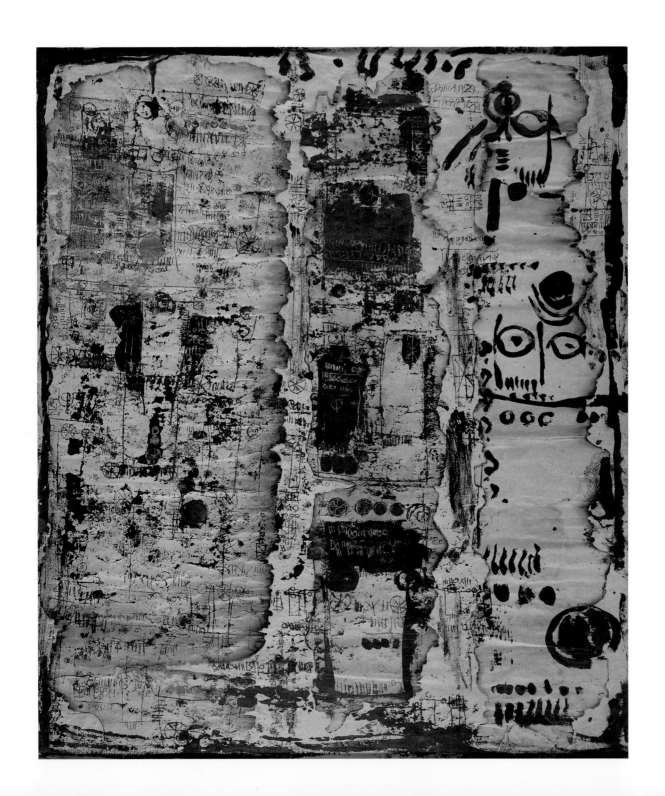

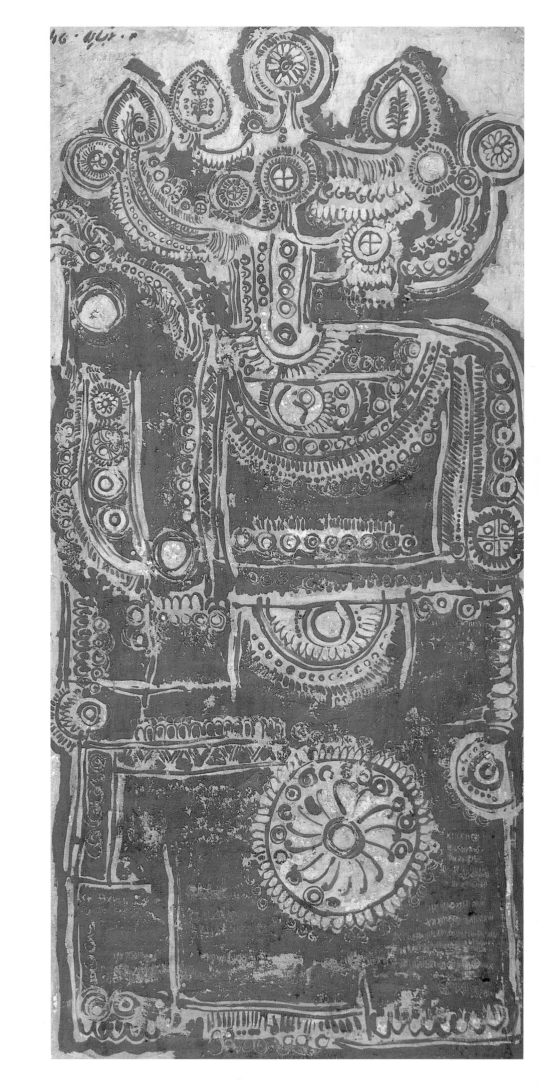

Massoud Arabshahi

Space on my Mind I, II, III, and IV
1981 (four drawings)
ink, gold paint and oil on paper,
each drawing 100 × 70cm
Collection of the artist

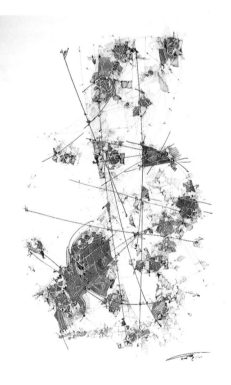
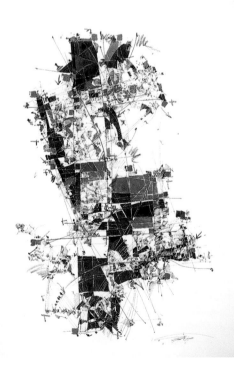

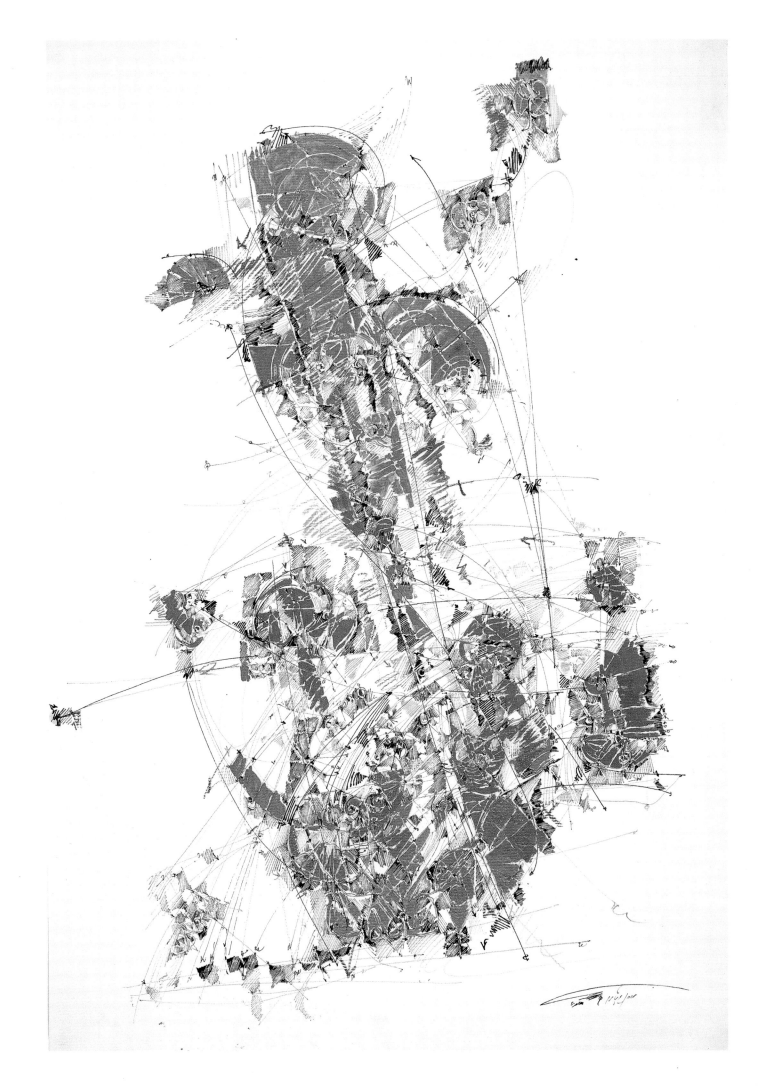

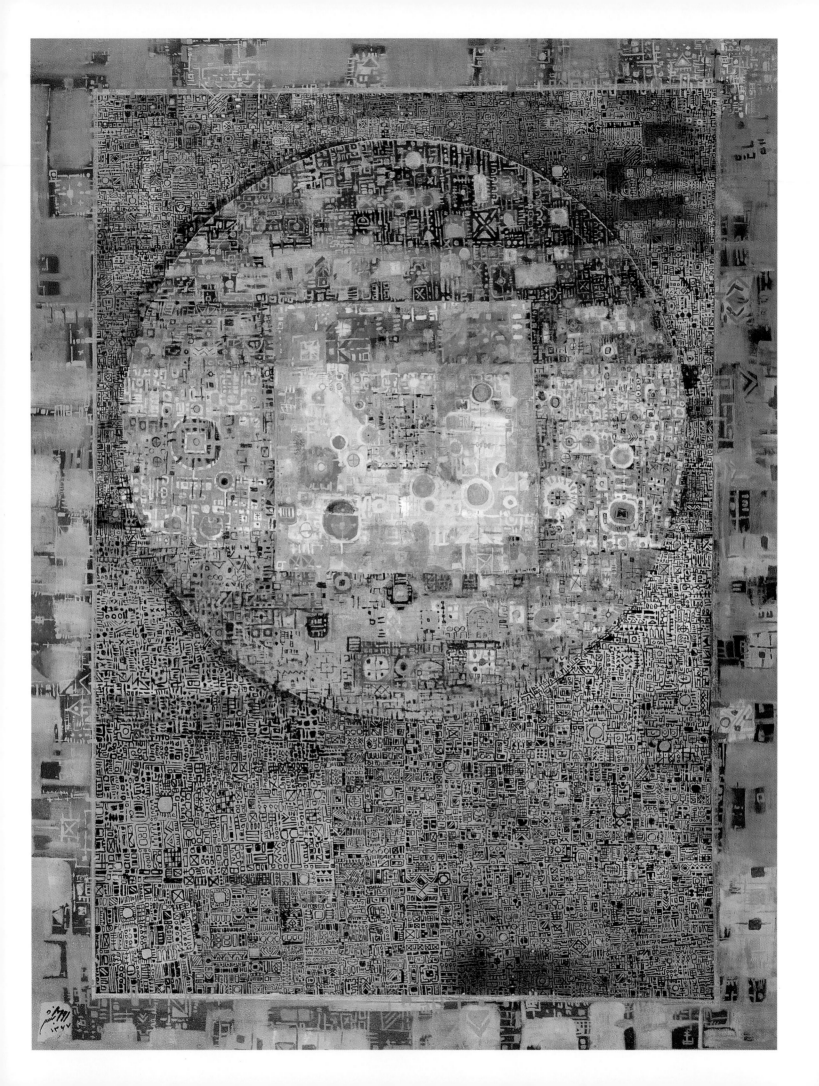

Jaafar Rouhbakhsh

Left

Untitled 1988 *
oil on canvas, 180 × 150cm
Collection of
Mr & Mrs Akbar Seif Nasseri

Below

Composition 1994 *
oil on canvas, 61 × 31cm
Tehran Museum
of Contemporary Art
TMCA 2980

Right

Untitled 1989
oil on canvas, 160 × 90cm
Tehran Museum
of Contemporary Art
TMCA 2873

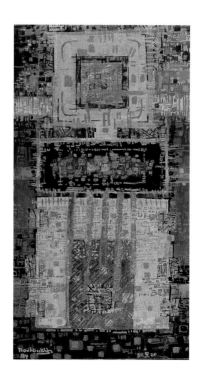

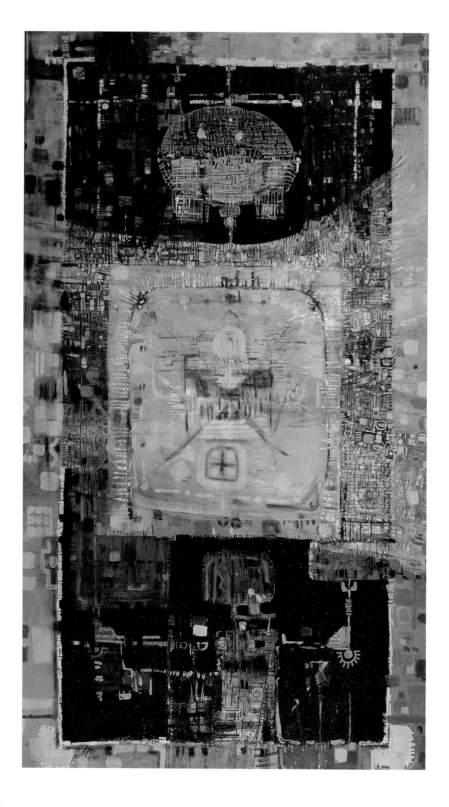

Mansour Qandriz

Untitled 1963
oil on canvas, 115 × 80cm
Tehran Museum
of Contemporary Art
TMCA 2332

Talisman *
Iran 20th century
metal
Private collection, London

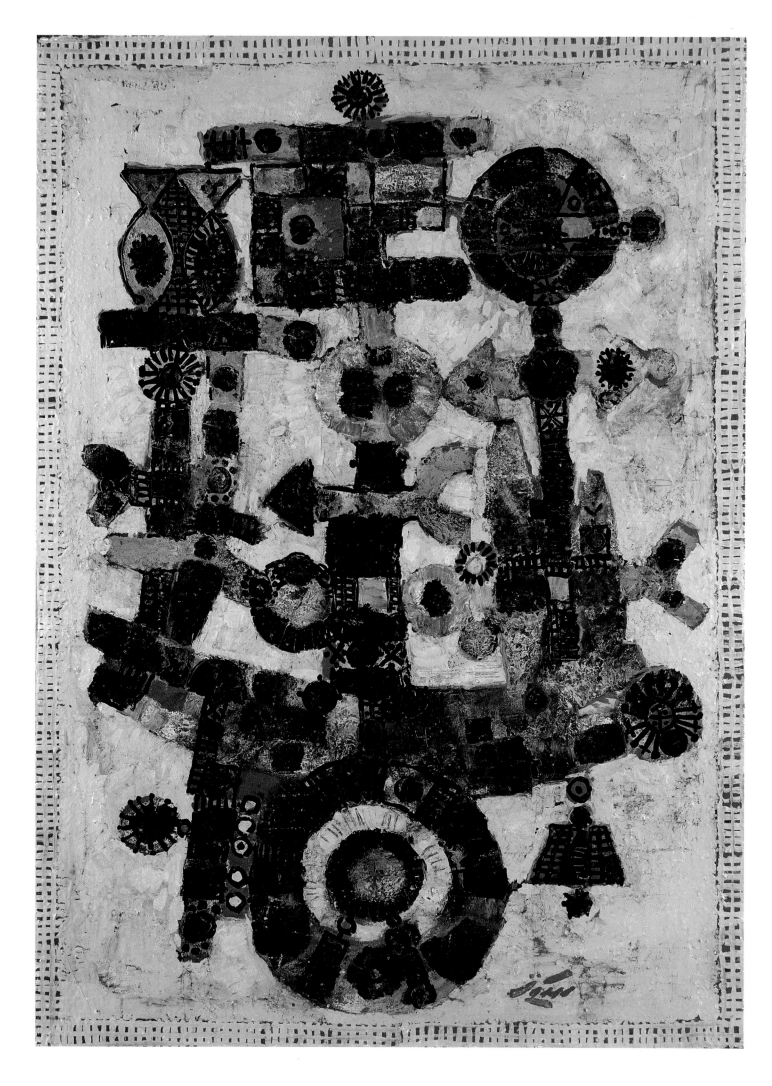

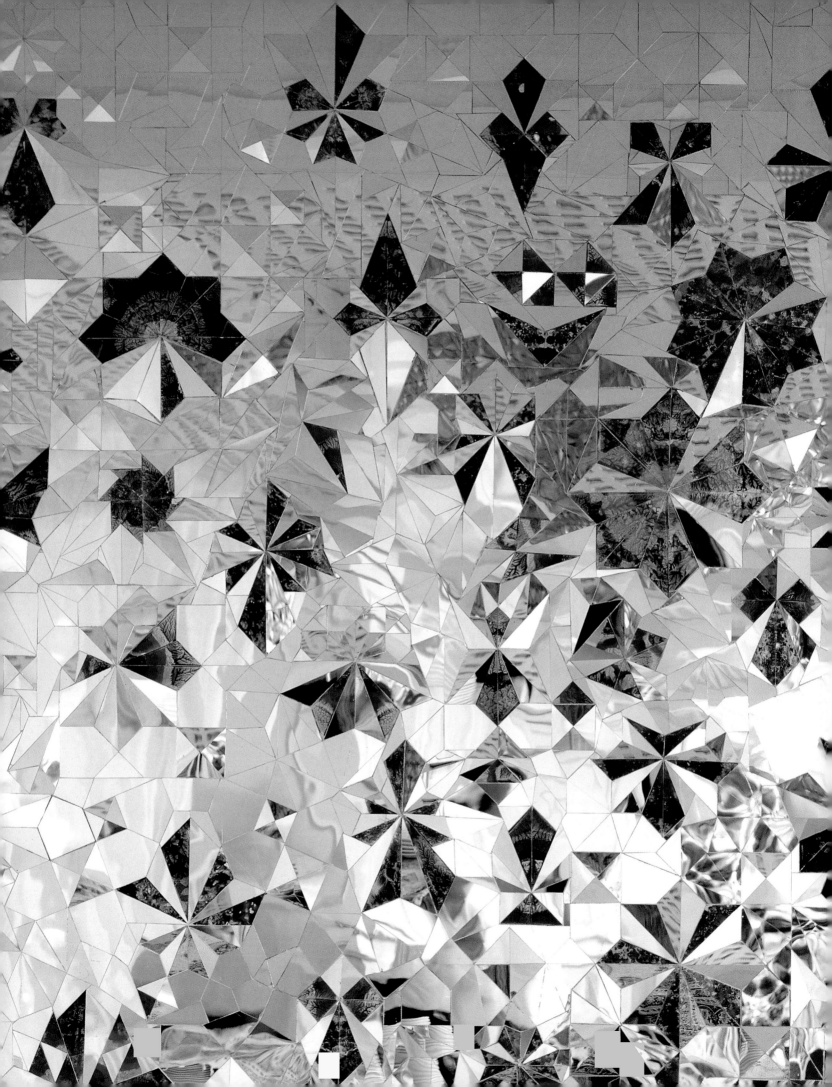

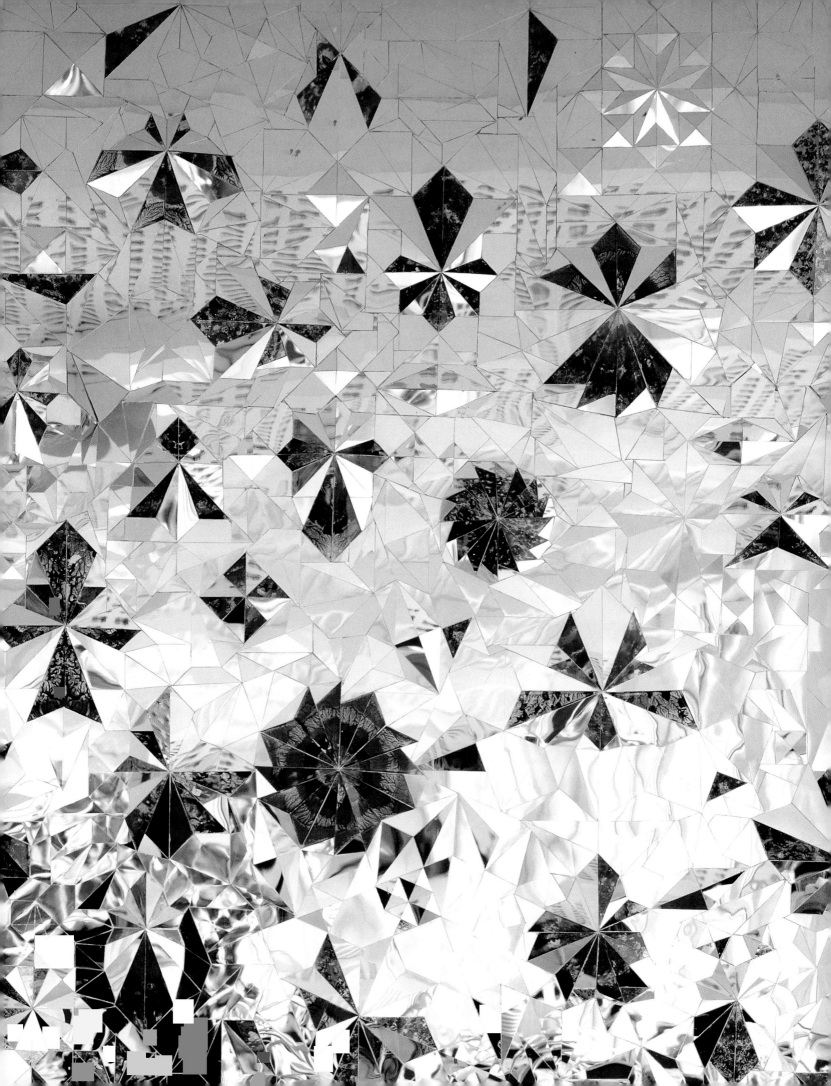

Monir Farmanfarmaian

Pages 64–65

Mirror Panel 1970s (detail) *
Laleh Hotel, Tehran

Right

Mirror Panel 1970s *
Laleh Hotel, Tehran

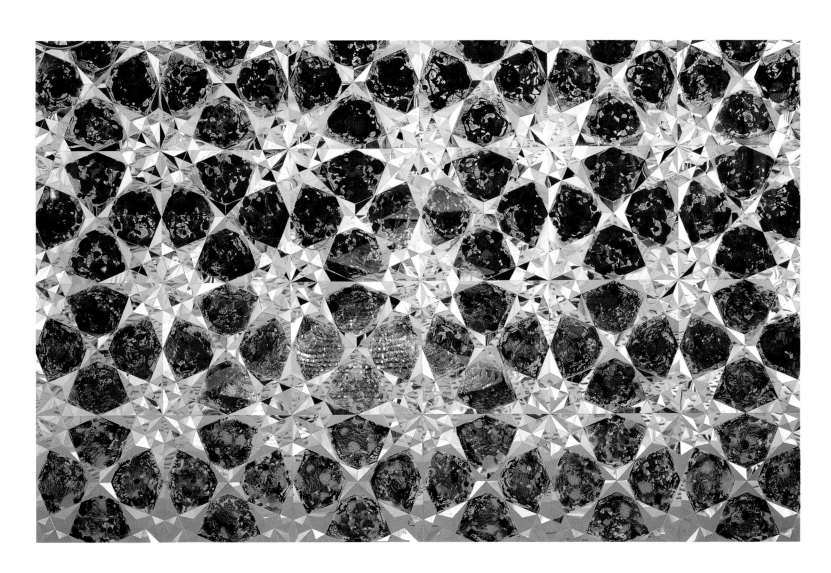

Monir Farmanfarmaian

Untitled, undated
collage, chalk, mirror on wood, 98 × 140cm
Tehran Museum of Contemporary Art
TMCA 2087

Untitled, undated
collage, chalk, mirror on wood, 103 × 103cm
Tehran Museum of Contemporary Art
TMCA 2089

Marcos Grigorian

Rebirth *c.* 1970
mixed media, 70 × 70cm
Collection of
Mohammad Ehsai

Untitled 1973
clay and straw on canvas,
165 × 200cm
Tehran Museum
of Contemporary Art
TMCA 209

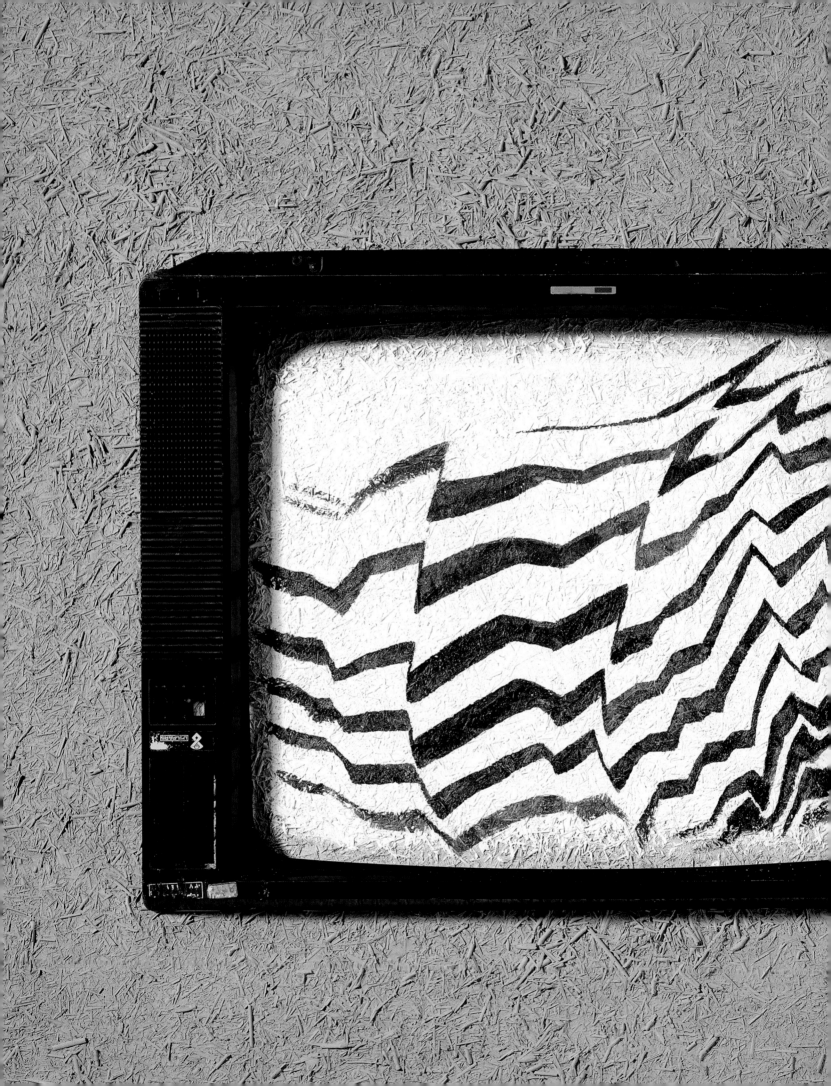

Parviz Kalantari

from the series *Mudvision*
1999–2000 (detail)
mixed media, 100 × 100cm
Collection of the artist

The Wise Sees within the Raw Clay 1999*
from the series *Mudvision*
mixed media, 50 × 70cm
Collection of the artist

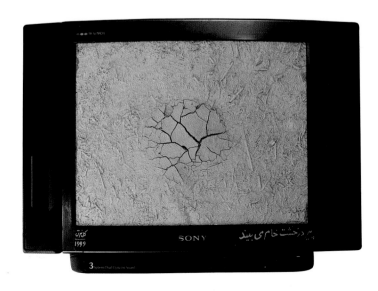

Sohrab Sepehri

The Body of Trees 1972
oil on canvas, 105 × 200cm
Tehran Museum
of Contemporary Art
TMCA 1354

Pages 76–77

Untitled 1972
oil on canvas, 117 × 147cm
Seyhoun Collection

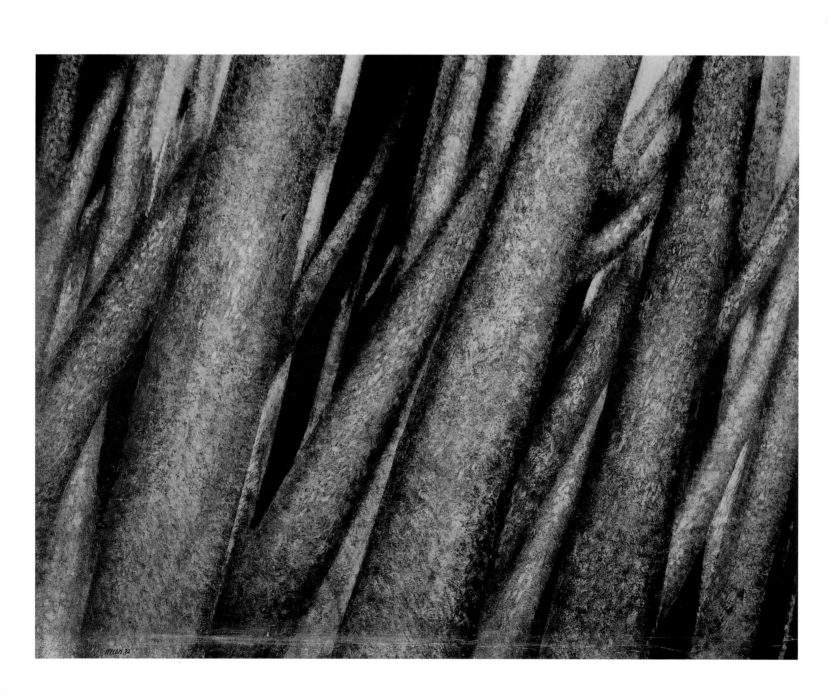

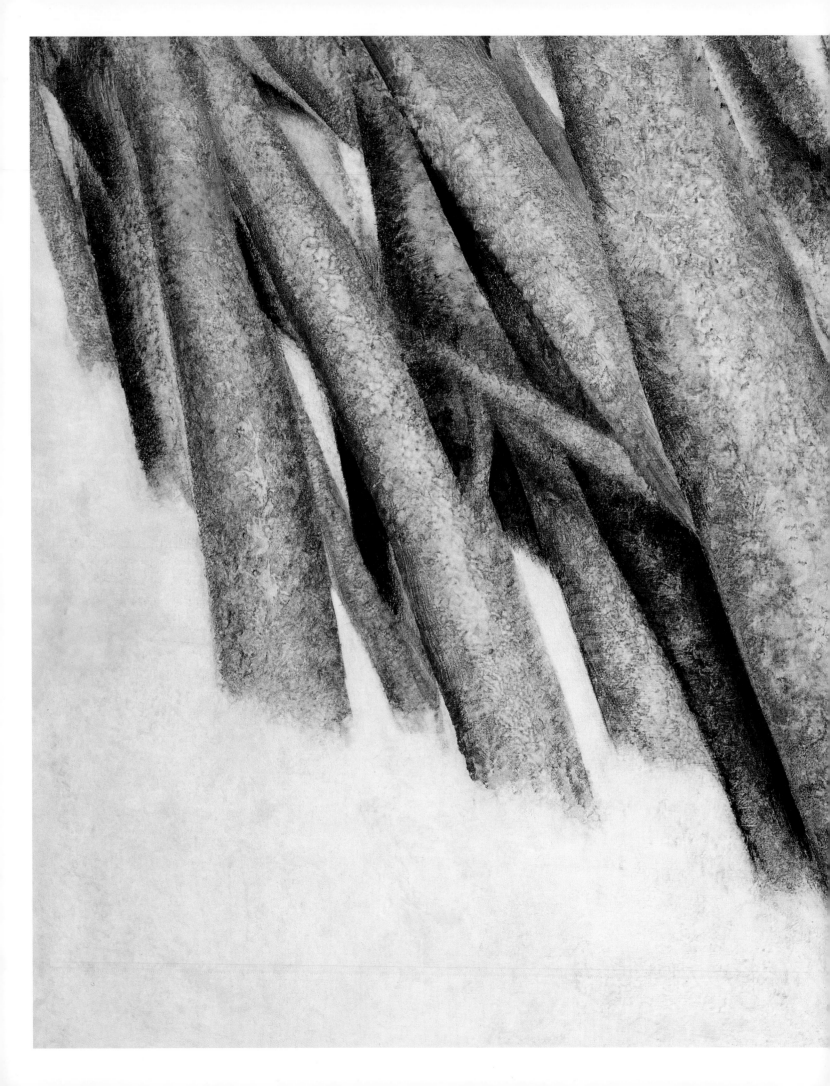

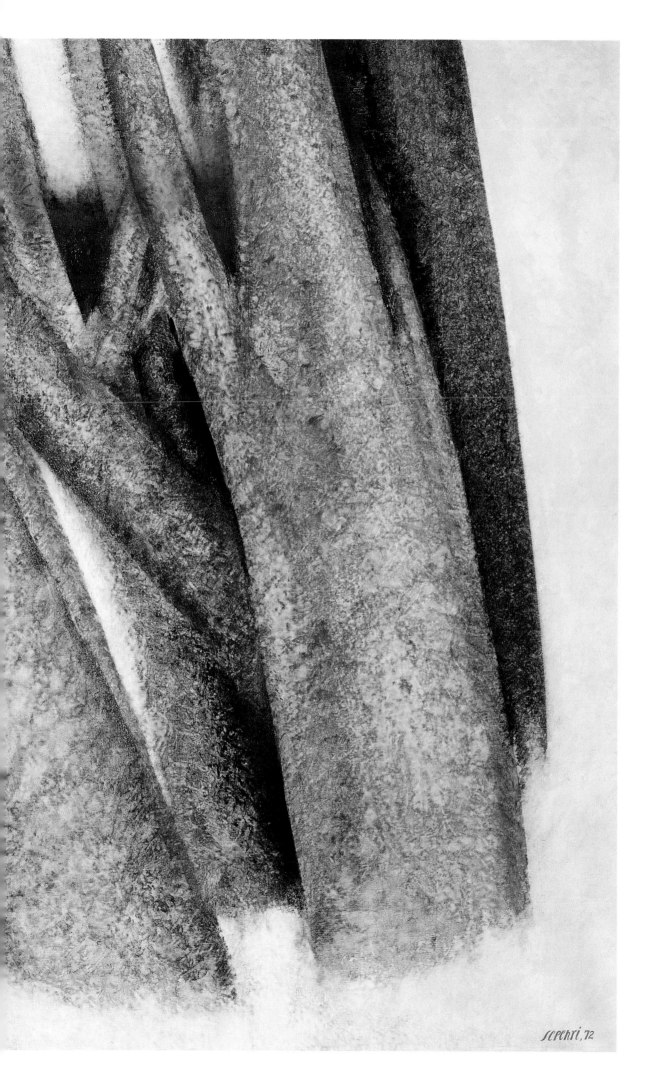

Sohrab Sepehri

Stones, undated
oil on canvas, 200 × 200cm
Tehran Museum
of Contemporary Art
TMCA 1356

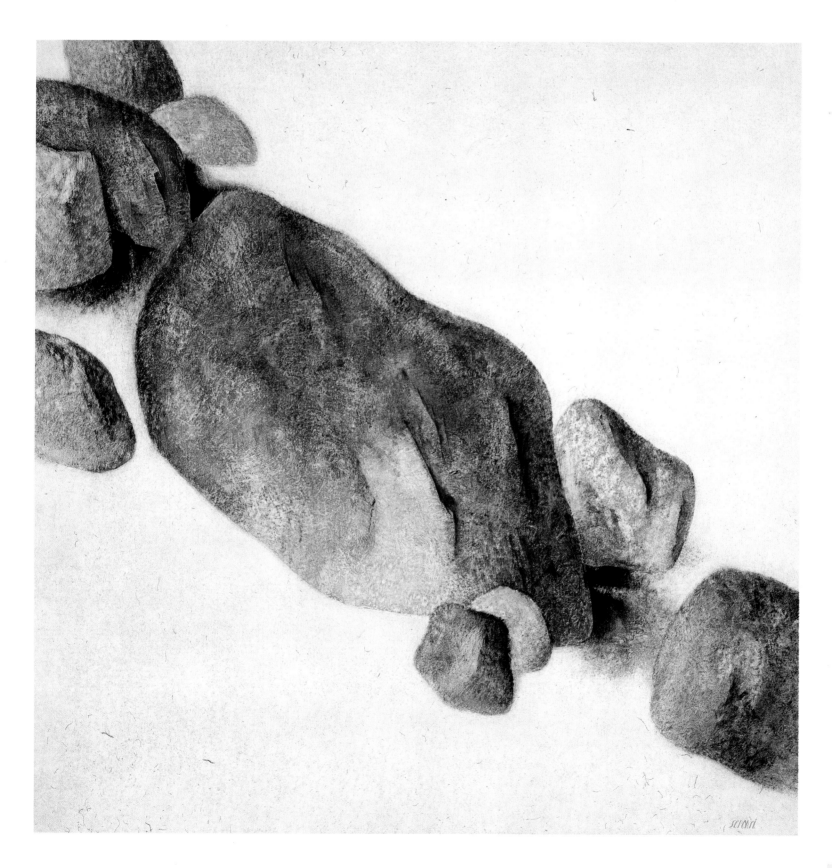

Abol Qassem Saidi

Abstraction of Flowers 1973
oil on canvas, 164 × 212cm
Tehran Museum
of Contemporary Art
TMCA 2203

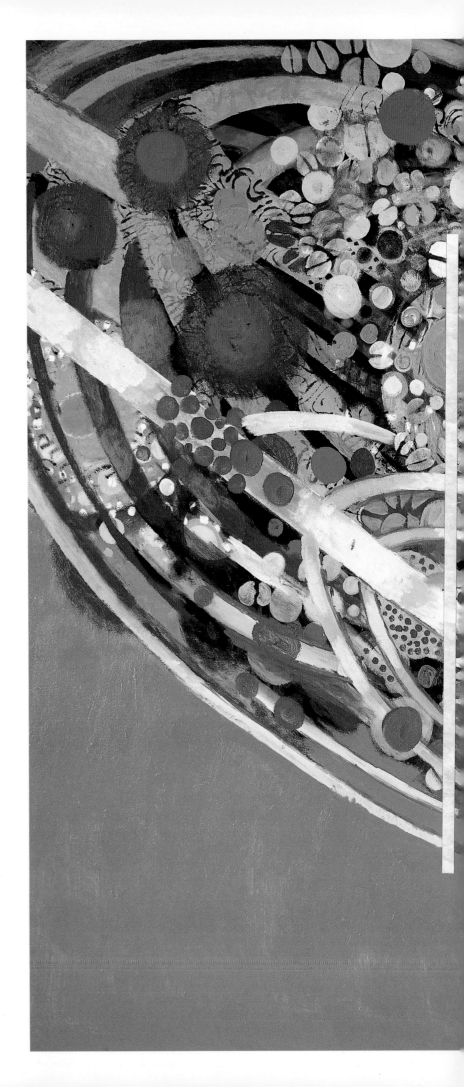

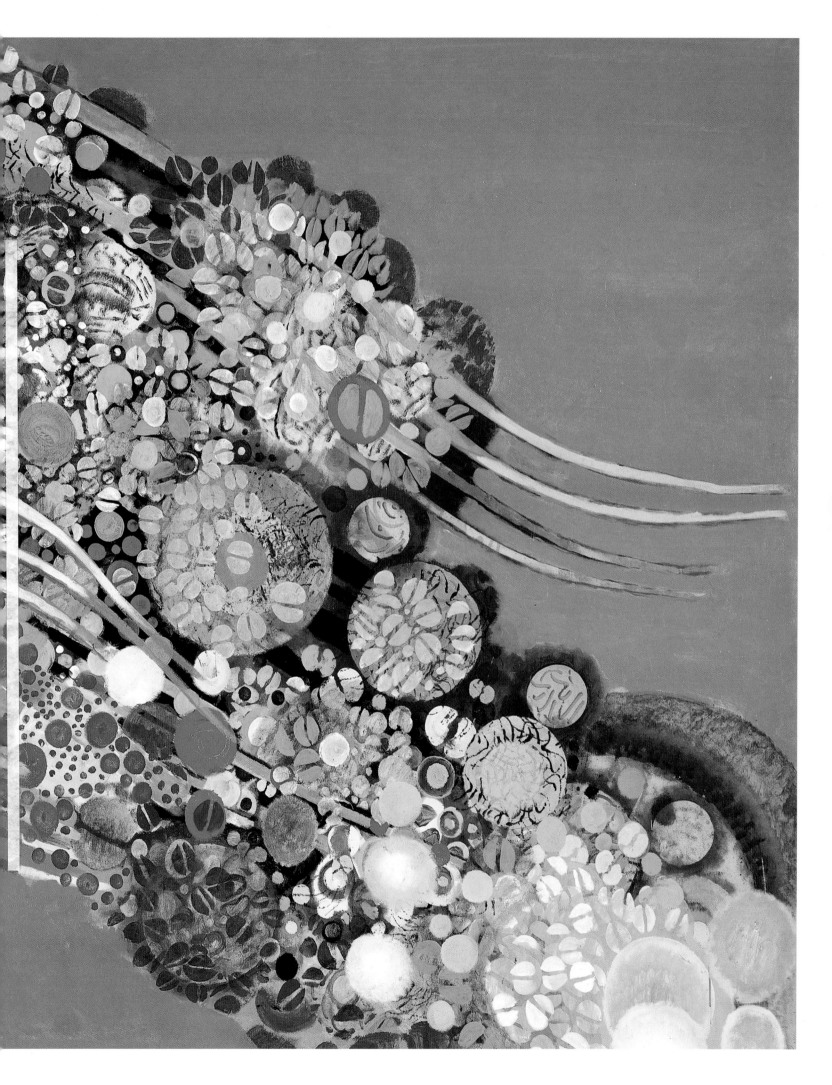

Abol Qassem Saidi

Still Life with Plate and Fruit 1990–93
(triptych)
oil on canvas, each painting 145 × 92cm
Collection of the artist

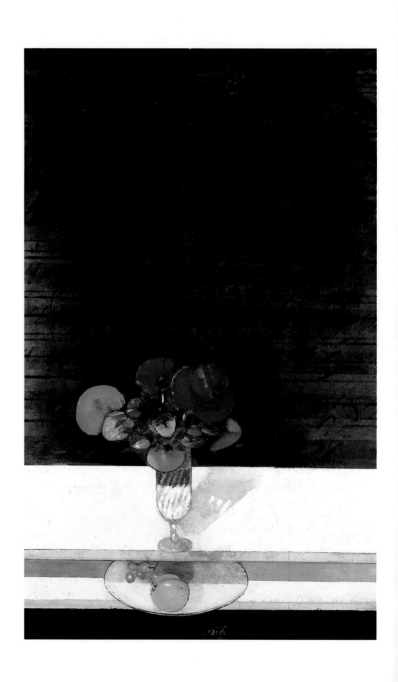

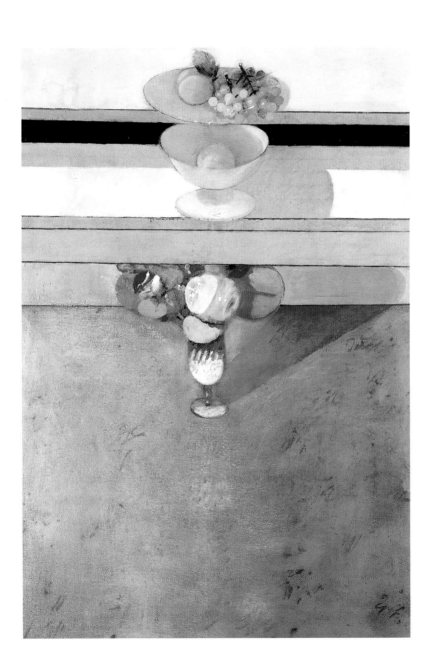
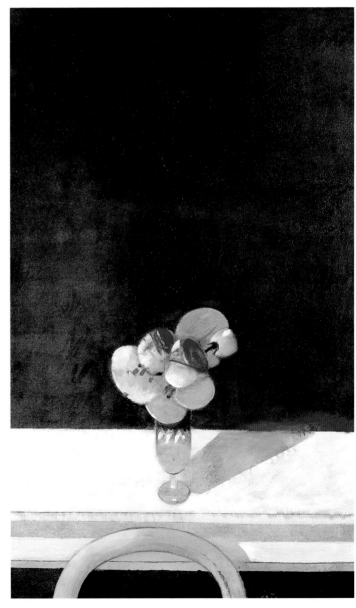

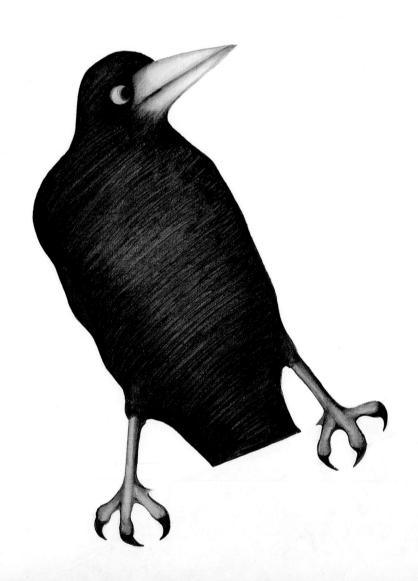

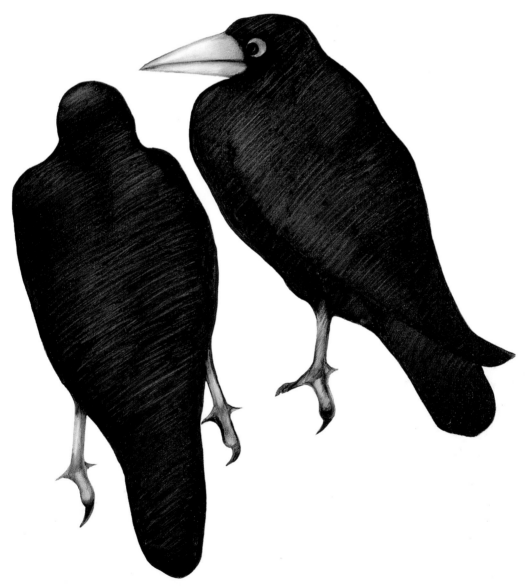

Alireza Esphabod

Pages 84–85

Three Crows, undated
oil on canvas, 126 × 200cm
Tehran Museum
of Contemporary Art
TMCA 170

Right

Bahman Mohassess

Still Life 1968 *
oil on canvas, 70 × 100cm
Seyhoun Collection

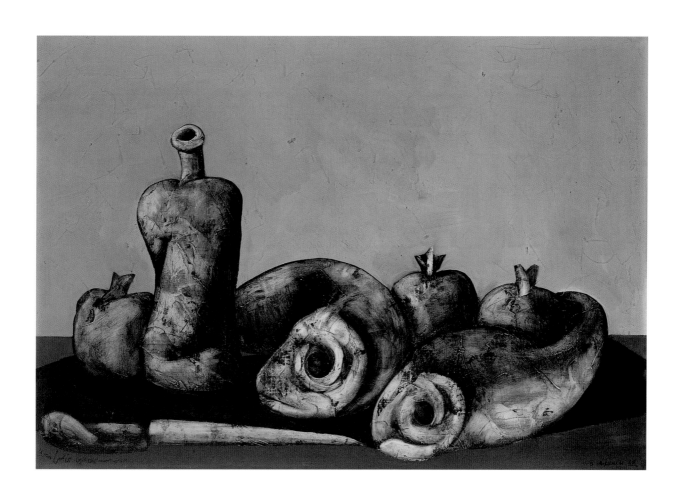

Aydeen Aghdashlou

Anno 1373 (two paintings) *
from the series *Falling Angels* 1994–97
oil on canvas, each painting 77 × 57cm
Collection of the artist

Memories of Ice & Fire III
from the series *Memories of Devastation* 1980
gouache on cardboard, 77 × 57cm
Collection of Mohammad Ehsai

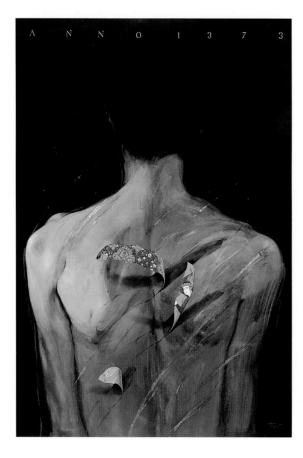
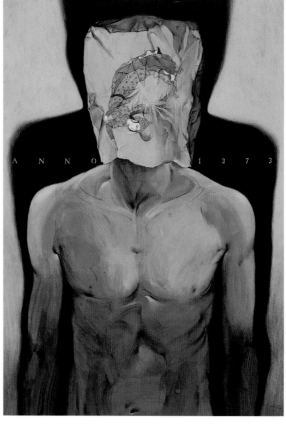

Qassem Hadjizadeh

The artist's studio 1998 with
painting of Taj-ol-Saltaneh *c.* 1990 *

**A Red-Haired Man
and a Black-Haired Man** 1975
oil on canvas, 136 × 136cm
Tehran Museum
of Contemporary Art
TMCA 74

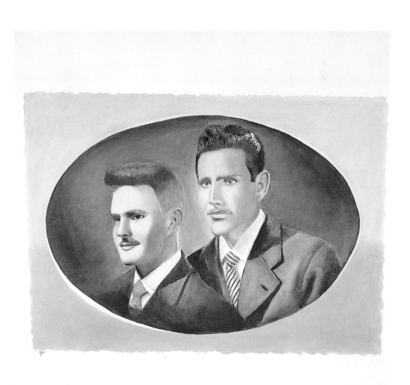

Hojatollah Shakiba

Qajar Woman, undated
gouache on board, 50 × 35cm
Seyhoun Collection

Untitled 1980
mixed media on paper, 71 × 101cm
Seyhoun Collection

94

Khosrow Hassanzadeh

Do I have to sign? 1999
oil on canvas, 180 × 120cm
The Trustees of the British Museum,
London

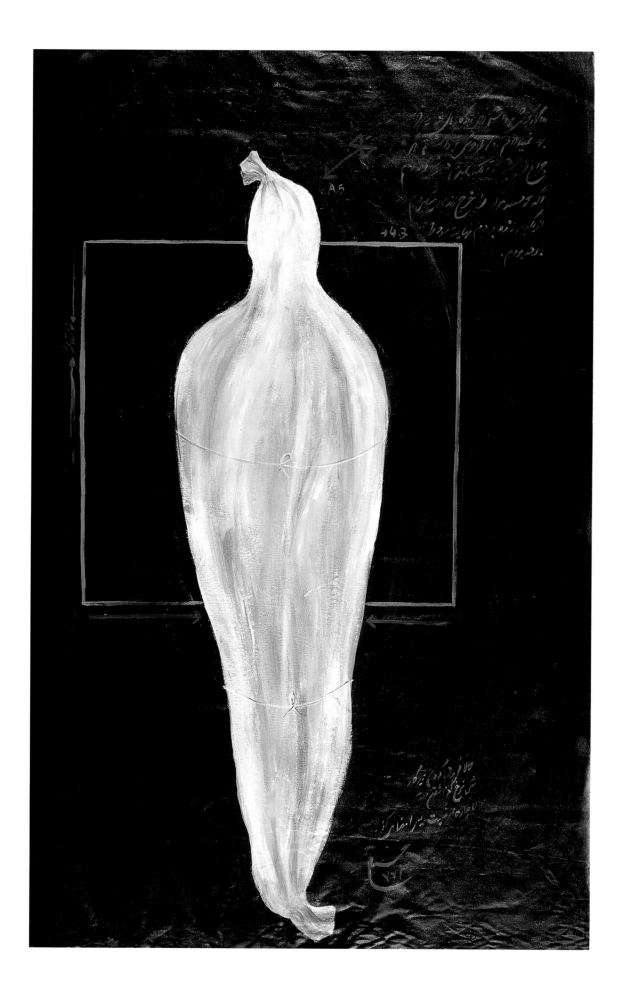

Khosrow Hassanzadeh

Three Comrades
from the series *War* 1997–98
ink and acrylic on paper, 250 × 180cm
Collection of the artist

Helmet
from the series *War* 1997–98
ink and acrylic on paper, 250 × 180cm
Collection of the artist

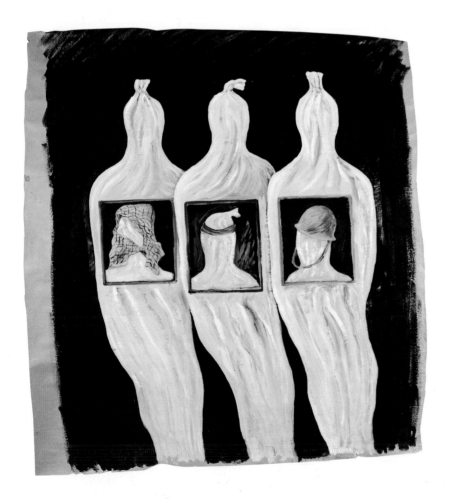

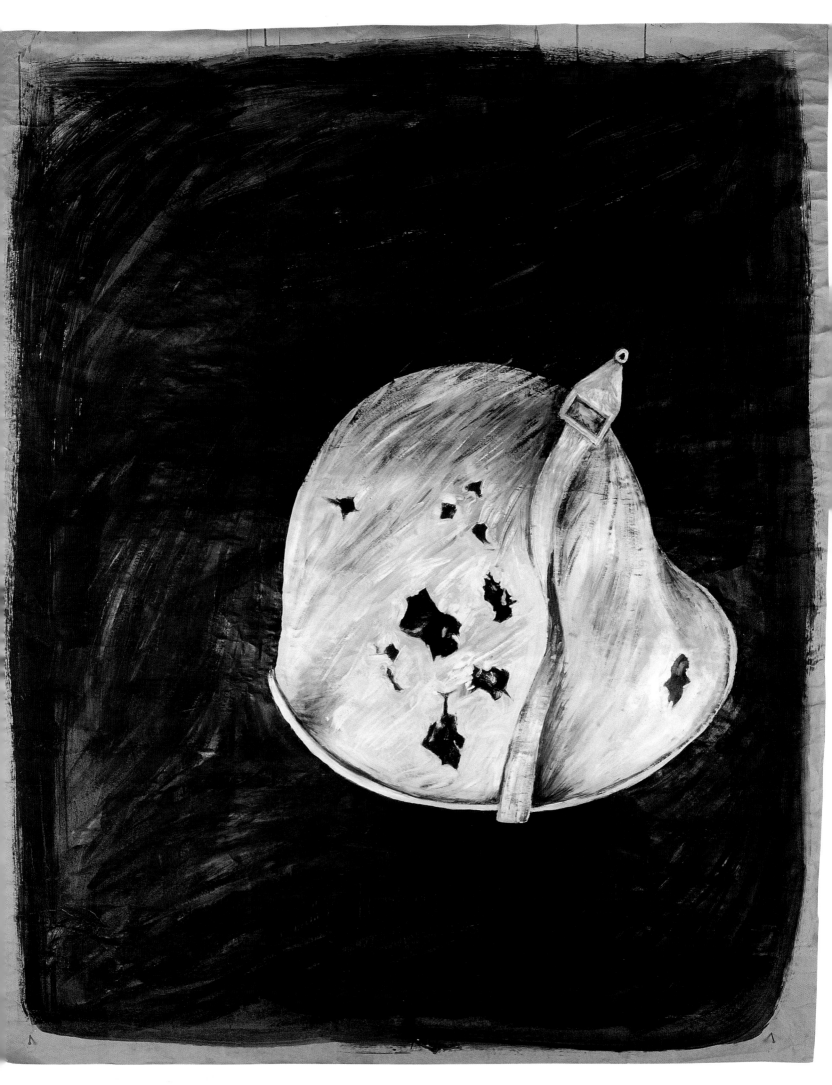

Bita Fayyazi

Cockroaches 1998 (detail)
ceramic, length 15cm
Collection of the artist

Pages 100–101

Cockroaches 1998
ceramic, each 15cm in length
Installation of 1,000 ceramic cockroaches
at Nikolaj Contemporary Art Center,
Copenhagen, 2000
Collection of the artist

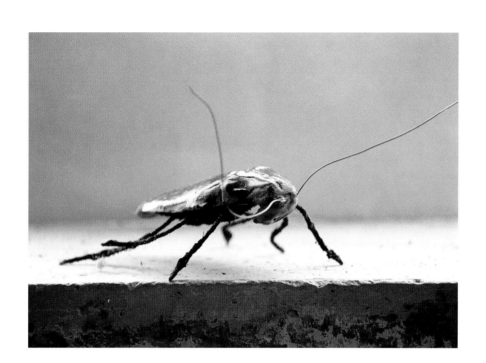

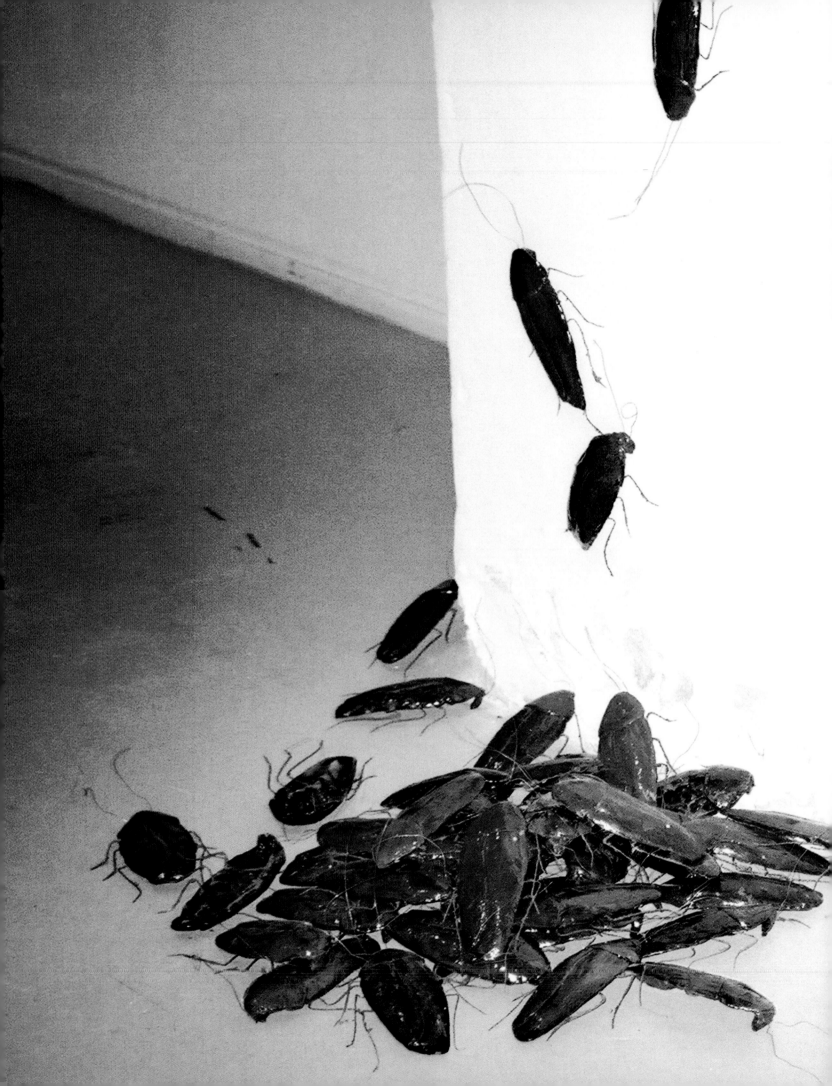

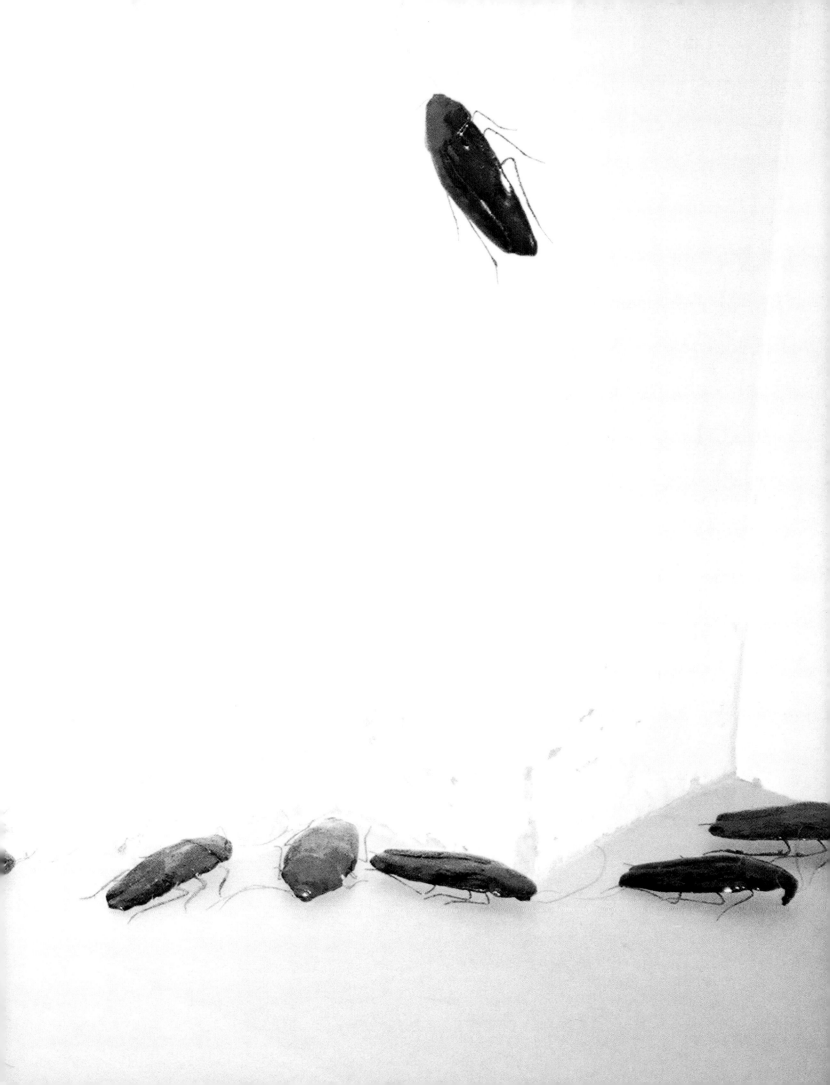

Ghazel

Pages 102–105
stills from the video series *Me* 1998–2000
Collection of the artist

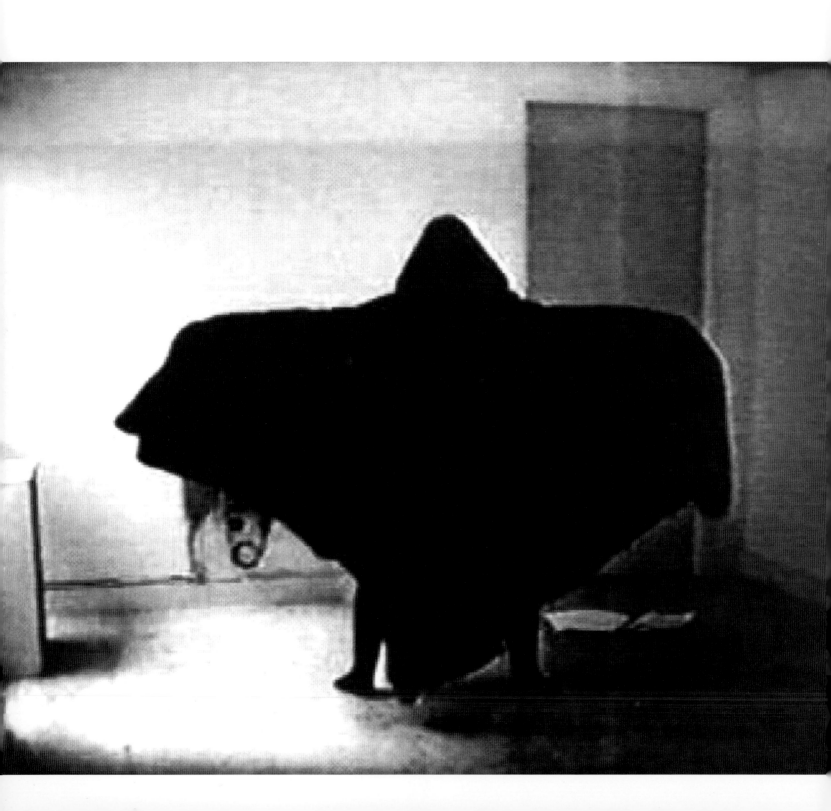

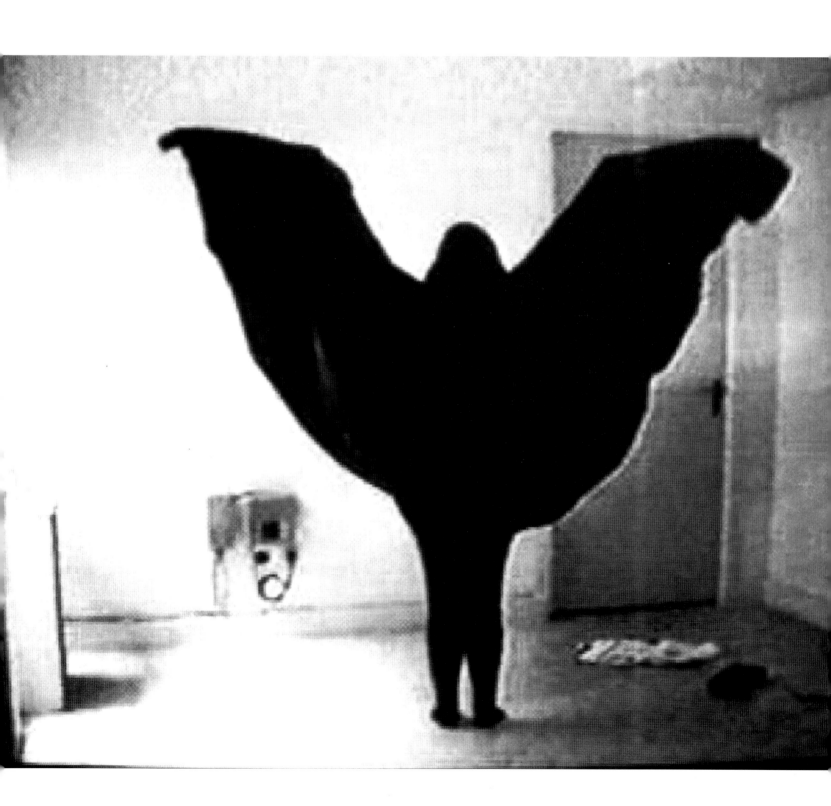

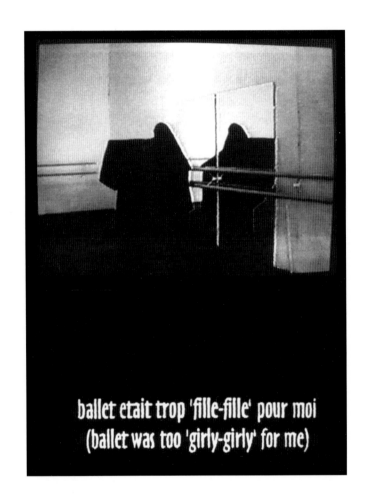

ballet etait trop 'fille-fille' pour moi
(ballet was too 'girly-girly' for me)

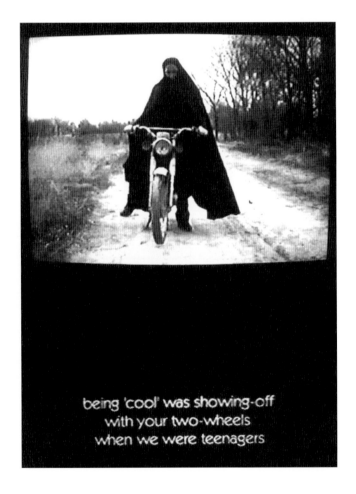

being 'cool' was showing-off
with your two-wheels
when we were teenagers

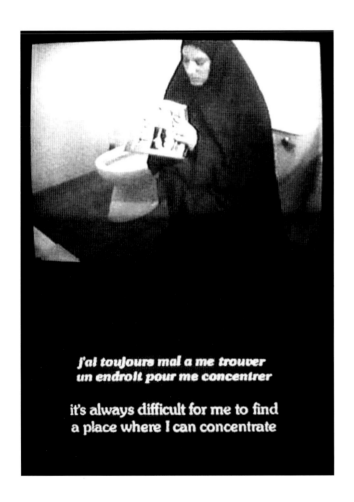

*j'ai toujours mal a me trouver
un endroit pour me concentrer*

it's always difficult for me to find
a place where I can concentrate

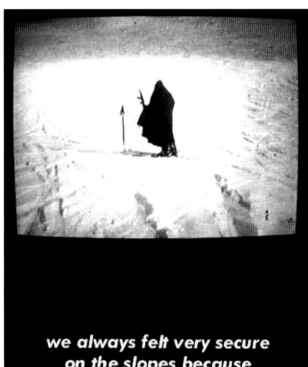

we always felt very secure
on the slopes because
many people were there to
assure our protection

Shadi Ghadirian

Pages 106–109
Untitled 1998 (four photographs)
silver bromide prints
Collection of the artist

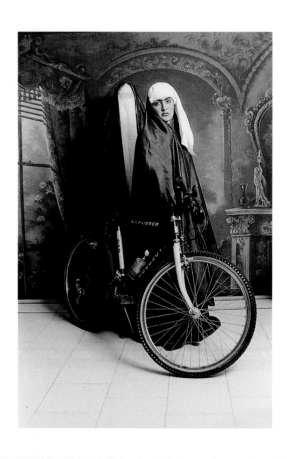

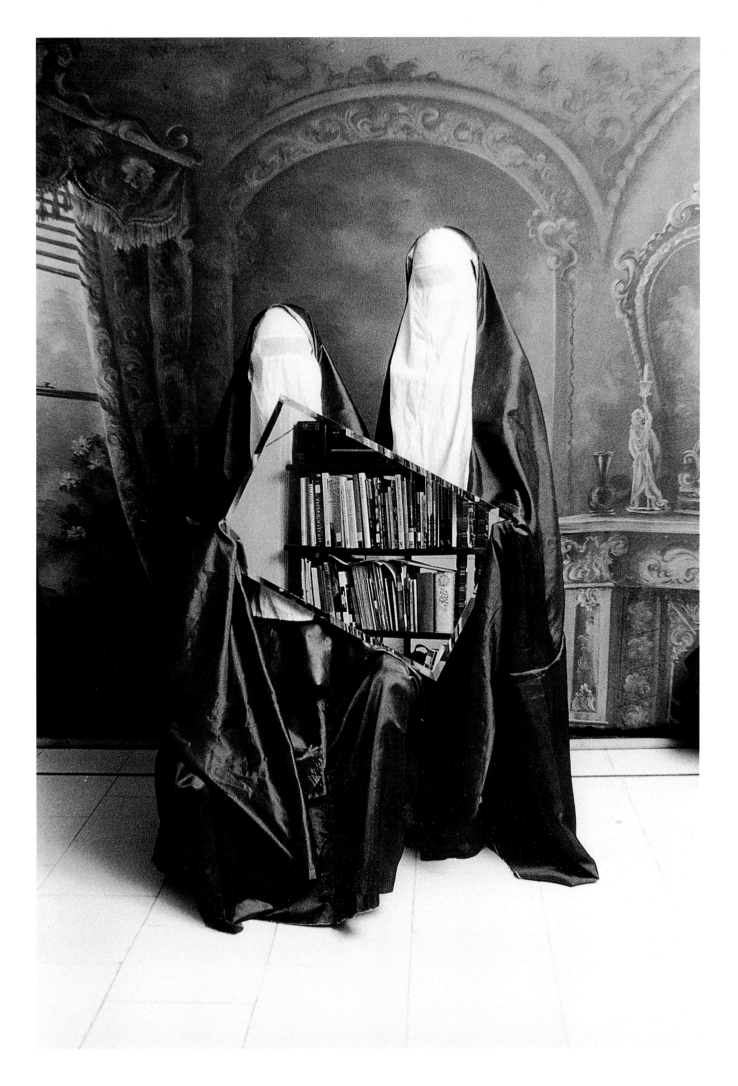

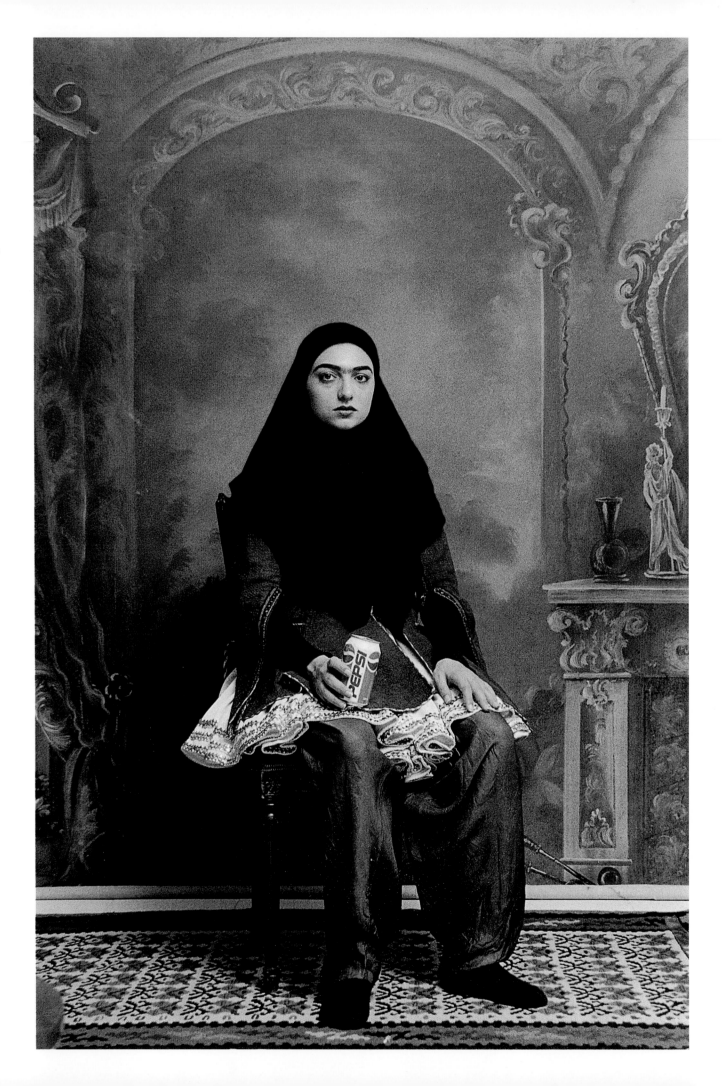

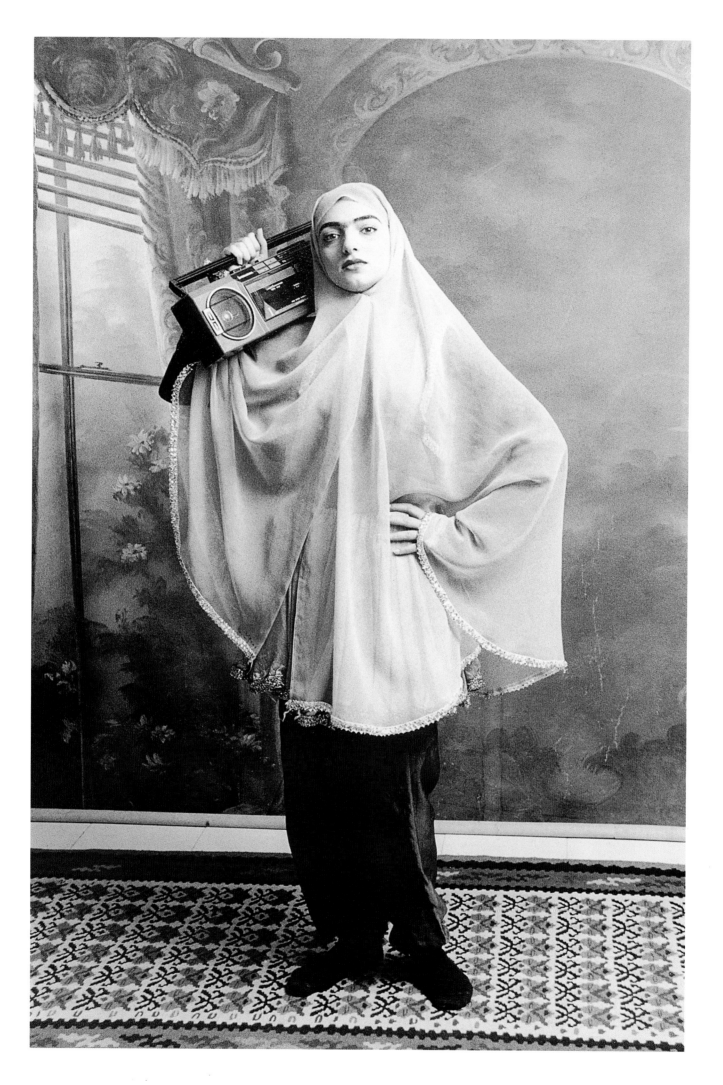

Fereydoun Ave

Rostam in Late Summer 1998
collage and house paint on cardboard, 75.5 × 110cm
Collection of the artist

Rostam in Late Summer 1998
collage and house paint on cardboard, 112 × 75cm
Collection of the artist

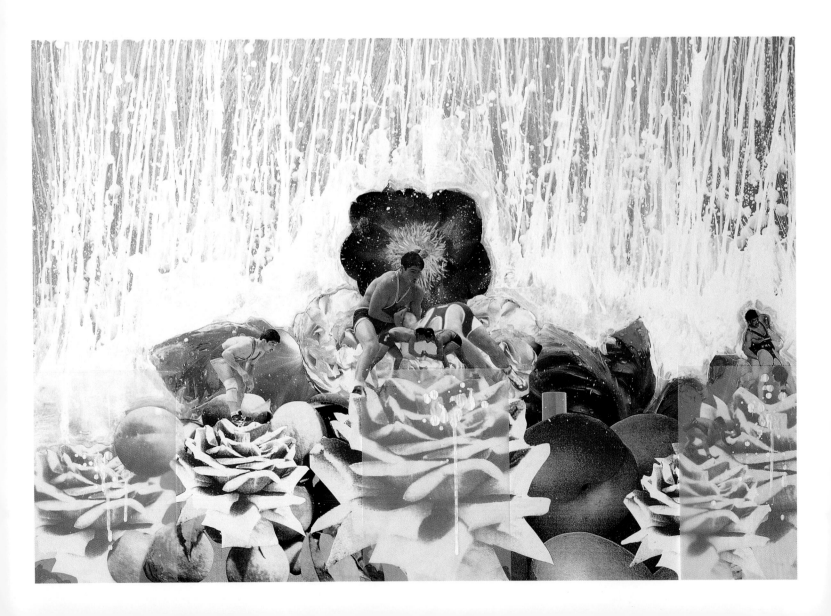

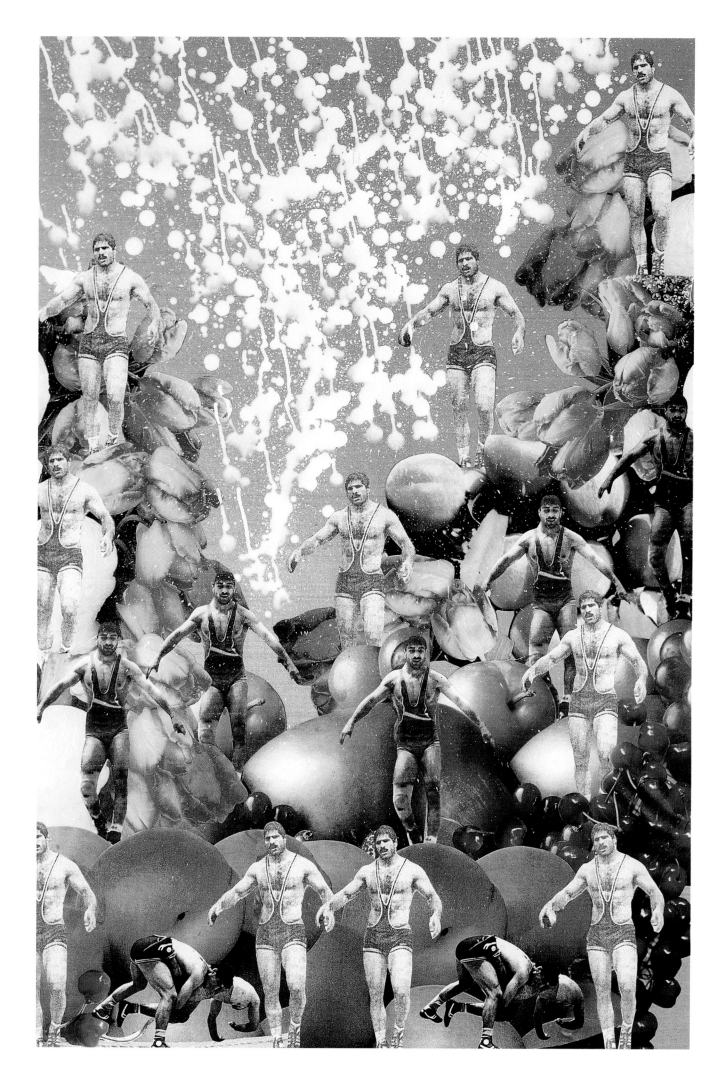

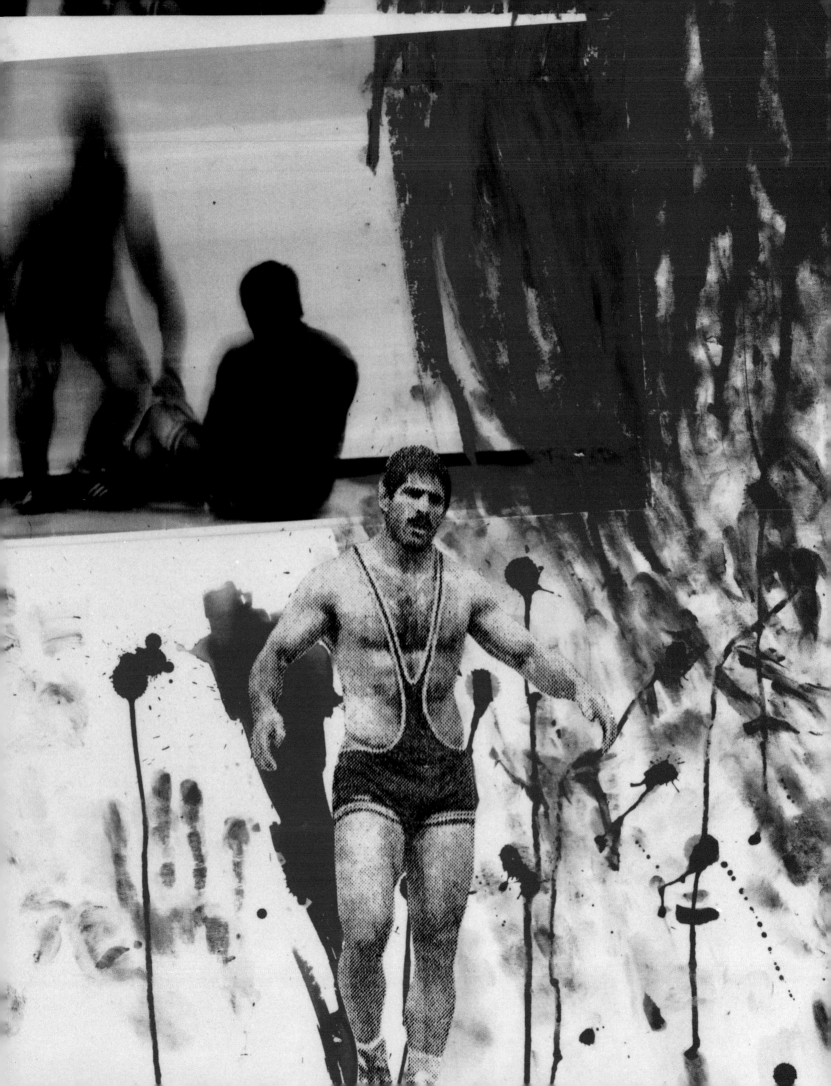

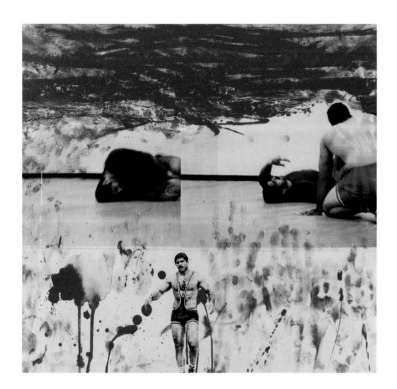 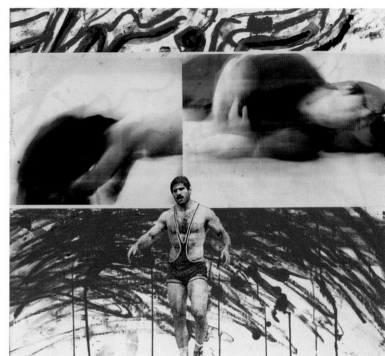

Fereydoun Ave

Left

Rostam and Sohrab III 1999 (detail)
mixed media, 110 × 75cm
Collection of the artist

Above left

Rostam and Sohrab I 1999
mixed media, 75 × 75cm
Collection of the artist

Above right

Rostam and Sohrab II 1999
mixed media, 75 × 80cm
Collection of the artist

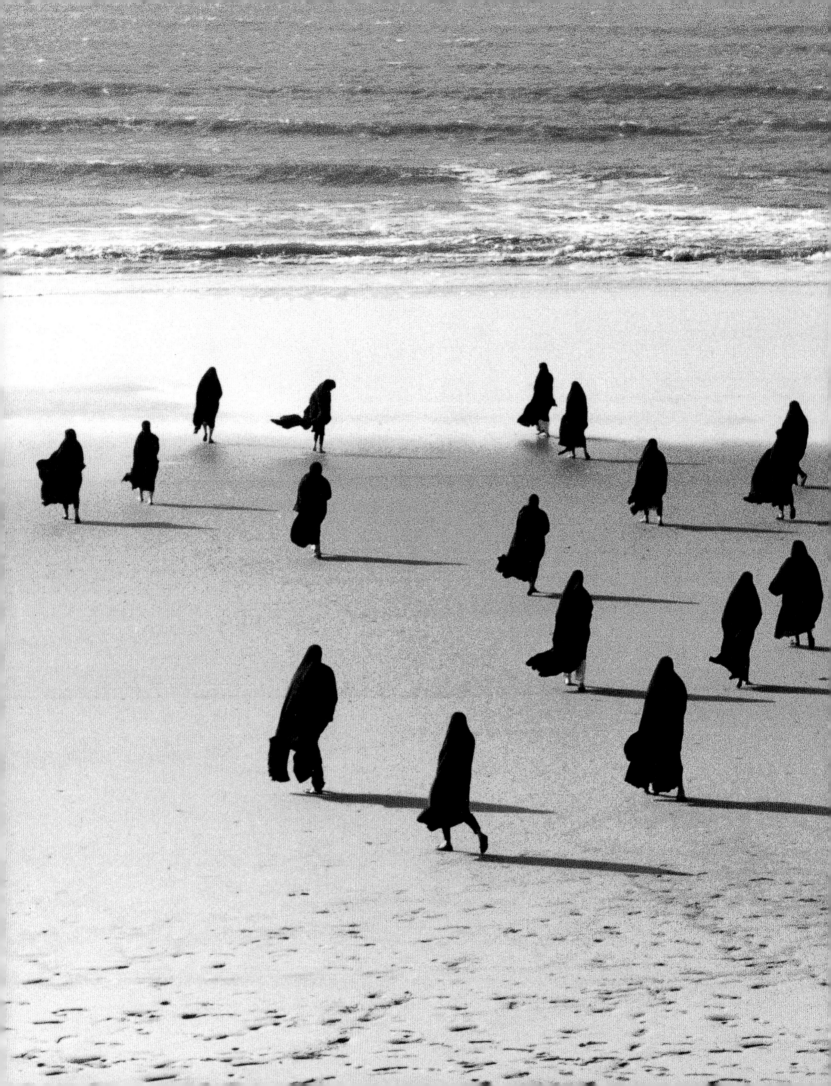

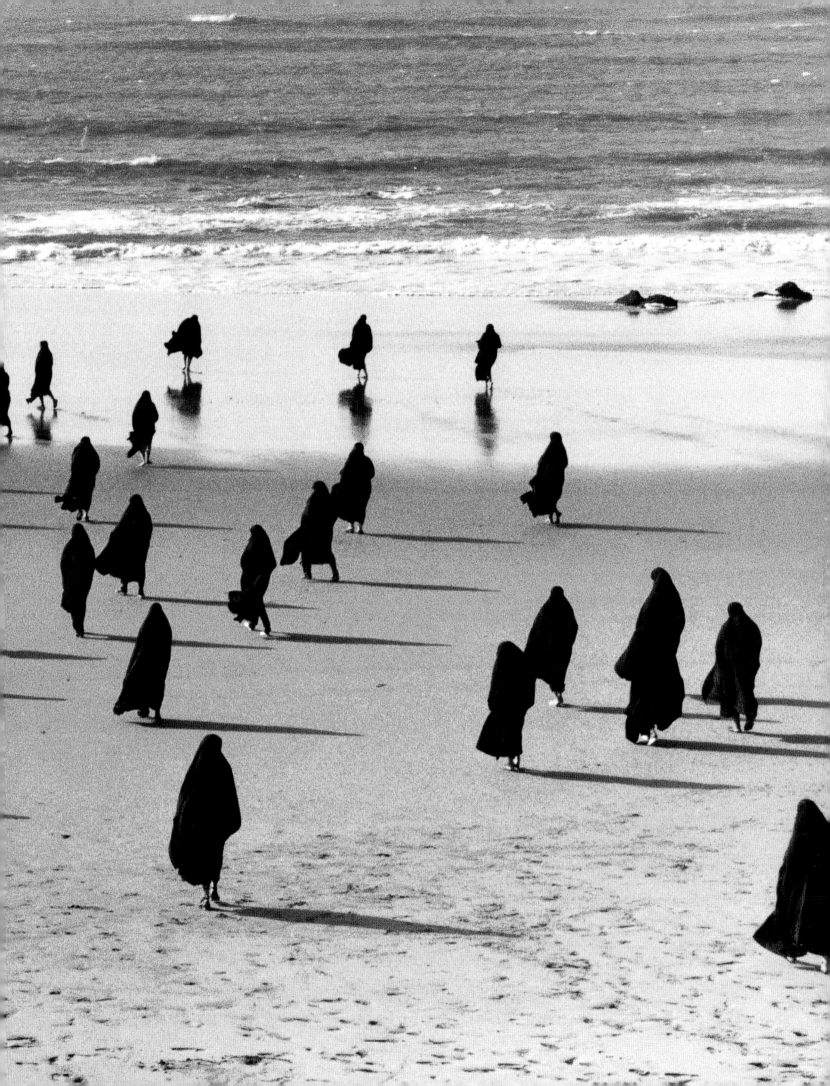

Shirin Neshat

Pages 114–115

Rapture 1999 *
production still
Courtesy of Barbara Gladstone,
New York

Right

Untitled 1996 *
from the series *Women of Allah*
black and white RC print and ink,
121.8 × 85.7cm
Courtesy of Barbara Gladstone,
New York

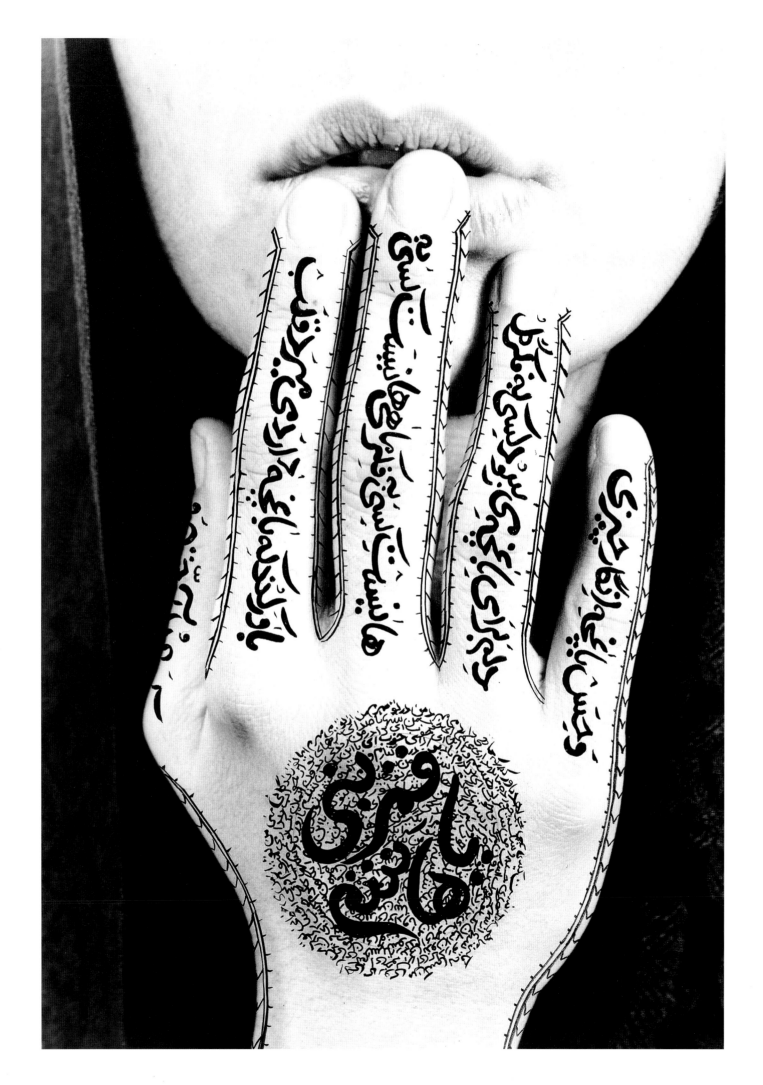

Shirazeh Houshiary

Isthmus 1992 *
copper and aluminium, two parts
340 × 220 × 90cm, 340 × 500 × 90cm
Courtesy of Lisson Gallery, London

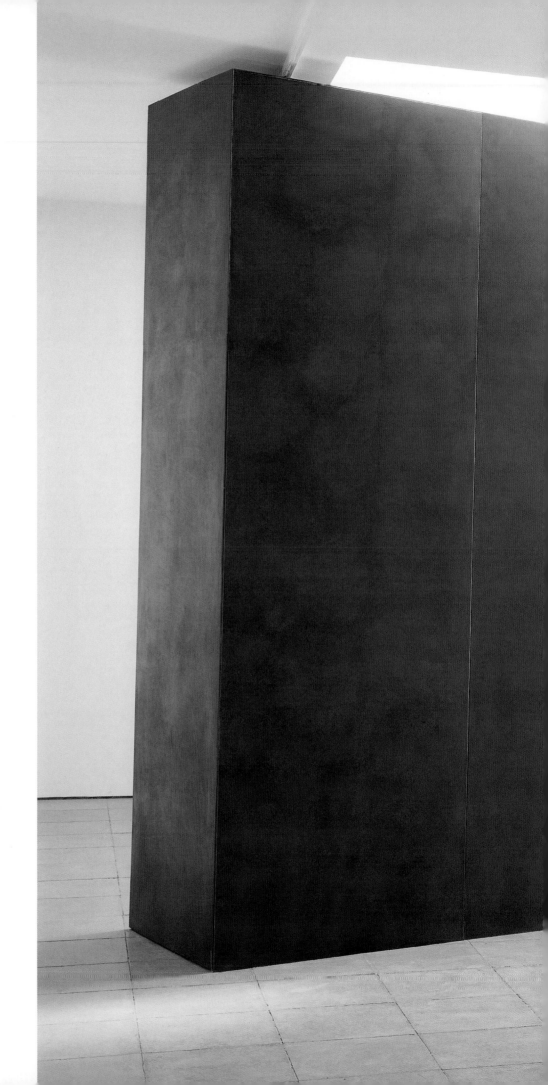

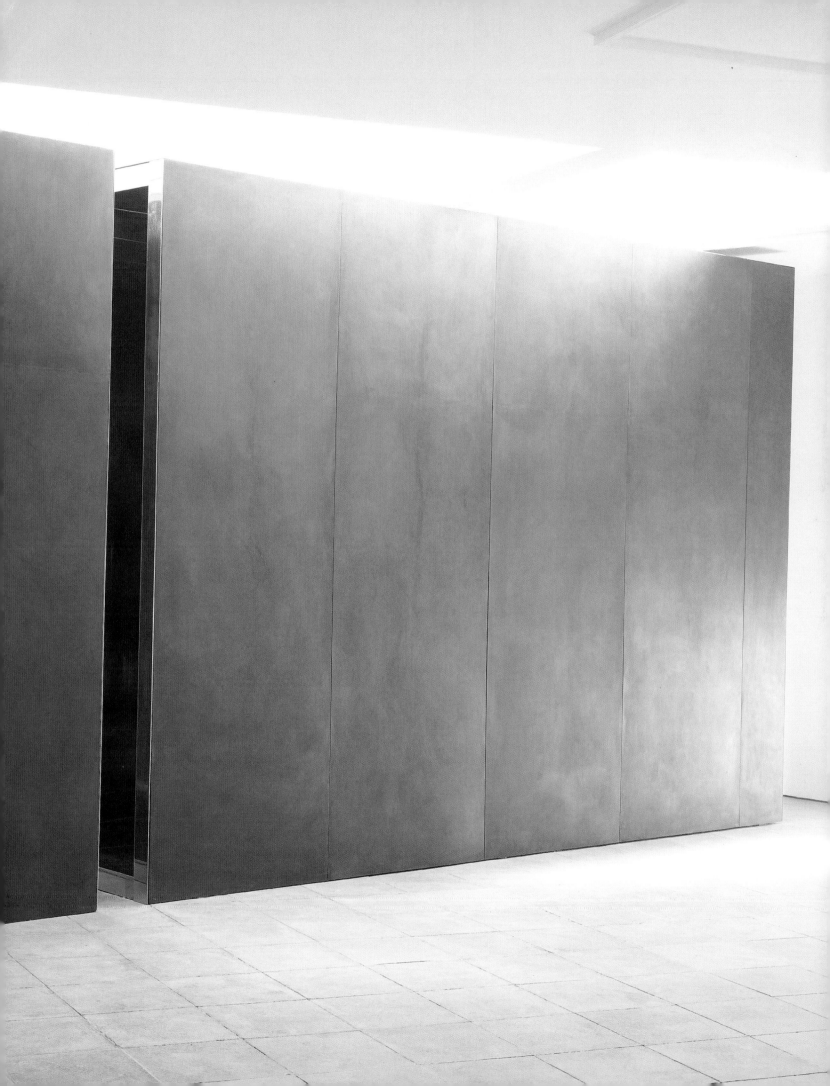

Shirazeh Houshiary

The Image of Heart 1991 *
lead and copper, 13 × 98.5cm diameter
Courtesy of Lisson Gallery, London

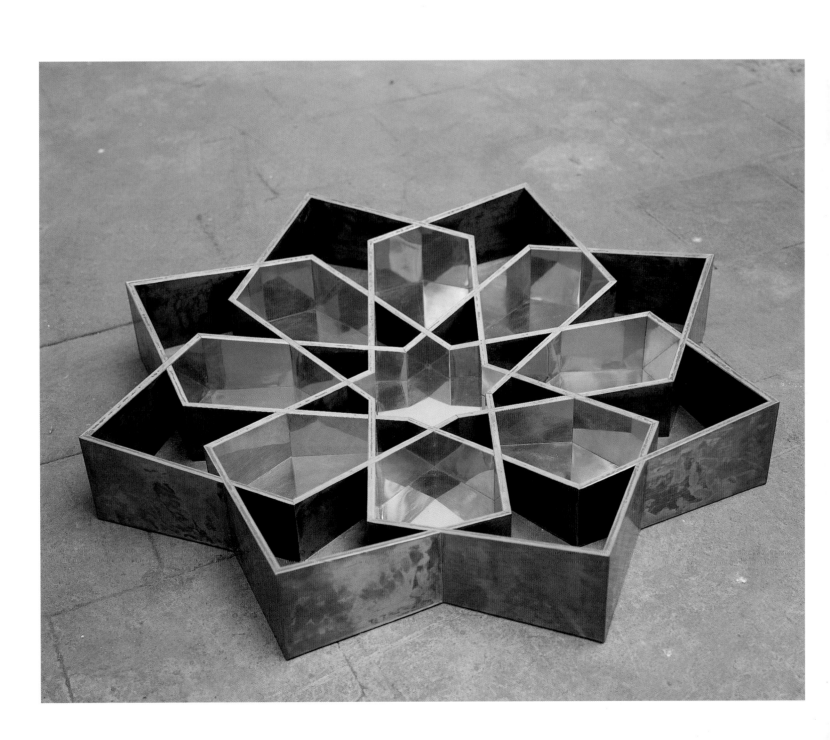

Siah Armajani

**Room for the Last Anarchist,
Noam Chomsky** 1998 *
290 × 183 × 73cm

Pages 124–125

Bridge over a Tree 1970 *
365 × 2560 × 120cm

Ruyin Pakbaz

Construction 1967 *
copper and nails on wood, 50 × 50cm
Collection of Mohammad Ehsai

BIOGRAPHIES

by Rose Issa (RI) and Ruyin Pakbaz (RP)
RP translated by Babak Fozooni

Nasrollah Afjai (ill. pp. 42–43)
Born Tehran 1933

Received diploma (with distinction) in calligraphy from the Society of Iranian Calligraphers. First solo show at Seyhoun Gallery, Tehran, 1974. Participated in a number of group exhibitions both in Iran and abroad, including: the first International Art Fair, Tehran, 1974; the Islamic World Festival, London, 1976; the International Exhibition of Traditional Painters, Bologna, 1977. Works in the collection of Tehran Museum of Contemporary Art.

Afjai has been active in the fields of *Lettrisme* (1960s calligraphic movement in Paris) and *Naqashi-Khat* (calligraphism). (RP)

Maliheh Afnan (ill. pp. 50–51)
Born Haifa, Palestine 1935

Graduated from the American University, Beirut, 1955; studied at Corcoran School of Arts, Washington DC, 1957-61 and received MA in Fine Arts from George Washington University, Washington DC, 1962. Lived and worked in USA, 1957-62; Kuwait, 1963-66; Lebanon, 1967-73; spent more than 20 years in Paris, 1973-97; moved to London in 1997. Participated in numerous group exhibitions in Washington DC and annual Salons in Lebanon, Paris (Salon d'Automne, Salon de Réalités Nouvelles, Salon de Comparaisons) and Switzerland. Several solo exhibitions in Basel (presented by Mark Tobey), Lebanon, London (now represented by England & Co Gallery) and Paris. Works in the collections of Akram Ojjeh Foundation; Institut du Monde Arabe; B.A.I.I. Bank, Paris; the British Museum, London.

Afnan's work is rooted in memory and inspired by imaginary or invented scripts and faces, 'a relic of an older civilisation or an archaeological excavation into the collective psyche', as the artist herself describes it. Her work is mostly on paper, but includes oil on canvas, and intimate-scale tablets of painted plaster, reminiscent of ancient texts, like palimpsest. She lives and works in London. (RI)

Aydeen Aghdashlou (ill. pp. 88–89)
Born Rasht, Iran 1940

Began studying at the Department of Fine Arts, University of Tehran, 1959, but left after a few years. First exhibition at the Iran American Society, Tehran, 1976. Exhibited at Tehran Museum of Contemporary Art (book cover designs), 1999, and at Seyhoun Gallery, Tehran, 2000. Selection of his paintings published as *Self-Portraits*, 1989; complete works published in 1993. Works in the collections of Jahan-Nama Museum, Tehran, and Tehran Museum of Contemporary Art.

Aghdashlou began his career as a writer in 1963 and has written many articles on contemporary and classical Iranian art, including the book *Aqa Lutf' Ali Suratgar* (1997). He has collaborated on educational films about Iranian art and presented the television programme *Ways of Seeing* (1975-77). The Reza Abbasi Museum, Tehran, was set up under his management in 1976. He has been a teacher and visiting lecturer at various art academies since 1974. As painter, graphic artist, art critic and teacher, Aghdashlou has been described as a 'magic realist'; he paints irregularly and rarely exhibits. He is deeply committed to Iran's cultural heritage, and concerned with the destructive impulse of the contemporary era: 'I have followed deterioration, monitored annihilation, and tried to picture this inevitable transformation: the corruption of values and dignity, downfall, decay and degeneration, advancing years and death.' (RP)

Hannibal Alkhas
Born Kermanshah, Iran 1930

After studying in Tehran, went to the USA and received a BA, 1957, and MA, 1959, from the Art Institute at Chicago. Returning to Iran, exhibited at the Iran American Society, Tehran, and Reza Abbasi Museum, Tehran, 1960. Founded Gilgamesh Gallery, 1961, which was active for two years. Participated in the third Tehran Biennial Exhibition, 1962, since when he has had numerous solo and group exhibitions in Iran and the USA. Taught at Tehran's High School of Fine Arts and, until 1980, at the Department of Fine Arts at the University of Tehran. Occasional art reviewer for the press. Works in the collection of Tehran Museum of Contemporary Art.

As a painter, draughtsman and teacher, Alkhas is one of the most influential figures in contemporary Iranian art. He believes in figurative painting that encompasses a message. Since the beginning of his career he has pursued a narrative expressionism consisting of mythic, religious and social themes. Assyrian and Achaemenid reliefs and iconography, as well as Mexican frescoes, have inspired his aesthetics. With a love of modern literature, in particular poetry, he has dedicated a number of his paintings to leading Iranian poets such as Nima, Forough and Shamlou. (RP)

Massoud Arabshahi (ill. pp. 56–59)
Born Tehran 1935

Graduated from the College of Decorative Arts, Tehran, 1968. First exhibition at the Iran-India Centre, 1964. Participated in three Tehran Biennials; the Paris Biennial, 1965; the International Art Fair, Basle, 1976, 1978; Wash Art, 1977; and Art Expo, Los Angeles, 1986-91. Solo shows in Tehran have included: Saman Gallery, 1977; Seyhoun Gallery, 1993; Golestan Gallery, 2000. Produced numerous architectural reliefs, including the façade of the Office for Industry & Mining, Tehran, 1971, and the entrance to the California Insurance Building, Santa Rosa, USA, 1985. Major publication, *Avesta*, with 82 images by the artist, published, 1978. Works in the collections of Tehran Museum of Contemporary Art and the Museum of Fine Arts, Tehran.

Active in painting, sculpture and architectural design, Arabshahi is inspired by the artistic heritage of the Middle East. At the beginning of his career he turned to Babylonian, Assyrian and Persian decorative motifs. With flexibility and intelligence he depicted these designs in colossal three-dimensional representations. Gradually he became interested in the symbolism of antiquity. He is currently concentrating on introducing into our dynamic world the archaic mysteries of bygone ages. He lives and works in Tehran and California. (RP)

Siah Armajani (ill. pp. 122–125)
Born Tehran 1939

Moved from Iran to the USA, 1960, and graduated from Macalester College, Minneapolis, with a major in philosophy, 1963. Painted and wrote poetry, early 1960s, and later dedicated his life to study, research and the development of public art projects. Numerous exhibitions and public art displays include: North Dakota Tower, 1968; Museum of Modern Art, Minnesota, 1970; Sound Chamber for Vesuvius, 1972; Philadelphia College of Art, 1978; Joslyn Art Museum, Omaha, Nebraska, 1980; Hudson River Museum, 1981; California Institute of Technology, 1982; Institute of Contemporary Art, University of Pennsylvania, Philadelphia, 1985; Kunsthalle, Basel, 1987; Museum of Modern Art, Frankfurt, 1991; Max Protetch Gallery, New York, 1991; Arts Club of Chicago, 1992; Ikon Gallery, Birmingham, 1994; Villa Arson, Niza, 1994; Villa Merkel, Esslingen, 1994; and Museo Nacional Centro de Arte Reina Sofia, Madrid, 1999. Best known today in the USA as a major sculptor working in public art. Famous for his Irene Hixon Whitney Bridge, Minneapolis, 1988; Poetry Garden, Lannan Foundation, Los Angeles, 1992; Olympic Tower and Bridge, Atlanta Olympic Games, 1996; Lighthouse and Bridge, Staten Island, 1997; Bridge for Beloit, Wisconsin, 1997; and Jardin Villa Arson, Nice, 1997.

Armajani is a pragmatic, prolific and gifted artist of many talents. His written manifestos, designs and constructed projects highlight his major concerns: the aesthetic, social and communicative functions of public spaces. The need to consider the role of the artist in society, and the concept of public art in general, is embodied in his work, from his early calligraphic work to his bridges, through which he explores conceptual proposals. The same motivation lies behind his communal spaces and gardens, his series entitled *Dictionary of Building*, and his homage to anarchists in sculptural works, as well as his *Street* series, light towers and park furniture. Most of his projects are a fusion of architecture, sculpture, poetry and painting. He lives and works in Minneapolis, Minnesota. (RI)

Fereydoun Ave (ill. cover and pp. 110–113)
Born Tehran 1945

Primary and secondary education in England, 1953-63; received BA in Theatre Arts from Arizona State University, USA, 1969; studied film at New York University, 1969-70. Started his professional career as stage and graphic designer at the Iran American Society, Tehran, 1970-73. Resident designer for the National Theatre, Tehran, 1973-77; advisor to National Iranian Television, 1973-75, and to Shiraz Arts Festival, 1973, while also

acting artistic director of the Zand Gallery, Tehran, 1974-79. Exhibited regularly in Iran since 1975, starting at the Iran American Society, then in his own gallery, Tehran, and abroad, mostly in Washington DC and Paris at Herve Van der Straten Gallery.

Ave is a designer, gallery owner and eclectic artist who works in series, each project representing a separate concept, and in different media, mostly collage, mixed-media assemblage, photography and works on paper. His skilfully drawn three-dimensional watercolours of natural elements, leaves, branches and flowers were followed by sculptural assemblages and collages inspired by Ferdousi's pre-Islamic epics. These demonstrate his abilities as a craftsman as well as his search – as a Zoroastrian – for a specific identity, even though he considers the artist, Cy Twombly, his true inspiration. He lives and work in Tehran, Paris and New York. (RI)

Akbar Behkalam
Born Tabriz, Iran 1944

Studied initially at the Institute of Fine Arts, Tabriz, 1961-64; then at the Institute of Fine Arts, Istanbul, Turkey, 1967-72. Between 1972 and 1974 lived in Paris, Frankfurt, Rome and Berlin, where he settled, 1976. Taught at the Institute of Fine Arts, Tabriz, and the Institute of Fine Arts, Tehran, 1974. First exhibition at Seyhoun Gallery, Tehran, 1975. Subsequent solo shows: Einsteinhaus, Ulm, 1979; Kulturzentrum Schalchthof, Kassel, 1980; Kunstamt Kreuzberg, Berlin, 1982; Galerie Linneborn, Bonn, 1983; Galerie Apex, Göttingen, and Galerie Chamissoplatz, Berlin, 1984; Galerie Sachs, Munich, 1985; Staatliche Kunsthalle, Berlin, and Museum Bochum, 1987; Galerie Walther, Dusseldorf, 1988; and numerous touring group exhibitions worldwide.

Behkalam's neo-expressionist paintings, with their spontaneous brushstrokes, always tell a story of tension, whether they refer to persecutions, revolutions, demonstrations or terror. Sometimes he uses Iran's bygone age (as in his *Persepolis* series) or the German revolution of 1848 to express his horror of political abuse. By superimposing images of past glory with tragic contemporary events, his art explores the dark and terrifying nature of mankind. He lives and works in Berlin. (RI)

Seyed Edalatpour (ill. p. 28)
Born Shiraz, Iran 1962

Moved to UK, 1983. Attended Foundation Course, Camberwell School of Art, London, and received First Class BA degree in Fine Art (sculpture) at Norwich School of Art. Also completed Interdisciplinary Course in Art and Architecture, Kent Institute of Art and Design, Canterbury. Artist-in-Residence, Ashford School, Kent, 1992-99. Lecturer at both Canterbury College and Kent Institute of Art and Design, and exhibited at *Sculpture in the Garden*, Wimborne, Dorset, 1997. Exhibited regularly at New York and London Print Fairs in recent years. Major exposure at Art '98 and the London Contemporary Art Fair, where he showed an installation of thirteen heads carved in Portland stone, 1998. Awarded Millfield Sculpture Commission, 1999, followed by a major solo show at Atkinson Gallery, Millfield. First public gallery exhibition of large sculptural installations, *Circling the Square*, Wolverhampton Art Gallery.

Edalatpour works in a variety of media, including drawings and prints, but is best known for his monumental sculpture of human heads in Portland stone, each with different expressions. Their mysterious presence, revealing a calm internal intensity, is reminiscent of large-scale Buddhist sculptures. He lives and works in UK. (RI)

Mohammad Ehsai (ill. pp. 36–39)
Born Tehran 1939

Responsible for the layout and calligraphical texts of schoolbooks for a number of years. Studied at the Department of Fine Arts, University of Tehran, where he later became a calligraphy instructor. First exhibited at Seyhoun Gallery, Tehran, 1973; Iran American Society, Tehran, 1974; Litho Gallery, Tehran, 1975; and Cyrus Gallery, Paris, 1975. Awarded a prize at the Cagnes-sur-Mer International Painting Festival, France, 1976, and took part in the International Art Fair at Basle, 1976-78. Involved in a number of design projects, including the conference hall of the Ellahiat Faculty, Iran, 1978. Works in the collections of Tehran Museum of Contemporary Art and the Museum of Fine Arts, Tehran.

An artist with a religious sensibility, Ehsai has achieved an aesthetic synthesis between traditional calligraphy and modern painting. He is an expert in both the *Nasta'liq* and *Sols* styles of calligraphy, and creates a novel visual order through a mixture of discipline and spontaneity. For him, letters represent pure visual elements and are not merely the constituent parts of significations. In his own words: 'The theme of my work is the *Kalâm* (the word of God), but my perspective on word-formations is not based on literary criteria; my experiments with *Kalâm* create compositions that look to the future at the same time as relying on the millennial traditions of my forefathers. The exoteric form of these letters is analyzed within my subjectivity, resulting in a fully abstract and personal aesthetic expression.' Ehsai is mostly inspired by classical Persian poetry. He lives and works in Tehran. (RP)

Alireza Espahbod (ill. pp. 84–85)
Born Tehran 1951

Graduated from the College of Fine Arts for Boys, Tehran, 1971; then from the College of Decorative Arts, Tehran, 1975. MA in design from Goldsmith's College, London, 1977. Participated in the First International Art exhibition, Tehran, 1974, and exhibited in many private galleries in Tehran, including the Seyhoun Gallery. Took part in the International Art Fair, Basle, 1976; solo exhibition at Bedford House Gallery, London, where some of his drawings were sold to the Tate Gallery, 1977. Collaborated with the poet Ahmad Shamloo in publishing essays and works in *Iran Shahr* magazine, London, mid-1970s. Their collaboration was to continue in Iran for another twenty years. Since returning to Iran, has exhibited in Tehran at the Golestan Gallery, 1981, and at the Seyhoun Gallery, 1983. Worked mostly as a graphic designer and art critic, 1984-88.

Espahbod's narrative paintings, from his *Crows and Trees* series of the 1970s to the more nightmarish figurative paintings of the 1980s and 1990s, reflect human anxieties and a concern for endangered life. His disquieting images of catastrophes, tortured faces, nightmarish situations, threatening animals and wandering spirits became increasingly unpopular

with the regime, and since 1990 he has not been permitted to exhibit. A monograph was published by Iranian Art Publishing, 1998. (RI)

Parvaneh Etemadi
Born Tehran 1948

Received training at the Department of Fine Arts, University of Tehran, but discontinued her studies in protest against the academic educational system. First solo show at Talar-e Qandriz, Tehran, 1969, then exhibited at: Seyhoun Gallery, Tehran, 1974, 1978; Wade Gallery, Los Angeles, 1986; Wade Gallery, Vancouver, 1987; Majless Gallery, Dubai, 1994; the Niavaran Cultural Centre, Tehran, 1998; and the Green Art Gallery, Dubai, 1999. Participated in the following exhibitions: Talar-e Qandriz, on the occasion of its one-hundredth exhibition, Tehran, 1998; International Art Fair, Basle, 1976; *Exhibition of Iranian Art*, Peking and Shanghai, 1978; *An Exhibition of Four Female Artists*, Foxly/Leach Gallery, Washington DC, 1978; and with Manjit Bawa at the Espace Gallery, New Delhi. Designed an installation on the theme of water for Basic Needs at Expo 2000, Hanover. Considered one of the most successful contemporary Iranian artists. Works in the collections of Tehran Museum of Contemporary Art and the Museum of Fine Arts, Tehran.

Etemadi is a painter with a discerning perception and an assured touch, as well as being a highly original designer. She has concentrated mainly on still lifes. In her early work she engraved simple forms of various objects onto a cement background which were then filled in with subdued colours. From 1980 to 1995 she meticulously drew flowers, lace, *termeh* (a hand-woven cloth with intricate designs), and numerous other objects. More recently she has created reproductions in collage on white paper to form heterogeneous designs that could best be described as 'paper dancers'. She lives and works in Tehran. (RP)

Monir Farmanfarmaian (ill. pp. 64–65, 66–69)
Born Qazvin, Iran 1924

First studied Fine Arts at the University of Tehran; then at Cornell University, New York; graduated from Parsons School of Design, 1946-49; Arts Students League, New York, 1950-53. Exhibited at the Venice Biennale, Iranian Pavilion (winning a Gold Medal, 1958), 1958, 1964 and 1966. Participated in the first Tehran Biennial, 1958. Has exhibited extensively in Iran, mostly at the Iran American Society, 1973 and 1976, and the Italian Institute, 1966 and 1968, then in the USA at Jacques Kaplan Gallery, New York and Washington DC, and at the Kennedy Center, Washington, 1975. Exhibited at Galerie Denise René, Paris and New York, 1977. Was in New York when the revolution took place in Iran, 1979, and remained there. Participated in group shows such as *The Heritage of Islam*, New York, 1982-84, and in touring exhibitions organised by the Bernice Steinbaum Gallery, 1985-86, and the Museum of Modern Art, New York, 1986-87. Works in the following collections: Carpet Museum, Tehran; Tehran Museum of Contemporary Art; Niyavaran Cultural Centre, Tehran; Grey Art Gallery, New York University, New York; Hotel Intercontinental, Tehran and Shiraz; Jeddah Airport, Saudi Arabia; Chase Manhattan Bank, New York.

Farmanfarmaian is, surprisingly, the only Iranian artist to have explored the use of mirror, latticed stucco carving and glass in her work. She incorporates traditional Islamic designs, toys and photographs to create kaleidoscopic images reflected in diamond-shaped mirrors. Her more recent constructions are more three-dimensional, made from wooden boxes, paint, glass mirror, fabric and photographs. She lives and works in New York. (RI)

Bita Fayyazi (ill. pp. 26, 99–101)
Born Tehran 1962

Studied ceramics and pottery at the Iranian Handicrafts Association and acquired extensive experience in tile work and murals; private courses in sculpture followed by a training in enamels and glazes at Maghsoud Chinaware Factory, Iran. Lived in the UK, 1975-82, then returned to Tehran. First exhibited her ceramics in Tehran, 1989, and, later, mostly abstract ceramics at Tehran Museum of Contemporary Art and at the Golestan Gallery, Tehran. Solo exhibition of wall murals, Classic Gallery, Isfahan. Sometimes works with a group of painters, film-makers and pho-tographers on multi-media installations, including her plaster sculptures (*Experiment 98* and *Children of the Dark City*, Tehran, 2000). Joint exhibition with Khosrow Hassanzadeh, Seyhoun Gallery, Tehran, 2000, and included in the group exhibition, *Ekbatana?*, Nikolaj Contemporary Art Centre, Copenhagen, 2000.

A ceramicist and sculptor, Fayyazi works obsessively by theme, pro-ducing works in great numbers: for her *Dead Dogs, Road Kills* series she made 150 prostrate earthenware dogs, which she later buried, filming the process; another 120 of her plaster crows were destroyed in the process of demolishing an abandoned house in a work entitled *The Art of Demolition*, 1998; she has made more than 1,000 ceramic cockroaches; and has created life-size plaster sculptures of children. She lives and works in Tehran. (RI)

Shadi Ghadirian (ill. pp. 8, 106–109)
Born Tehran 1974

Graduated in Photography, Azad University, Tehran, 1998. Exhibited in Tehran at: Aria Gallery, and Tehran International Documentary Photography Exhibition, 1997; Barg Gallery, and Sooreh International Photography Exhibition, 1998; Lili Golestan Gallery, 1999. Also shown in group exhibitions: *Iran: Neue Bilder-Neue Stimmen*, Haus de Kulturen de Welt, Berlin, 2000; *Ekbatana?*, Nikolaj Contemporary Art Centre, Copenhagen, 2000; *Inheritance*, Leighton House Museum, London, 2000; as well as at Guildhall University, London, 2000; Ballymens Borough Council, London, 2000; Iranian Women's Study Foundation, Berkeley, University of California, 2000; *Young Iranian Photographers*, Barg Gallery, Tehran, 2000; and *Iran, regards croisés*, Galerie FNAC, Paris, 2001.

Ghadirian is known primarily for her small studio portraits of young women, mostly friends and family, dressed in late nineteenth-century Qajar style, juxtaposed with modern daily objects referring to forbidden things. The images illustrate, with dry humour, the paradoxes in the life of young Iranian women, and their subtle defiance. She lives and works in Iran. (RI)

Ghazel (ill. pp. 102–105)
Born Tehran 1966

Based in France since 1986. Received BA and MA in Visual Arts from Ecole des Beaux Arts, Nîmes, France, 1990, 1992; then BA in Cinematography, Paul Valéry University, France, 1994. Grant for Berlin, 1993, followed by a grant from FIACRE, French Ministry of Culture, for art project in New York, 2000. First group exhibition, Nîmes, 1991, and Aachen (Ludwig Forum für International Kunst). Participated in the Biennale des Jeunes Créateurs d'Europe de la Mediterrannée, 1992; Club Berlin, Kunstwerke, Venice Biennale, 1995; *Wanted* performances, Berlin, Montpellier, Stockholm, Sète, Paris, 1997. Untitled events in Avignon, Berlin, Montpellier, Nîmes and Tehran, 1997; *Several Home Installations I, II, III*, Mardabad, Tehran, 1993-98; solo exhibitions, Berlin (*Wedding I, Tacheles*); and *Sans Titre* pamphlets, Montpellier; *Vote* posters, Tehran, 1999; participated with her video series, *Me*, in *Ekbatana?*, Nikolaj Contemporary Art Centre, Copenhagen, 2000.

Ghazel's early conceptual works consisted mostly of happenings, installations in her old house in Iran, and pamphlets haphazardly distributed – all reflecting her nomadic life from the age of twenty in the USA, Europe and Iran. Her work with young immigrants in France, and later with young delinquents in Tehran, as well as her own uprooted status, accentuated her need to combine social work and art therapy. Her self-portrait video performances since 1997 emphasise the paradoxes of her situation as a woman and as an outsider within and outside her home country. She lives and works mostly in France. (RI)

Marcos Grigorian (ill. pp. 70–71)
Born Kropotkin, USSR 1925

His family moved to Tabriz, Iran, 1930. Studied in New Julfa, Isfahan, and Tehran before gaining employment with the American Military Transport School. Studied painting at Kamal-ol-Molk Art School, Tehran, and at the Academy for Fine Arts, Rome, 1950. Exhibited at Fiorani Gallery, Rome, and Raymond Duncan Gallery, Paris. Returned to Tehran, 1954, to begin his artistic career in earnest, and played a significant role in the development of Iran's modernist movement. Established the Aesthetic Gallery, Tehran, and presented young artists there and at the Venice Biennale; founded Tehran's Biennial Exhibition, 1958; formed collection of coffee-house paintings; exhibited and acted in films. Travelled to the USA, 1962, and continued his work in New York and Minnesota. Taught at the Department of Fine Arts of the University of Tehran, 1971-78; organised solo exhibitions at the Iran American Society, Litho and Saman galleries, Tehran. Returned to New York, 1979, and founded Gorky Gallery, 1981. Works in the collections of Ente Nazionale Turistica, Rome; Ben & Abby Grey Foundation, Minnesota; Gorky Gallery, New York; Museum of Modern Art, New York; Tehran Museum of Contemporary Art.

After a figurative period in an expressionist style (the last example of which was a series of twelve panels entitled *The Nazi Massacre of the Jews*), and inspired by the harsh realities of the Iranian desert landscape, Grigorian began, in 1960, to use materials such as soil, straw, polyester and occasionally paint. His geometrically simple relief-constructions are a reminder of humanity's eternal bond with the earth. (RP)

Qassem Hadjizadeh (ill. pp. 90–91)
Born Lahijan, Iran 1947

Received diploma from Tehran's High School of Fine Arts, 1967. First
exhibited at Talar-e Qandriz gallery, Tehran, 1969, then organised solo
exhibitions at the Iran American Society, Tehran, 1972, 1974, 1977; Litho
Gallery, Tehran, 1974; Seyhoun Gallery, Tehran, 1985; and elsewhere includ-
ing Galerie Caroline Corre, Paris, 1987. Participated in Cagnes-sur-Mer
International Painting Festival, 1974, and the International Art Fair, Basle,
1976, 1978. Travelled extensively throughout the USA, Europe and Africa.
Works in the collection of Tehran Museum of Contemporary Art.

Hadjizadeh's special interest in old photographs stemmed from his
early years when he worked on his father's photographic archive of
celebrity portraits, weddings, architecture and landscapes. Photographs
have became the main source of his imagery; he reproduces but modifies
them, effacing the backgrounds, adding intense colours and lines, and
altering placement and scale. His individual and personal interpretation
of recent memories, with its strong element of nostalgia, distinguishes
his work from photo-realism. He lives and works in Paris. (RP)

Khosrow Hassanzadeh (ill. pp. 95–97)
Born Tehran 1963

After returning from the Iran-Iraq war, studied at the Faculty of Painting
of the Mojtama's-e-Honar University, Tehran, 1989-91. Combined full-time
work with literary studies at the Faculty of Persian Literature of Azad
University, Tehran, and attended some private art courses with the artist
Aydeen Aghdashlou, 1996-98. Began exhibiting at the Jamshidiyeh Gallery,
Tehran, 1991, then at other Tehran galleries: Barg Gallery, 1994; Bokhara
Gallery, 1995; and most recently at the Seyhoun Gallery. Has worked with
a group of dynamic artists on several multi-media installation projects:
The Art of Demolition, *Experiment 98*, and *Children of the Dark City*, 2000. His
solo exhibition at Diorama Arts, London, 1999, introduced his work to
some public institutions: the British Museum, London; the World Bank,
Washington DC; and Tehran Museum of Contemporary Art. He has been
the subject of several documentaries by Maziar Bahar, and the BBC.

Khosrow Hassanzadeh's figurative paintings and drawings (primarily
on paper) are personal visual diaries. They relate to his war-time experi-
ence at the Iran-Iraq front, or illustrate key moments in his own family
life, including portraits of his mother, wife and children, as well as
numerous self-portraits. The paintings are often covered with his own
text, war letters or love poems. Mysterious numbers, codes and collages of
wallpaper are added to his patchwork compositions. He lives and works
in Tehran. (RI)

Mehdi Hosseini
Born Kashan, Iran 1943

Studied at Tehran's High School of Fine Arts, and then in the USA.
Received a BFA from the Art Institute of Chicago, 1968, and an MFA from
Pratt Institute, New York, 1970. Began teaching on his return to Iran. On
the science board of the Department of Fine Arts, University of Tehran,
from 1980. First exhibition at Tehran Gallery, 1973. Participated in many

solo and group exhibitions, including: *One Hundredth Exhibition*, Talar-e
Qandriz, Tehran, 1974; International Art Fair, Basle, 1976; Tehran Museum
of Contemporary Art, 1977, 1989; *Exhibition of Contemporary Iranian Painters*,
Moscow, 1999; Ninth Asian Biennial, Dhaka, Bangladesh, 1999; *Exhibition
of Contemporary Iranian Painting*, Rome, 2000. Works in the collection of
Tehran Museum of Contemporary Art.

A painter, draughtsman and teacher, Hosseini has an expressive
pictorial ability. Ordinary people and familiar objects are his subject-
matter, which he portrays in simplified form, creating fragmented
images in two dimensions: the reflection of a devastated and recon-
structed world. (RP)

Shirazeh Houshiary (ill. pp. 118–121)
Born Shiraz, Iran 1955

Resident in UK since 1974. Graduated from Chelsea Art College, London,
1979; Junior Fellow, Cardiff College of Art, Wales, 1979. Numerous solo
exhibitions: Lisson Gallery, London, 1984, 1992, 1994, 2000; several times at
the Tate Gallery, London (short-listed for the Turner prize in 1994); Centre
Georges Pompidou, Paris, 1989; the Rijksmuseum Kroller-Müller, Otterlo,
1990; the Venice Biennale, 1993; *Dancing Around My Ghost*, Camden Arts
Centre, London, 1993; *Turning Around My Center*, touring from University
of Massachusetts to York University, Ontario, 1994; *Isthmus*, a touring exhi-
bition which began at Magasin, Grenoble, 1995. Works in the collections
of numerous international museums.

Houshiary established herself in London in the late 1980s as one of
the leading sculptors of her generation. Her early work, of welded and
patinated metal forms reminiscent of Islamic calligraphy, moved on to
become more structural, comprising lead-lined containers, patterned on
the inside in gold, silver and copper, which drew on the tradition of
Islamic sacred geometry. The exhibition, *Isthmus*, 1994, was accompanied
by a lavish book, which included her drawings inspired by Rumi's poetry,
representing a high point in her career. Houshiary now produces fewer
sculptures, the most recent being a large lead-and-gold tower in front of
Sheffield Cathedral. Her subtle graphite drawings on paper and canvas
date back to 1992, where 'marks' composed of sacred words are repeated
like a mantra, or appear to dissolve into light in her more recent 'self-
portraits'. Through imparting symbolic expression to her Sufi beliefs,
Houshiary has developed a spiritual approach to her work. She lives
and works in London. (RI)

Parviz Kalantari (ill. pp. 72–73)
Born Zanjan, Iran 1931

Graduated from the Department of Fine Arts, University of Tehran, 1957.
First came to prominence during a group show at the Aesthetic Gallery,
Tehran, 1952. For 25 years most of his output evolved around illustrating
academic and children's books, but also had a number of solo exhibi-
tions: Department of Fine Arts, University of Tehran, 1962, 1971; Seyhoun
Gallery, Tehran, 1973, 1975, 1976. Collaborated with the Museum of
Anthropological Research, the result of which was displayed as a series of
paintings about peasants and tribal people at Ketab Sara, 1987.
Participated in group shows at Colombia University, New York, 1968;

International Art Fair, Basle, 1976; Wash Art, 1977; Museum of Pacific Asia, Pasadena, 1984; Tehran Museum of Contemporary Art, 1999, 2000. Works in the collection of Tehran Museum of Contemporary Art.

Kalantari is a painter and illustrator, devoted to the traditions of his homeland. Since the late 1960s, Kalantari has depicted rural architectural forms in his clay and straw tableaus. Occasionally he decorates these earthy works with ceramic patterns or coloured figures. Recently, he has produced works in a more conceptual vein (for example, his series entitled *Mudvision*). (RP)

Hossein Kazemi
Born Tehran 1924, died 1996

Trained at the Department of Fine Arts, University of Tehran, 1943-46. Aided by fellow painters, founded the first ever Iranian art gallery, Apadana, 1950, where he exhibited his work. Travelled abroad and enrolled at the Ecole des Beaux Arts, Paris, 1953. While in Paris exhibited at the Romeo-Juliet Gallery, the Museum of Modern Art and the Tedesco Gallery. Returned to Iran and exhibited at the Reza Abbasi Museum, 1959. In the same year he began experimenting with pottery. Years later he entered the Tehran and Venice Biennials as well as a number of solo and group exhibitions, including: ceramic works at Valoris, France; paintings at the Cyrus Gallery, Paris; drawings at Litho Gallery, Tehran. Director of the High School of Fine Arts at Tabriz and Tehran, 1958-67. Taught at, and for some time directed, the College of Decorative Arts, Tehran, until his migration to France, 1979. Works in the collections of the Museum of Fine Arts, Tehran, and Tehran Museum of Contemporary Art.

One of the pioneers of modernism in Iran, Kazemi was a painter, ceramic artist and an influential teacher. During his mature period he was greatly influenced by the dualistic philosophy of ancient Persia. The main theme of his paintings depicts the 'unity of contraries', through symbolic and semi-abstract motifs (plants & stone, earth & sky, cypress tree & soil, etc). (RP)

Christine Khondji
Born France 1947

Elementary school in Tehran, then studied Islamic Art and Oriental Archaeology, Paris, and Photography, London. Exhibitions: *Shamanic Self Portraits*, October Gallery, London, 1997; in *Morpheus Armen*, Berchem Cultural Centre, Antwerp, Belgium, 1998; *Siyah Qalam au présent*, French Institute, Istanbul, 1999; *Christine Khondji*, French Cultural Centre, Alexandria, Egypt, 2000; and several group and solo exhibitions in Paris. Works in the collections of the British Museum, London, and the World Bank, Washington DC.

Khondji's paintings and photographs are mostly autobiographical life-size self-portraits on paper. Some are recognisable metaphoric figures, others are images of her inner world, of the unseen; or of unperceived objects of fear and fantasy incorporated into one figure, filled with animals and djinns, not unlike Indian composite Sufi drawings. She also writes short stories and novels. She divides her time between London and Paris. (RI)

Reza Mafi (ill. pp. 44-45)
Born Mashhad, Iran 1943, died 1982

Born into a family of calligraphers. Began his creative career with coloured calligraphy exercise-pages (*Siyah-Mashq*), but soon altered his style to work more freely. First exhibited at Seyhoun Gallery, Tehran, 1968, where he went on to have regular annual shows of his latest work. Also exhibited at the Cyrus Gallery, Paris, 1971 and 1972, and participated in many other exhibitions in Iran and abroad, including: the inaugural International Arts Exhibition, Tehran, 1974, and the Festival of Islamic Art, London, 1976. Works in the collection of Tehran Museum of Contemporary Art.

Mafi was a master calligrapher and one of the representatives of the *Naqashi-Khat* (*Lettrisme*) movement. Towards the end of his life he used brown and beige elegant curves with great freedom of expression. He brought a fresh attitude towards the aesthetics of traditional handwriting and believed, in his own words, that 'scripts in general, and the *Nasta'liq* style in particular, are extremely rich in form. Their ups and downs, tension and curls are hugely expressive'. (RP)

Ali Mahdavi (ill. p. 25)
Born Tehran 1974

Studied art at Ecole Boulle, and later at the Ecole Nationale des Arts Appliqués Duperré, followed by the Ecole Nationale Supérieure des Beaux Arts, Paris. Graduated, with special Jury mention, 2000. Attended the Royal College of Art, London (Erasmus Scholarship), 1998. Exhibited in *Question de Corps*, Galerie Gregoire Gardette, Nice, and *Visage et Expression*, Ecole Nationale des Beaux Arts, Paris, 1997, and in the Daler-Rowney Prize Exhibition, Royal College of Art, London, 1998. Received first prize from Live for a Moment, an Inter-European Polaroid competition, 1996, and Scholarship LVMH for the San Francisco Art Institute, 2000. He lives and works in Paris. (RI)

Ardeshir Mohassess
Born Rasht, Iran 1938

Started young as a cartoonist for the Iranian daily newspaper *Keyhan*, and later for the London-based political weekly *Iran Shahr*. Soon earned many followers among poets and writers. Became the voice of dissent in Iran in the 1960s and 1970s, when the Shah banned the publication of his work. Left Iran for Paris, 1976, and then New York, 1977. Awarded the Erwin Swann Award for excellence in cartoon, caricature and comic strip art, and has had numerous exhibitions worldwide. His work has been featured in many journals, newspapers and other publications in France, Iran and USA. His most popular book, *Life in Iran*, was published by Mage Publishers for the Library of Congress (see Bibliography), 1994.

One of Iran's greatest visual satirists and commentators, Mohassess is an exceptionally original cartoonist, caricaturist, graphic artist and critic. He uses satire to denounce double standards, hypocrisy, greed, autocratic regimes, and the numerous faces of injustice. His powerful pen-and-ink drawings formed from miniature-like fine lines, or rough drawings of grotesque creatures, often depict historical situations set in

another period, but their critical meaning is diverted towards all repressive regimes, independent of time and place. He denounces the brutality of societies in general, and in the third world in particular.
He lives and works in New York. (RI)

Bahman Mohassess (ill. p. 87)
Born Rasht, Iran 1931

As a teenager, studied with Habib Mohammadi (a painter trained at Moscow's Arts Academy). Moved to Tehran with his family, 1948. Spent a few months at the Department of Fine Arts, University of Tehran, and around the same time joined the Fighting Rooster Society. For a time was editor of a literary and cultural weekly, *Rooster's Claw*. Went to Europe, 1954, deciding to settle in Italy. Studied at the Art Academy, Rome. Held a number of exhibitions before taking part in the Paris, São Paolo, Tehran and Venice biennials. Returned to Iran to pursue his artistic career, 1963. Exhibited at the Goethe Institute and Talar-e Qandriz, Tehran. Organised a series of solo exhibitions, participated in conferences, translated into Persian works by Pirandello, Malaparte, Ionesco and Genet, and produced a number of plays, including *Henry IV*. Unable to continue his work in Iran, decided to move back to Italy. Ironically, whilst there, commissioned to produce a number of statues for display in Tehran. Occasionally visited Iran in recent years. Works in the collections of the Jahan-Nama Museum, Tehran; Museum of Fine Arts, Tehran; and Tehran Museum of Contemporary Art.

Mohassess is a painter, sculptor and intellectual with a profound grasp of modern culture. Unlike most of his generation, he has no great desire to keep returning to the traditional arts, preferring to view life and humanity through modern eyes. In a monograph of 1976 the Italian critic, Giuseppe Selvaggi, observes: 'In his paintings, the most evident testimony to Mohassess' cultural modernity is demonstrated in his linear treatment of colour, bands of colours opposing each other and fusing together, strips of different shades in the background which, by virtue of this bifurcated variation, assumes the disquieting strength of a landscape. This is a geometric search for light and into light.'
Mohassess lives and works in Italy. (RP)

Nosratollah Moslemian
Born Salmas, Western Azerbaijan 1951

Graduated from the Department of Fine Arts, University of Tehran, 1977, where he held his first exhibition. Subsequent exhibitions in Tehran at: Private Atelier, 1986-97; Seyhoun Gallery, 1987-92; Tehran Museum of Contemporary Art, 1988; Barg Gallery, 1998, 2000. Other solo and group exhibitions include: Tehran Museum of Contemporary Art, 1990; French Embassy, Tehran, 1996; touring Iranian art exhibition, London, Bern, Geneva, 1999; and First Biennial of Paintings of the Islamic World, Tehran (first prize), 2000. Taught at the Department of Fine Arts, University of Tehran, 1979-81, and has been teaching at Azad University, Tehran, since 1991.

Moslemian's metaphorical paintings present the past and present simultaneously. After making a series of expressionist paintings on the theme of war, inspired by Persian pictorial tradition, he found his own unique, lyrical style. This approach is evident in his portrayal of faces and postures, and is characterised by a use of bright colours and curved lines, and by the creation of a segmented, imaginary space. (RP)

Shirin Neshat (ill. pp. 114–115, 117)
Born Qazvin, Iran 1957

Left Iran for USA, 1974, where she studied art and was in Los Angeles when the revolution took place in Iran, 1979. Returned to Iran, 1990, and, deeply affected by the radical transformations, has since been going back and forth. Numerous major solo exhibitions in the USA and Europe. First became famous for her photographic series, *Women of Allah*, 1993-97, where she inscribed on images of parts of her body texts by Foroogh Farokhzad and other calligraphical texts. Over the past seven years she has moved from a use of still photography and the single image to film installations, usually dual projections. Major work to date includes: *Turbulent*, 1998, a trilogy of video films realised with a team of close friends and colleagues, shown at St Mary-Le Bow, Tate Modern and Rotterdam Film Festival, 1999; *Rapture*, 1999; and *Fervour*, 2000. Received the Golden Lion Award at the Venice Biennale, and exhibited in Kunsthalle, Vienna, and Serpentine Gallery, London, 2000.

Working in photography and video installation, Neshat's art, which has a distinctive stark and minimalist style, refers to the social, cultural and religious code of Iranian society. She uses recognisable symbols like the veil or chador, and strong contrasts of black and white, picture and script, male and female, in order to challenge perceptions of contemporary Islam. She lives and works in New York. (RI)

Nasser Ovissi (ill. p. 16)
Born Tehran 1934

Graduated in law, University of Tehran, 1956. Prize-winner in first exhibition, 1957. Participated in Biennial exhibitions: Paris 1959; Tehran, 1960-66; Venice, 1962; São Paolo, 1963; and the Graphics Biennial, Florence, 1968. Solo shows: Borghese Gallery, Tehran, 1966; San Fedele Gallery, Milan, 1966; Gallery 88, Rome, 1968; Huber Gallery, Zurich, 1969; Colombia University, New York, 1972; and Sheikh Gallery, Tehran, 1978. Has worked outside Iran for the past twenty years. Works in the collections of Campione Museum, Italy; Jahan-Nama Museum, Tehran; Museum of Fine Arts, North Carolina; and Tehran Museum of Contemporary Art.

A painter, lithographer and ceramicist, Ovissi was one of the first Iranian modernists to return to the artistic traditions of the past. At the height of his success he painted imaginative works with stylised figures and calligraphic elements. He has drawn inspiration from Saljuq ceramics, Qajar paintings and Qalam-Kar clothes (of printed textiles, mostly made in Isfahan). In 1965 the Italian art critic, Giulio Carlo Argan, wrote: '… Ovissi's style is imbued with a quality which places his paintings at the threshold of poetry and on the frontier between painting and calligraphy… For him subject matter is not an end in itself; he sets out instead to move beyond subject matter to find a continuity and rhythm which only forms can generate'. (RP)

Faramarz Pilaram (ill. p. 41)
Born Tehran 1938, died 1983

Received a Diploma in painting from Tehran's High School of Fine Arts. Entered the College of Decorative Arts, and studied interior design, 1961. Studied in France for a year, 1970. Participated in Tehran's Biennial, 1962 (winning a silver medal), 1964, 1966; Venice Biennale, 1962; International Art Fair, Basle, 1976, 1978; and Wash Art, 1977. Organised a number of solo exhibitions in Tehran, including at the Borghese Gallery, Iran American Society, Seyhoun Gallery, as well as at Cyrus Gallery, Paris. During his last years, taught interior design at the College of Science & Technology, Tehran. Works in the collections of Jahan-Nama Museum, Tehran; the Museum of Modern Art, New York; and Tehran Museum of Contemporary Art.

One of the representatives of the 'neo-traditionalist' *Saqqakhaneh* school of painting, Pilaram was one of the first Iranian painters to gravitate towards *Lettrisme* and calligraphic forms. In his early compositions he used geometric forms and religious icons (such as *Alam, Panjeh,* etc.), filling in the background using a seal-impression technique. These works resembled the early *Saqqakhaneh* output of Hossein Zenderoudi. Later, he turned to calligraphy (especially the *Nasta'liq* style), and, basing himself on the traditions of calligraphic-exercise-writing, he experimented with various decorative forms. He also produced massive three-dimensional wooden constructions. (RP)

Mansour Qandriz (ill. p. 62)
Born Tabriz, Iran 1935, died 1965

Studied at Tehran's High School of Fine Arts. Spent two prolific years in Tabriz, 1958-60. First exhibited at the Reza Abbasi Museum, Tehran, 1960. Entered the College of Decorative Arts, Tehran, 1961. With the help of fellow painters, founded the Art Centre, Tehran, 1964, renamed Talar-e Qandriz in his honour after his death. Works exhibited a number of times at the Centre. Participated in the São Paolo Biennial, 1962, 1964, and the Paris Biennial, 1965. Works in the collection of the Ben & Abby Grey Foundation, Minnesota, and Tehran Museum of Contemporary Art.

One of the most talented modernist painters, Qandriz's untimely death prevented him from completing his work. He belongs to the *Saqqakhaneh* school of painting. His early figurative images reveal the influence of Matisse, Picasso and Persian miniatures. Later, using traditional textile and felt designs, he developed an individual 'primitive' and semi-abstract style characterised by geometric patterns and stylised motifs (human, birds, fish, the sun, sword, etc.). His last compositions gravitated towards a deceptively simple expressiveness. (RP)

Jaafar Rouhbakhsh (ill. pp. 60–61)
Born Mashhad, Iran 1941, died 1996

Studied at Tehran's High School of Fine Arts, 1960. Continued at the College of Decorative Arts, receiving an MA in painting and interior design, 1971. Participated in the third Tehran Biennial, 1962, and the Paris Biennial, 1965. First solo exhibition at the Department of Fine Arts, University of Tehran, 1965, followed by numerous exhibitions, including:

Cyrus Gallery, Paris, 1975; Belle-Chasse Gallery, Paris, 1976; Rojo y Negro Gallery, Madrid, 1976; and Seyhoun Gallery, Tehran, 1988. Taught for many years at Tehran's College of Decorative Arts. Works in the collections of the Maeght Foundation, St Paul de Vence; the Museum of Fine Arts, Tehran; and Tehran Museum of Contemporary Art.

The characteristics of Rouhbakhsh's paintings during the last decade of his career place him in the *Saqqakhaneh* school. In his heterogeneous experiments he always tried to revive the spirit of traditional Persian design in novel forms. His later compositions, with their flower and bird motifs, geometric patterns, and bright ornamental colours, are testimony to his achievements. In an exhibition of his work in 2000 at the Galérie Doctorhaus, Bern, his paintings were described as follows: 'Every manifestation of the magic and mystery of the East and the spirituality of Sufism is realized in Jaafar Rouhbakhsh's paintings through an extraordinary fusion of the heritage of the past and the modernity of the contemporary world.' (RP)

Abol Qassem Saidi (ill. pp. 80–83)
Born Arak, Iran 1926

Spent much of his youth in France; studied at the Ecole des Beaux Arts in Paris. From 1965 to late 1970s divided his time between Paris and Iran; since 1980s has lived in Paris and San Francisco. Received awards: Prix de la Jeune Peinture, 1959; Tehran Biennial, 1961; Fondation Taylor, France, 1988; Léon-Georges Baudry (given by the Fondation Taylor), 1991; Prix Monte-Carlo, 1993. Worked in Iran for the Shiraz Festival, 1967-77. Opposed to exhibiting in private galleries, but has exhibited in many Salons: Salon d'Automne; Salon de la Jeune Peinture, 1954-66; Salon de Comparaisons; Salon de Mai; Salon des Grands et des Jeunes d'Aujourd'hui; Salon Nationale des Beaux Arts. Also exhibited at the Biennials of São Paolo, Tehran and Delhi, and generally in France, USA and Switzerland. Works collected and commissioned include those at: Saderat Bank, London; University of Shiraz; Tehran Airport; Tehran Opera; Computer Land, San Francisco; Tehran Museum of Contemporary Art.

Saidi paints mostly still lifes, such as flowers and vases, or nature, such as trees and branches. He regards painting as a *Yadegari,* or souvenir, a trace that one leaves behind. His abstract figurative work is highly contemplative in its evasive simplicity. In his work Saidi likes to express a certain atmosphere, a suspended moment, a silent smile. (RP)

Hojatollah Shakiba (ill. pp. 92–93)
Born Gorgan, Iran 1949

Won many prizes at an early age. Studied at the Department of Fine Arts, University of Tehran, 1974-78. Worked in graphic design and advertising for many years. Exhibitions include: International Art Fair, Basle, 1976; Seyhoun Gallery, Tehran; Mehrshahr Gallery, Tehran, 1977; Niyavaran Cultural Centre, Tehran; and Tehran Museum of Contemporary Art, 1987, 1988; 'War Week', Daneshjou Park, Tehran (first prize), 1988; Asian Exhibition, Bangladesh, 1988; Seyhoun Gallery, from 1988 to 1991; *Portrait Painters of Iran,* Tehran Museum of Contemporary Art, 1991.

A commercially successful and productive painter, inspired by the recent past – Qajar princesses, decorative paraphernalia, and war heroes

– Shakiba's nostalgic figurative work combines flowers, nightingales, old photography, lacquer-type paintings and Qajar decorative motifs. The contrast of skilfully painted motifs, and the presence of fractures and cracks, hints at the permanent threat of things to come, and the uncertainty of both past and future. He lives mostly in Iran and UAE. (RI)

Sohrab Sepehri (ill. pp. 75–77, 79)
Born Kashan, Iran 1928, died 1980

Taught initially, then moved to Tehran to pursue a career in painting and poetry. Entered Department of Fine Arts, University of Tehran, 1948; established contact with the Fighting Rooster Society (a group of modernist painters and poets) and printed a book of poems, *Death of Colour*, 1951. Travelled to Paris to continue studying, 1957. Participated in two Tehran Biennial Exhibitions, 1958, 1960. Travelled to Japan, 1960, to gain a deeper appreciation of Far-Eastern art. Following successful exhibitions at Reza Abbasi Museum, Tehran, 1961, established as an artist with a unique style. Gave up all teaching and government employment in this period and concentrated on exhibiting abroad, including: the São Paolo Biennial, 1969; the Cagnes-sur-Mer International Painting Festival, 1969; Benson Gallery, New York, 1971; Cyrus Gallery, Paris, 1972; and in Tehran at Borghese Gallery, 1965, and Seyhoun Gallery, annually. Last book of poetry, *Hasht-Ketab*, published, 1977. Works in the collections of the Ben & Abby Grey Foundation, Minnesota; the Jahan-Nama Museum, Tehran; Museum of Fine Arts, Tehran; and Tehran Museum of Contemporary Art.

Sepehri was a painter and poet who is accorded a high status in contemporary Iranian art and literature due to his innovative synthesis of western and eastern cultures. He was a thoughtful and inquisitive artist, and a perfectionist. He continued to analyse the heritage of eastern art without neglecting contemporary trends. He loved the natural surroundings of his homeland, and most of his paintings, both figurative and abstract, revolved around desert landscapes. Whether improvising with fluent lines and earthy colours or composing geometric forms with bright colours, he always emphasised the 'void' (in the sense taught by Zen Painting). (RP)

Koorosh Shishegaran (ill. pp. 48–49)
Born Tehran 1945

Studied at Tehran's High School of Fine Arts. Received a BA from the College of Decorative Arts, 1973. First exhibited at Mess Gallery, Tehran, 1973. Since then has had a number of solo shows in Tehran, including: Talar-e Qandriz, 1976; Classic Gallery, 1989; Golestan Gallery, 1992, 1997; and Arya Gallery, 1996; and participated in group exhibitions in Britain, Iran, Italy, Oman, Switzerland, Turkestan and Syria. Designed and printed, at his own expense, numerous posters with socio-political themes and plastered them widely throughout Tehran, 1976-81. Has also organised exhibitions of posters in Iran and abroad. Works in the collection of Tehran Museum of Contemporary Art.

Shishegaran is a painter, graphic artist and interior designer who is concerned with the social use of art. One of the main characteristics of his painting is a free use of form. In recent years he has created dynamic compositions with vivid colours and jumbled curved lines, giving the

impression of spontaneity while being carefully crafted. He lives and works in Tehran. (RP)

Jazeh Tabatabai (ill. pp. 15, 138)
Born Tehran 1928

Began a literary career at the early age of twelve. Graduated from the Department of Fine Arts, University of Tehran, 1960; continued training in the dramatic arts. Exhibited paintings and sculpture at Reza Abbasi Museum, Tehran, 1960. Participated in three Tehran Biennial exhibitions, winning prizes. Exhibited sculpture at the Paris, Venice and São Paolo Biennials in the 1960s and had solo exhibitions in Frankfurt, London, Madrid, Tokyo, Vienna and other major cities. Has lived in Spain since the 1980s, occasionally visiting Iran. Most recent exhibition in Tehran, 1994. Founded Modern Art Gallery, Tehran, 1957. Works in the collections of the Jahan-Nama Museum, Tehran, and Tehran Museum of Contemporary Art.

A sculptor, painter, poet and novelist, Tabatabai is considered one of the pioneers of modern art in Iran. His work is inspired by Iranian folklore and attempts to link the past with the present. His imagination and use of satire are exemplified in his sculpture, where he selects used metal parts – from automobiles, bicycles, home appliances, or broken watches – with great care and welds them into fantastic figures, chickens and other animals. He lives and works in Iran and Spain. (RP)

Sadeq Tabrizi
Born Tehran 1939

Graduated in painting and interior design from the College of Decorative Arts, 1967. Exhibited initially at the Iran American Society, 1959. Participated in numerous exhibitions both in Iran and abroad, including: International Ceramic Exhibition, Prague, 1962; the Tehran Biennial, 1962, 1966; Talar-e Qandriz, Tehran, 1964; International Art Fair, Basle, 1978; China Art Expo, Beijing, 1977; East & West Art, Melbourne, 2000. Solo exhibitions include: Borghese Gallery, Tehran, 1970; Cyrus Gallery, Paris, 1972; Bengston Gallery, Stockholm, 1973; Hilton Hotel, Los Angeles, 1992; and Colombia University, New York, 1992. Works in the collections of the Ben & Abby Grey Foundation, Minnesota; the Museum of Fine Arts, Tehran; and Tehran Museum of Contemporary Art.

Tabrizi is a creative painter and ceramicist, intimately acquainted with traditional Persian art. He works mostly on parchment. In his earliest paintings he used ornamental patterns, figurative miniatures, texts, postal stamps, semi-precious stones and other objects in satirical compositions. Since the 1970s he has produced rhythmic and lyrical compositions using calligraphic elements. He lives and works in the UK. (RP)

Parviz Tanavoli (ill. pp. 12, 20, 52–55)
Born Tehran 1937

Graduated from Tehran's High School of Fine Arts, 1956, then studied in Italy, first in Carrara, 1956-57, then in Milan with Marino Marini, 1958-60. Returned to Iran, 1960. Taught sculpture at Minneapolis College of Arts and Design, 1962-63, before returning to Iran to teach sculpture at Tehran University, 1964. First exhibition at the Municipal Cultural Hall, Tehran, 1957, Reza Abbasi Hall, Tehran, 1959, and the Iran Club, London, 1960. Created the Atelier Kaboud, 1960, where Grigorian, Sepehri, Saffari and Zenderoudi first exhibited. Exhibited extensively in Milan, New Delhi and Paris, and organised a touring exhibition of Iranian artists in USA, starting in Minnesota, 1961. Exhibited regularly in Europe, USA and Tehran, including: Venice Biennale, 1964; Borghese Gallery, Tehran, 1965; and Seyhoun Gallery, Tehran, 1967. Opened Rasht 29, an artist's cafe, with Kamran Diba and Roxane Saba, 1967; then founded Club 5, with Mohassess, Sepehri, Saidi and Zenderoudi, and with them exhibited at the Shiraz Festival. Exhibited at Iran American Society in 1969, 1970, 1973, 1976; and several times in Minnesota, where he kept a close link with the Abby Grey Foundation. Founded the Tehran Rug Society, 1973, and organised several touring exhibitions of tribal rugs of Iran, in 1974 and 1975, the last shown at Barbican Art Gallery, London. Travelling exhibition and publication of his collection of Iranian locks; and an exhibition of his more recent collection of metal works shown at the Ashmolean Museum, Oxford, 2000.

Tanavoli has successfully worked with various materials on different scales, using a variety of techniques. Co-founder of the *Saqqakhaneh* school, he experimented with religious subject matter in three-dimensional form. His *Heech*, or 'nothingness', series, which started in 1960 as a voice of protest against derivative works and continued throughout the 1970s, was one that endured and went on to earn wide recognition. This was followed by his *Lock* series, in which the locks sometimes became intertwined with the human body. Later, inspired by the pre-Islamic legendary sculptor, Farhad the mountain carver, he started the *Wall* series. The concision, mastery, accuracy and perfect finish of his relief panels, as well as the stylisation and contours of his sculptures, demonstrate his creative eye and his respect for the craftsman's skill. He lives and works in Vancouver and Tehran. (RI)

Mohammad Ali Taraghijah (ill. pp. 46–47)
Born Tehran 1943

Graduated in mechanical engineering from the College of Science & Technology, Tehran. Won gold medal at Iran's inter-collegiate arts competition, 1967. First exhibited his still-life paintings at the Tehran Gallery, 1976, and then at the International Art Fair, Basle, 1978. By the beginning of the 1980s developed a unique style of painting, characterised by sylised horses that became his trademark. Since then he has exhibited widely, including at: Gallery 8, Yverdon, 1984; Corsh Gallery, Chicago, 1985; Galerie d'Art du Vieux Montreux, Montreux, 1985; Taichi Gallery, Tokyo, 1988; Galeothek Gallery, Innsbruck, 1988; Im Ried Gallery, Zurich, 1989, 1991; and Seyhoun Gallery, Tehran, 1992. One of his paintings selected by the Director of International Research (TIMOTCA), Belgium, for UNESCO. Works in the collection of Tehran Museum of Contemporary Art.

Taraghijah is an artist who represents the spirit of traditional Persian painting in new forms. He lives and works in Iran. (RP)

Mohsen Vaziri
Born Tehran 1924

Graduated from the Department of Fine Arts, University of Tehran, 1947. Practising artist in Rome, 1954-63, receiving diploma there from the Academy of Fine Arts, 1958. While in Rome aimed to imbue his figurative paintings with an Iranian character. Turned to informal painting and won first prize at the second Tehran Biennial, 1960. Then exhibited 'Sand-Paintings' in Florence, London, Munich and Rome, attracting attention of western critics. Returned to Iran, 1964. Taught for 12 years at the College of Decorative Arts and the Department of Fine Arts, University of Tehran. Solo exhibitions have included: Seyhoun Gallery, Tehran, 1971-76; Iran American Society, Tehran, 1971; Tylor School of Art, Rome, 1972; and Santoro Gallery, Rome, 1977. Since 1980s divided his time between Rome and Tehran. Last solo show at Barg Gallery, Tehran, 1993. Participated in: Rome Guadriennial, 1960; Venice Biennale, 1960, 1962, 1964; Museum of Modern Art, New York, 1964; Royan Art Festival, 1968; and the Cagnes-sur-Mer International Painting Festival, France, 1971. Wrote the book, *Design Methodology*, which has been reprinted numerous times. Works in the collections of the Museum of Modern Art, New York; Niyavaran Palace, Tehran; and Tehran Museum of Contemporary Art.

Vaziri is a painter, sculptor and teacher who contributed greatly to the introduction of modern art in Iran. In 1961 the Italian critic, Giulio Carlo Argan, commented: 'Amongst the foreign artists based in Rome, the Iranian painter Mohsen Vaziri, because of the direction of his explorations and the authenticity of his images, is one of the most interesting. This exploration revolves around a single fundamental and constant theme: space. At issue is the discovery of the origins of this theme, not in a metaphysical geometric construct, or the traditional image of nature, but in the primordial human experience...' During the various stages of his career, ranging from sand compositions to metal or plastic compositions, or mobile wooden sculptures, Vaziri has always grounded his work in the abstract signification of space, form and movement. (RP)

Hossein Zenderoudi (ill. pp. 6, 19, 30–35)
Born Tehran 1937

Graduated from Tehran's High School of Fine Arts, 1958. Awarded first
prize at the Iran American Society, Tehran, 1959, and at the second Tehran
Biennial, 1960. Moved to France, 1961, and received scholarship from the
Paris Biennial, 1961, followed by many more prizes, from São Paolo to
Turin, including *Selection des Critiques, Connaissance des Arts* magazine,
Paris, 1971. Numerous exhibitions: first exhibition, 1957, at the Kaboud
Atelier, created by Parviz Tanavoli, Tehran, where he exhibited until 1961;
Paris Biennial, 1959, 1961, 1963; Tehran Biennial, 1960, 1962, 1964, 1966; Venice
Biennale, 1962; São Paolo Biennial, 1963; Maison de la Culture, Le Havre,
1963; Salon de Comparaisons, 1963, 1968; Salon de la Jeune Peinture, Paris
1963, 1964, 1965; Salon de Réalités Nouvelles, Paris, 1971, 1973. Many touring
exhibitions worldwide: in Italy, Morocco, Switzerland, Turkey and USA.
Continued exhibiting in Iran in many galleries, such as Reza Abbasi
Museum, Borghese, Iran American Society, Seyhoun and Zand, as well as
in Galerie Stadler, Paris, 1970-81; Leila Taghinia-Milani Gallery, New York,
1983, 1984; Musée Bossuet, Meaux, France, 1988; Leighton House Museum,
London, 1993; Musée de Bernay, France, 1994; Abbatiale Benedictine de
Bernay, France, 1995; Scryption Museum, Tilburg, The Netherlands, 1997.
Works in the collections of museums of modern art in Paris, New York,
Turin, Tehran, Amman, Alborg; the Pompidou Centre, Paris; the British
Museum, London; Wereldmuseum, Rotterdam; Musée des Beaux Arts, La
Chaux de Fonds, Switzerland; Malmo Cultural Centre, Sweden; tapestries
in Riyadh and Jeddah Airports, Saudi Arabia.

Co-founder of the *Saqqakhaneh* school and one of Iran's leading
modernists, Zenderoudi has persistently worked with Iranian source
materials, exploring Islamic religious folk art and calligraphy in his
rhythmical compositions of letters. He lives and works in Paris. (RI)

SELECTED BIBLIOGRAPHY

Jazeh Tabatabai

Lioness and Sun Lady, No. 12, c.1960 *
metal, 140 × 160 × 40cm
Collection of the artist

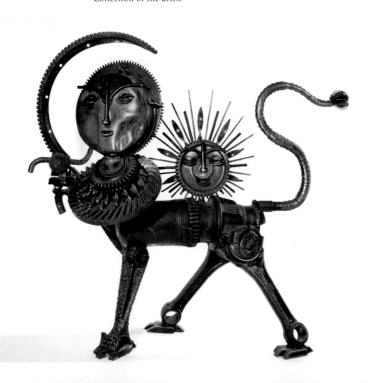

Books and Essays
Unless otherwise stated, publications are in English

Aghdashlou, Aydeen, *Years of Fire and Snow, Selected Essays 1992-99*, Ketab-e-Siamak Publications, Tehran 1999 (in Persian)

Aydeen Aghdashlou: Selected Works, Iranian Art Publishing, Tehran 1993 (in English and Persian)

Ali, Wijdan (ed), *Contemporary Art from the Islamic World* (with essay on Iran by Kamran Diba), Scorpion Publishing Ltd., London 1989

Massoud Arabshahi: Painting, Sculpture, Drawing (with an introduction by Hadi Saif), Offset Press, Tehran 1980

Massoud Arabshahi: Relief in Architecture (with an introduction by Hadi Saif), Offset Press, Tehran 1980

Avesta, A Collection of Paintings, Massoud Arabshahi (ed. Firooz Shirvanloo), Niyavaran Cultural Centre, Tehran 1978

Borrowed Ware, Medieval Persian Epigrams (translated by Dick Davies), Anvil Press Poetry, London 1996

Chelkowski, Peter and Dabashi, Hamid, *Staging A Revolution: The Art of Persuasion in The Islamic Republic of Iran*, Booth-Clibborn Editions, London 1999

Daneshvari, Abbas, *Akbar Behkalam, Movement and Change, Paintings and Sketches 1977-1988*, Mazda Publishers, Washington DC 1989

Dowlatabadi, Mahmoud, *Mohammad Hossein Maher*, Forogh-e Danesh, Iran 2000

Emami, Karim, 'Art in Iran: XI. Post-Qajar Painting', in *Encyclopaedia Iranica* (ed. Ehsan Yarshater), London and New York, vol. ii, pp. 640-46

Emami, Karim and Lamborn Wilson, Peter, *Saqqakhaneh*, Tehran Museum of Contemporary Art 1977 (in English and Persian)

Ali-Reza Espahbod: Selected Works, Iranian Art Publishing, Tehran 1998 (in English and Persian)

Parvaneh Etemadi: Selected Works, Iranian Art Publishing, Tehran 1998 (in English and Persian)

Portraits of Fassounaki (ed. Nader Tabassian and Saed Meshki), Mahriz Publications, Iran 1998

Green Memories, Works of Ghassem Hadjizadeh, Iranian Art Publishing, Tehran 1992 (in English and Persian)

Abbas Kiarostami, Photographs (interviews by Michel Ciment), Editions Hazan, France 1999

Koran (illustrations by Zenderoudi, Hossein), Editions Ph. Lebaud, Paris 1972 and 1980

Manifestation of Feelings, A Selection of Paintings by Iranian Female Artists, Visual Arts Association, Niyavaran Cultural Centre, Tehran 1995-99 (volumes produced annually)

Mohassess, Ardeshir, *Life in Iran* (introduction by Bernard F. Reilly), from the Library of Congress Drawings Collection, Mage Publishers, Washington DC 1994

Mojabi, Javad, *Pioneers of Modern Persian Painting*, Iranian Art Publishing, Tehran 1998

Gholam Hossein Nami: Selected Works, Iranian Art Publishing, Tehran 1996 (in English and Persian)

Pakbaz, Ruyin, *Naqqashi Iran – Az Dir Baz Ta Emhrouz* [Persian Painting, from the Classical Era to the Present], Narestan, Tehran 2000 (in Persian)

Pakbaz, Ruyin (compiled by), *Encyclopaedia of Art (Painting, Sculpture, Graphic Arts)*, Farhang-e Moasser Publications, Tehran 1999 (in Persian)

Paz, Octavio, *One Earth, Four or Five Worlds, Reflections on Contemporary History* (translated by H. Lane), Carcanet, Manchester 1985

The Essential Rumi (translated by Coleman Barks and John Moyne), Harper, San Francisco 1995

Ali Akbar Sadeghi: Selected Works, Iranian Art Publishing, Tehran 1998 (in English and Persian)

Paintings and Drawings of Sobrab Sepebri (ed. Pirouz Sayyar), Soroush Press, Tehran 1992 (in English and Persian)

Sobrab Sepebri, Les Pas de l'Eau (translated from Persian into French by Daryush Shayegan), Editions Orphée, La Différence, Paris 1991

Shakiba's Paintings, Iranian Art Publishing, Tehran 1997 (in English and Persian)

Shayegan, Daryush, *Cultural Schizophrenia, Islamic Societies Confronting the West*, Saqi Books, London 1992 (originally published in French as *Le Regard Mutilé: Schizophrenie Culturelle: Pays traditionnels face à la modernité*, Editions Albin Michel, Paris 1989)

Daryush Shayegan, Sous les Ciels du Monde (interviews by Ramin Jahanbegloo), Editions du Felin, Paris 1992 (in French)

Shayegan, Daryush, *Honar Bi Jaygab, Asiya dar Barabar Gharb* [A Placeless Art, Asia Facing West], Daryush Shayegan 1976 (in Persian)

Shayegan, Daryush, *Les Illusions de l'Identité*, Editions du Felin, Paris 1992 (in French)

Iron Sculptors, Jazeb Tabatabai (collection of essays and interviews on and with the artist), Tehran 1971

Parviz Tanavoli, Iranian Art Publishing, Tehran 2001

Yarshater, Ehsan, 'Modern Persian Painting' in *Highlights of Persian Art*, Bibliothèque of Persia, New York 1982

Zandi, Maryam, *Portraits, A Portfolio of Iranian Artists*, Maryam Zandi, Tehran 1997

Zenderoudi, Hossein (illustrated and translated by), *Hafez, Dance of Fire*, Mage Publishers, Washington DC 1988

Exhibition Catalogues

Maliheb Afnan, Leighton House Museum, London 1993

Maliheb Afnan, Retrospective, England & Co., London 2000

Siah Armajani (with essays by Siah Armajani, Alicia Chillida, Maria Dolores Jimenez-Blanco, Pablo Llorca, and Nancy Princenthal), Museo Nacional Centro de Arte Reina Sofia, Madrid 1999 (in English and Spanish)

Contemporary Pottery of Iran: A Selection of Works from the Fifth Exhibition of Contemporary Potters of Iran, Visual Arts Association, Tehran 1996

Ekbatana? (including works by Bita Fayyazi, Shadi Ghadirian, Ghazel, Fariba Hajamadi, Elahe Massumi), Nikolaj Contemporary Art Centre, Copenhagen 2000

Emami, Karim, *Modern Iranian Art: A Retrospective Exhibition*, Iran American Society, Tehran 1976

Shirazeb Houshiary: Dancing Around My Ghost, Camden Arts Centre, London 1993

Shirazeb Houshiary, Turning Around the Centre, University Gallery, University of Massachusetts, and Art Gallery of York University, Toronto, 1993-94

Shirazeb Houshiary: Isthmus, Magasin, Centre National d'Art Contemporain, Grenoble; Museum Villa Stuck, Munich; Bonnefantemuseum, Maastricht; and The British Council, 1995

Shirazeb Houshiary, Centre d'Art Contemporain, Geneva, and Museum of Modern Art, Oxford 1998

Iranian Contemporary Painting (published on the occasions of the First, Second, and Third Iranian Painting Biennials), Visual Arts Association, Tehran 1991, 1993, 1995

Kelke-e Meshkin, A Selection of the Works exhibited at the First Islamic Calligraphy Festival, Tehran Museum of Contemporary Art, Tehran 1977

Shirin Neshat, Women of Allah, Maison Européenne de la Photographie, Paris 1998 (in English and French)

Shirin Neshat, Henie Onstad Kunstsenter, Norway 1999

Shirin Neshat, Rapture, Galerie Jerome de Noirmont, Paris 2000

Shirin Neshat, Kunsthalle, Vienna, and Serpentine Gallery, London, 2000

Photo Biennial (9th catalogue), Tehran Museum of Contemporary Art, Tehran 2000

Parviz Tanavoli, Bronze Sculptures, Grey Art Gallery, New York University, New York 1977

Hossein Zenderoudi, Musée Bossuet, Meaux 1988

Selected Periodicals

Exhibitions of Visual Arts (quarterly with gallery listing), Tehran Museum of Contemporary Art

Golestan (monthly on literature and arts), first published Tehran 1999 (in Persian)

Negab-e-Noo, Tehran 2000 (in Persian)

Photographers (bi-monthly), special issue on Iranian photography with an introduction by Tirafkan, Sadegh, Japan, April 1999 (in English and Japanese)

Shahr (monthly on art and society), Tehran 2000 (in Persian)

TAVOOS, Iranian Art Quarterly, Iranian Art Publishing, first published Tehran 1999 (in Persian and English)

Zanan (monthly women's issues, sociology), first published Tehran 1991

LENDERS TO THE EXHIBITION

Massoud Arabshahi
Fereydoun Ave
The Trustees of The British Museum
Mohammad Ehsai
Bita Fayyazi
Shadi Ghadirian
Ghazel
Khosrow Hassanzadeh
Parviz Kalantari
The Khalili Collections, London
Collection Mr & Mrs Akbar Seif Nasseri
Seyhoun Collection
Tehran Museum of Contemporary Art

BARBICAN ARTS PARTNERS

Linklaters
Merrill Lynch
Bloomberg
Clifford Chance
BP Amoco
Slaughter and May
Richards Butler

PHOTOGRAPHY CREDITS

ADAGP, Paris and DACS, London, pp. 31–35
Atelier Lorca, Tehran, pp. 76–77, 87, 92–93
Larry Barns, pp. 114–115, 117
Claire Boit, p. 25 top
Courtesy the Trustees of the British Museum,
London, p. 95
Y. Dehghanpour, p. 53
Jila Dejam-Tabah, TMCA, pp. 31–33, 35, 36–39, 41–45,
47–49, 55–61, 63–65, 67–72, 75, 79–81, 84–85, 88, 89, 91, 126
Mr Djodat, pp. 82–83
Courtesy England & Co., London pp. 50–51
Nirvan Fadaii-Moghadam, p. 99
Bita Fayyazi, p. 26
Courtesy Galerie 213, Paris, p. 25 right
Shadi Ghadirian, pp. 8, 106–109
Ghazel pp. 102–105
Courtesy Barbara Gladstone Gallery, New York,
pp. 114–115, 117
Kaveh Golestan pp. 23, 24, 25 left
Rose Issa, pp. 15, 16, 21, 90, 100–101
Courtesy Parviz Kalantari, p. 73
Courtesy the Khalili Collections, London,
pp. 18 bottom, 20
M. Khayati, cover and pp. 110–113
Courtesy Lisson Gallery, London, pp. 118–119, 121
Shirin Neshat, pp. 114–115, 117
Sue Omerod, pp. 118–119, 121
Courtesy Pratt Contemporary Art, Sevenoaks, p. 28
Courtesy Saadabad Palace, Iran, p. 14
Courtesy Abol Qassem Saidi, pp. 82–83
Heini Schneebelli, pp. 95, 97
Rik Sferra, p. 122–123
Shirana Shahbazi, pp. 96
Courtesy Jazeh Tabatabai, p. 138
Courtesy Parviz Tanavoli, p. 12, 52–54
Courtesy Tehran Museum of Contemporary Art,
pp. 31, 32–33, 38–39, 41–44, 47, 57, 61, 63, 68, 69, 71, 75,
79, 80–81, 84–85, 91
J. Waibel, p. 54
Courtesy Walker Art Center, Minneapolis,
pp. 124–125
Courtesy Wereldmuseum Rotterdam, p. 34
Gareth Winters, pp. 17, 18 top, 62

EDITORS' ACKNOWLEDGEMENTS

At Tehran Museum of Contemporary Art, where the exhibition began, we thank Dr. Sami Azar, Director, Jila Dejam-Tabah and the photography team, Mrs. Larejani, Shahbazi Moqaddam, Ismail Nia, Mir Reghabi.

Without the Iran Heritage Foundation's support we would never have been able to develop and realise this project and we acknowledge Vahid and Maryam Alaghband, Farhad Hakimzadeh and Roxane Zand in particular. We are also thankful for the interest and support of Katriana Hazell, Cultural Director, and Sir Peter Wakefield, Chairman, Asia House; Philippa Bruckshaw and Michael Reilly, Cultural Relations Department of the Foreign & Commonwealth Office; Janet Rady and Michael Noel-Clarke, Chairman of the Iran Society; Camilla Edwards and Terry Sandell OBE of Visiting Arts; and H.E. the British Ambassador to Iran, Mr. N.W. Browne CMG.

For their insight and advice, we thank the scholars and critics Aydeen Aghdashlou (also a participating artist), Kamran Diba, Karim Emami, Mahmoud Kavir, Janet Lazarian, Leyle Matine-Daftari, Ruyin Pakbaz (who has also contributed biographies to this publication), Venetia Porter-Tripp of the British Museum, Daryush Shayegan for his apt and illuminating preface, and Tirdad Zolghadr, as well as the publisher, Manijeh Mir Emad Nasseri, chief editor of various monographs and of *TAVOOS* magazine.

We are especially grateful to all of the artists who have participated in the exhibition and those who are included in this publication. We give special thanks to Massoud Arabshahi, Fereydoun Ave, Mohammad Ehsai, Parviz Kalantari, Hossein Khosrowjerdi and Parviz Tanavoli. We also acknowledge the photographers Jamshid Bayrami, Kaveh Golestan, Mahmoud Kalari, Abbas Kiarostami and Seifollah Samadian. Galleries in Tehran have been extremely helpful with information, in particular, Mrs. Baradaran at Barg Gallery, Lili Golestan, and Massumeh and Nader Seyhoun of Seyhoun Gallery.

We also offer our thanks to the following for their personal help: Fatemeh Farmanfarmaian, Hengameh Golestan, Massoud Golsorkhi, Katia Hadidian, Pedram Khosrownejad, Michket Krifa, Fatemeh Mo'tamed Aria, Jim Muir, Azar Nafisi, Marie Perrin and Sadeq Samii.

The lenders to the exhibition are listed opposite and we are grateful not only to them but also to other collectors who have also offered advice freely: Ibrahim Golestan, Shirin Mahdavi Kazemi, Dr. Kazerouni, Mr. Khosrowvi, Goli Larizadeh, and Nazi Mahloudji. We also wish to thank David Gilmour and Delfina Studios for offering studio space in London.

We thank our translators, Babak Fozooni, Ros Schwartz and Bahi Shahid, and are grateful to Edward Booth-Clibborn and Mark Sutcliffe of Booth-Clibborn Editions for their keenness to work with us on this project, and to Carolin Kurz, catalogue designer. Finally, we wish to thank the Barbican team and in particular Sophie Persson, Curatorial Assistant, for her enthusiasm and painstaking work on this project.

Carol Brown, Rose Issa

INDEX